New Orleans Cemeteries

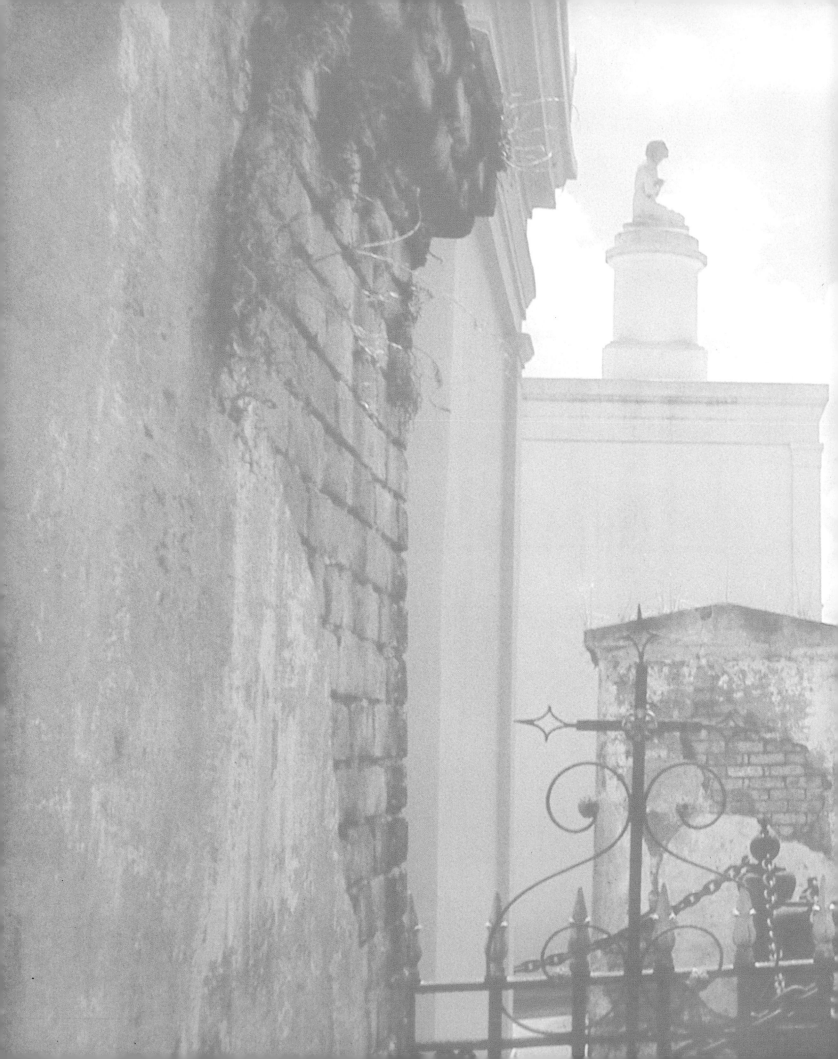

New Orleans Cemeteries

LIFE IN THE CITIES OF THE DEAD

text and photographs by
ROBERT FLORENCE

photographs by
MASON FLORENCE

BATTURE PRESS ❧ NEW ORLEANS, LOUISIANA

Published by Batture Press, Inc.
P.O. Box 19381, New Orleans, LA 70179-0381
Phone: (504) 947-2120 Fax: (504) 947-2130

Manufactured in Hong Kong

Library of Congress Catalog Card Number: 97-070870

1 2 3 4 5 6 7 8 9 1 0

Designed and produced by 10th Street Productions

Project Editor: Ann Cahn
Production Manager: Thomas Nau
Design and Art Director: Janet Pedersen

"They told me to take a street-car named Desire, and then transfer to one called Cemeteries..."

—Tennessee Williams

Dedicated to our parents,

David and Michelle Florence,

and to our grandmother,

Rowena Myers

Acknowledgments

We are enormously grateful to all the subjects of this book

Thanks to Thomas Nau and Janet Pedersen for making this book happen,

and to Jason Berry and Nancy Sternberg for editorial contributions.

For input and inspiration, thanks go to the following:

Neil Alexander, Trey Anastasio, Bruce Barnes, Clementine Bean, Caryn Cossé Bell,

Myrna Bergeron, Rabbi Murray Blackman, Ed Boardman, Clayton Borne, Michael D. Boudreaux,

Paula Burch, Robert Olen Butler, Ann Cahn, Richard Caire, Elizabeth Calvit, Leah Chase,

Phyllis Clemons, Alison Cook, Chris Cottrell, David Cuthbert, Shannon Dawdy,

Randolph Delehanty, Joe DeSalvo, Wanda Lee Dickey, Faulkner House Books, Byron Fortier,

Jiro and Yasuyo Goto, Roger Green, Kenny Hauck, The Historic New Orleans Collection,

Lloyd W. Huber, Oulaivanh Jaigla, Rosemary James, Jerah Johnson, Caroline Krieger,

Joe Logsdon, Perry Matthieu, Susaune Yee McKamey, Father Ray John Marek, Don Marquis,

Earl Milton, Bill Morrison, New Orleans Archdiocesan Cemeteries, Greg Osborn, Allison Peña,

Steve and Kathy Pollak, JoAnne Prichard, Anne Rice, Jody Rome, Richard Rochester,

Save Our Cemeteries, Richard Sexton, Michael P. Smith, Gregg Stafford,

and Tulane University Library.

And special appreciation goes to Helene Florence,

for tireless patience and invaluable feedback.

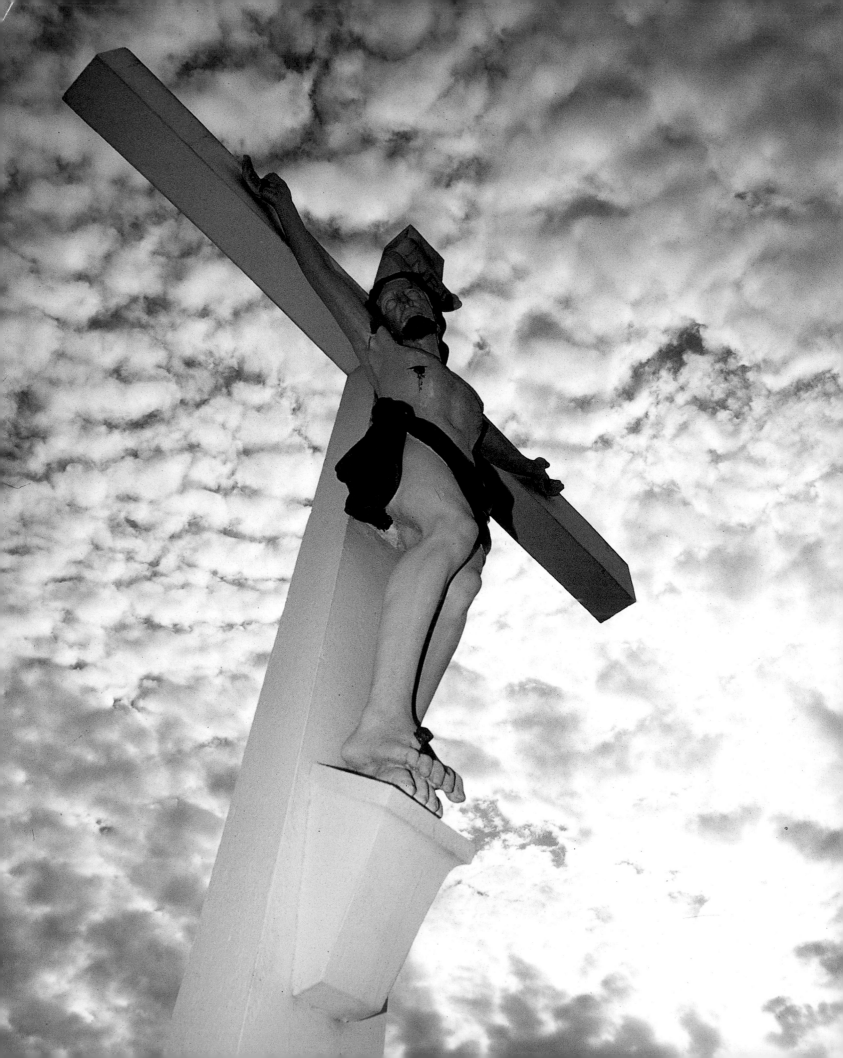

CONTENTS

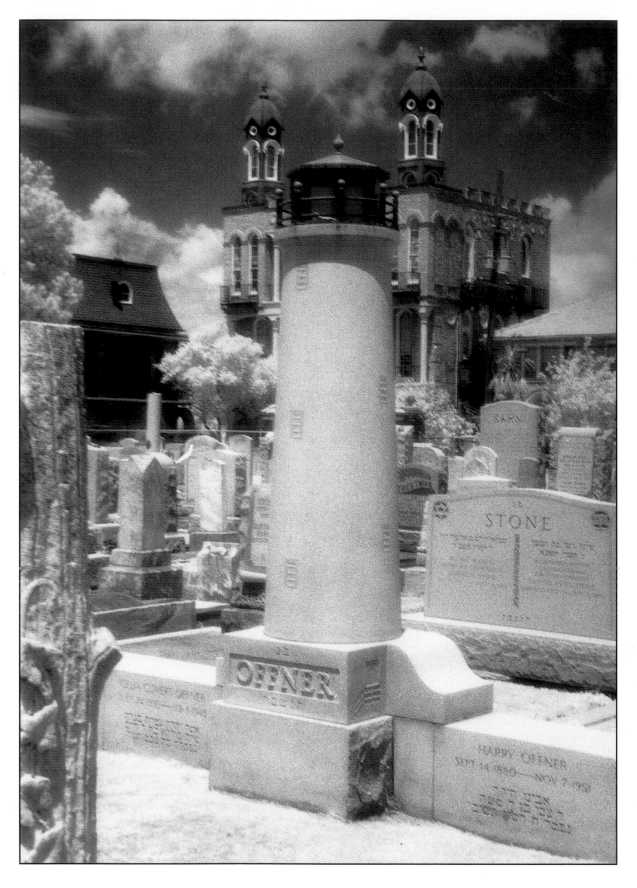

Grave of Harry Offner, former president of the charitable organization Lighthouse for the Blind. Gates of Prayer Cemetery, New Orleans

Preceding spread: Larger-than-life-size crucified Christ. St. Bartholomew Cemetery, Algiers, Louisiana

FOREWORD

Some people may look at the scale of *New Orleans Cemeteries* and wonder how much information there could possibly be about one city's graveyards. However, anyone even slightly familiar with the cemeteries of New Orleans will recognize that this book conveys only a small fragment of the entire story told by these "cities of the dead."

First of all, this book profiles only twelve of New Orleans's more than forty cemeteries, plus one burial ground in Lafitte, Louisiana. Although every cemetery is worthy of attention, various constraints made omissions necessary. Likewise, the inclusion of five profiles on individual cemetery visitors in no way implies that these five people in any way epitomize all New Orleanians' relationships with their "cities of the dead."

New Orleans Cemeteries is not only fragmentary in graveyards and people omitted but also within those it does depict. Part of the magic of these burial grounds lies in how they awesomely unfold under sustained scrutiny, in the boundless wonder revealed by repeat visits. The photographs in this book offer only a fraction of each cemetery's complete picture and the text is a brief introduction at best. There is so much more to be discovered in these Crescent City cemeteries, *all* of the cities of the dead:

Ahavas Sholem (Elysian Fields, Stephen Girard, Frenchmen, and Mandolin streets)

Anshe Sfard (Elysian Fields, Frenchmen, Stephen Girard, and Mandolin streets)

Beth Israel (Stephen Girard, Elysian Fields, Frenchmen, and Mandolin streets)

Carrollton (Adams Street, between Hickory and Birch)

Charity Hospital (5050 Canal Street)

Chevra Thilim (formerly Temmeme Derech) (Botinelli Place, near Canal Street)

Chevra Thilim Memorial Park (5000 block of Iberville Street)

Cypress Grove (120 City Park Avenue)

Dispersed of Judah (4901 Canal Street)

Gates of Prayer No. 1 (Beth Israel) (4800 block of Canal Street)

Gates of Prayer No. 2 (Joseph Street, between Pitt and Garfield)

Greenwood (5242 Canal Boulevard)

Hebrew Rest #1 (2003 Pelopidas Street)

Hebrew Rest #2 (2003 Pelopidas Street)

Hebrew Rest #3 (2003 Pelopidas Street)

Holt (635 City Park Avenue)

Jewish Burial Rites (Elysian Fields, Frenchmen, Stephen Girard, and Mandolin streets)

Lafayette #1 (1427 Sixth Street)

Lafayette #2 (Washington Avenue, between Loyola and Saratoga)

Masonic (400 City Park Avenue)

Metairie (5100 Pontchartrain Boulevard)

Mount Olivet (4000 Norman Meyer Avenue)

Odd Fellows Rest (5055 Canal Street)

Potter's Field (Old Gentilly Road)

St. Bartholomew (Algiers)

St. John/Hope Mausoleum (4841 Canal Street)

St. Joseph No. 1 (2220 Washington Avenue)

St. Joseph No. 2 (2220 Washington Avenue)

St. Louis No. 1 (Basin between Conti and St. Louis streets)

St. Louis No. 2 (North Claiborne Avenue, between Iberville and St. Louis streets)

St. Louis No. 3 (3421 Esplanade Avenue)

St. Mary (Algiers)

St. Mary-Carrollton (Adams Street, between Spruce and Cohn streets)

St. Patrick No. 1 (143 City Park Avenue)

St. Patrick No. 2 (143 City Park Avenue)

St. Patrick No. 3 (143 City Park Avenue)

St. Roch No. 1 (1725 St. Roch Avenue)

St. Roch No. 2 (1725 St. Roch Avenue)

St. Vincent de Paul No. 1 (1322 Louisa Street)

St. Vincent de Paul No. 2 (1322 Louisa Street)

St. Vincent de Paul No. 3 (1322 Louisa Street)

St. Vincent—Soniat Street No. 1 (1950 Soniat Street)

St. Vincent—Soniat Street No. 2 (1950 Soniat Street)

Valence Street (Valence Street, between Danneel and Saratoga streets)

"There is no architecture in New Orleans, except in the cemeteries."

—Mark Twain, humorist

"A New Orleans cemetery is a city in miniature, streets, curbs, iron fences, its tombs above ground—otherwise, the coffins would float out of the ground—little two-story dollhouses complete with doorstep and lintel. The older cemeteries are more haphazard, tiny lanes as crooked as old Jerusalem, meandering aimlessly between the cottages of the dead. I remember being a pallbearer at St. Louis #1, one of the oldest cemeteries, stepping across corner lots like Gulliver in Lilliput."

—Walker Percy, novelist

"There is something musical about the cemeteries of New Orleans."

—Danny Barker, American griot

"When I came to New Orleans in 1959, everything about the city intrigued me, not the least its cemeteries. It was not the above-ground tombs or the continual raking out of half-decayed corpses after a year or so in order to make room for the newly dead that fascinated me. I had become accustomed to both in Europe. What took my eye was the surreal beauty of the places. They evoke in me an aesthetic experience of the first magnitude, an experience at the same time, visual, visceral, and cerebral."

—Jerah Johnson, historian, from *A History of My Tomb*

"Them tourists travel in loud groups, smilin' and talkin' to us like we been hangin' around waitin' for them to come to New Orleans and ooh and aah over stuff we never even notice, like plarines and graves. Plarines and graves! Plarines so full of sugar that gets in your teeth and make you holler for your mama who been gone forty years. And they crazy about them graves. I hear them where I work, down in the Quarter. 'Aboveground graves!' they always say, like they never heard of such a thing. I don't get it, me. I ain't never seen folks buried no other way."

—Phyllis Clemons, playwright, from *Busrider*

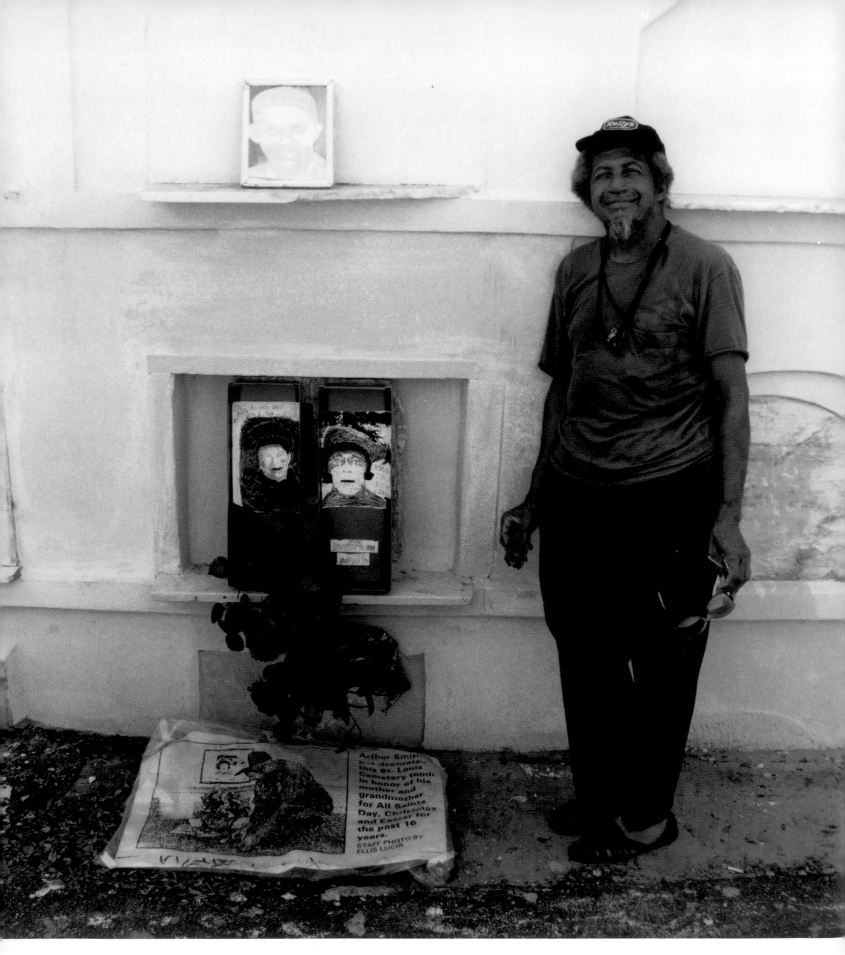

Within discarded doll boxes, Arthur Raymond Smith displays images of two irreplaceable loved ones: grandmother Amanda Carroll and mother Ethel Davis

Arthur Smith

HOMAGE FROM THE HEART

"The lizards are simply ridiculous!" exclaims Arthur Raymond Smith, caretaker of one of New Orleans's most enigmatic gravesites, as he shoos away a chameleon from the crevices of his family tomb. While being photographed by a German tourist, Arthur straightens an enlarged multicolored photocopy depicting the image of a weirdly ethereal human face. He arranges some flowers—artificial and real—then positions strings of beads—Mardi Gras and rosary—which adorn the grave of his grandmother, Amanda Dorsey Boswell Carroll. "Just as the sun is shining, I know she's smiling down on us," blurts Mr. Smith in an infectiously giddy tone as he gingerly places bricks wrapped in yellow ribbon on either side of the vault. Cleaning up some of the general trash that litters the cemetery path, he takes care to put cans and plastic containers into his bag of recyclables. "In the name of the Father, the Son, and the Holy Spirit, may her sweet soul rest in peace," Arthur proclaims, making the sign of the cross. He then gathers his clanking bag of bottles and crushed aluminum, waves good-bye, and exits the cemetery. St. Louis Cemetery #1 falls silent.

In a city full of curious characters whose truths are more compelling than fiction, Arthur Smith stands out. His insular world revolves around New Orleans cemeteries, affectionately referred to as "cities of the dead." Arthur's day to day life is a constant flurry of activity centered around preparation for the devotional decoration of his family burial sites, an activity that brings him in contact with scores of bewildered, admiring people. Since 1978 his semiregular ritual has been a source of curiosity and aesthetic pleasure to thousands. People have mistaken Arthur's personalized portraiture of Amanda Dorsey Boswell Carroll for everything from a voodoo altar to folk art. Situated just inside the entrance of St. Louis Cemetery #1, this shrine, which in its many forms has ended up in the photo albums and home videos of nearly every camera-carrying cemetery visitor, is one of the most profound remembrances to a deceased loved one imaginable.

Arthur's commemorative efforts are a part of a

process that he calls "The Annual Forget Me Not Oh My Darling All Seasons Occasion." He inaugurated this tradition in 1978 when his mother, Ethel Boswell Davis, died and was buried in the Carrollton Cemetery. His memorials result from his deep love for and gratitude toward his mother and grandmother who raised him as an ailing child. Mr. Smith was born November 14, 1932, on his grandmother's birthday. "The day she made forty . . . I was her birthday present," he explains, his voice wistful, his face smiling. Double pneumonia struck Arthur at two months old, leaving him with severe bronchial asthma well into his adult life. Though these two ladies suffered from poor health themselves, they pulled Arthur through a rough childhood, his mother raising him around a demanding work schedule and his grandmother literally leaving a sickbed to care for him.

The most important days on Arthur's "Forget Me Not . . . All Seasons Occasion" calendar are All Saints' Day, Christmas, Easter, and Mother's Day, but he visits the cemeteries several times a month, changing the enlarged colorized photocopies and arranging the flowers. Other objects can end up on this graveyard shrine, but Arthur normally leaves out religious paraphernalia to avoid creating what he calls a "Marie Laveau the voodoo queen look." Moreover, he explains, "I don't want to offend people of other denominations." Arthur himself was baptized a Catholic at Corpus Christi Catholic Church on St. Bernard Avenue and Galvez Street, but he veered away from the faith at age fourteen, becoming Baptist because he did not like confession but he did like to sing. At one point in the mid-1960s, Arthur experimented with opening his own church, but today he is nondenominational because he feels that "church doctrine causes too much confusion if you don't execute it correctly." But the practices of the Catholic Church are ingrained in Mr. Smith, and making the sign of the cross, genuflecting, recitations of Hail Mary, and prayers of the rosary instinctively flow from him.

An odyssey through the cities of the dead with Arthur Smith begins at his home, a shotgun house that serves as creative headquarters. Here he collects discarded items and combines them in an aesthetic scheme, which he reviews for many long hours before transporting his inspired creations to the cemeteries. Arthur's inventiveness lies in his use of other peoples' throwaways, his vision of artful promise realized in what most consider garbage. The mind-boggling clutter about his home suggests the crucial myopia of an artist deep in creativity. Although it would seem impossible to most people that every discarded scrap of matter that Arthur brings home is useful, for him each collected object has a specific place and projected purpose.

Mr. Smith refers to the first section of his house as "The King's Room," which he has "dedicated to the Heavenly Father." This is where he works on artificial flower arrangements that are blessed annually by a priest on All Saints' Day and where he embellishes the photocopies of his family members' faces with makeup, crayons, and Mardi Gras beads. The following section is the "Queen's Room," dedicated to Amanda Dorsey Boswell Carroll and Ethel Boswell Davis. The back section is Arthur's room, replete with a painting of the Last Supper, and a dysfunctional kitchen that includes a St. Joseph's altar. Because he "likes to keep things clean," many items in his home are covered in plastic—numerous pictures, newspaper clippings, and recent wedding and funeral announcements.

The action does not stop within Arthur's house. His backyard is a complex of sectioned areas that he calls "rooms," each with an

Mr. Smith sings "I Stand Accused (of Loving You Too Much)" at the gravesite of his mother. Carrollton Cemetery. ➤

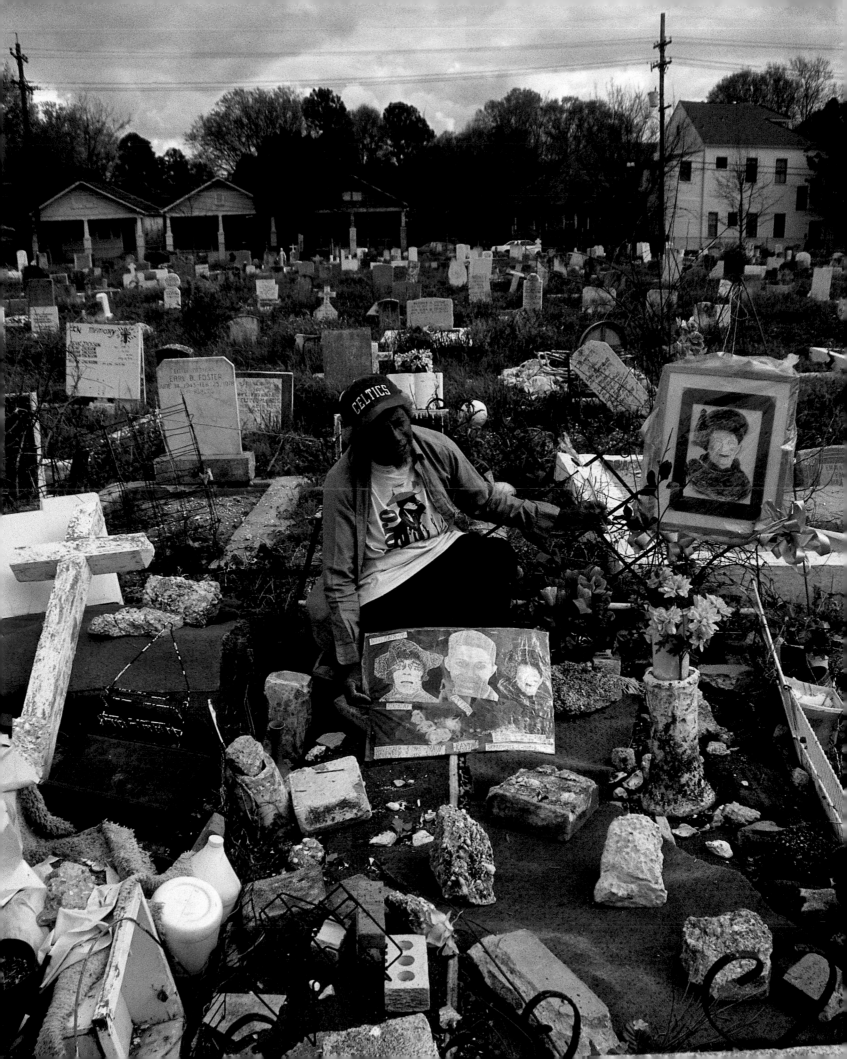

arrangement of discarded chairs. From the front of his house hang numerous stuffed animals and other playful adornments. He established the first New Orleans Valentine's Day parade, inspired by the Easter Parade of his former employer, Germaine Wells, whose family owned Arnaud's Restaurant. In his alley sits the shopping cart once used to collect cans now draped with the colorized portraits of mother and grandmother enclosed in red heart-shaped frames. In February 1996 this "float" inaugurated the premiere Valentine's Day parade in a parade-oriented city considered one of the world's most amorous places.

Leaving home with his creations crammed into tattered plastic bags, Arthur's first stop on the "Forget Me Not ... All Seasons Occasion" rounds is St. Louis Cemetery #1. Against the front wall vault he positions a picture of his grandmother connected with paper clips and pipe cleaners to a damaged picture frame and he arranges a bouquet of artificial silk flowers on the marble ledge. Arthur willingly answers the questions of curious and slightly stunned visitors. In his cheerfully impassioned rapid-fire speech, Mr. Smith effortlessly exhibits his encyclopedic memory, reeling off dates and reciting the litany of family members therein entombed. "The tomb was purchased by Amanda for her husband, Anthony 'Tony' Boswell, in 1927; he died at age thirty-nine years. Too premature. It was so unfortunate. Next came his brother, Gus Boswell; we called him 'Beau.' That was my first funeral, February 1941. The funeral procession had to drive up from around the corner on St. Louis Street, 'cause back then there were railroad tracks in front of the cemetery. Then, of course, there was

Amanda Dorsey Boswell Carroll, November 3, 1945. Then her cousin Veronica, November 1947, Truman was in the White House. She might have died from having children too fast."

A tourist interrupts Arthur to ask him if his memorial is a "voodoo tomb," for there are Xs scratched around the vault, implying that it has something to do with Marie Laveau, the legendary New Orleans voodoo queen. Arthur winces and says, "Yeah, I know. That's why I paint over those foolish markings every time I see them." He then sounds resigned and explains, "My grandmother might have played the lottery or smoked her

Arthur reclines in "the chapel." Holt Cemetery

cigarettes, but she definitely was no voodoo worshiper. But if these people want to call her a priestess, that's okay. She lived an exemplary life. Though she was a poor Negro woman, she lived a lawful life and raised four children the best she could. Considering that she ministered to her husband and family, you could call her a priestess. But she didn't mess with no hoodoo." Mr. Smith explains that he finds more significance in his tomb bearing the only photographic image in the cemetery, aside from that of Marie Laveau's neighbor in burial, the late mayor Dutch Morial.

After addressing the voodoo question, Arthur resumes his family roll call. "The final burial was for John Dorsey, January 1951. His coffin was wider than the vault, so they had to knock off some of the wall here, but it was patched up so you wouldn't know the difference. We don't bury in there nowadays because today's caskets are too big. Only room for babies." Because many older tombs cannot accommodate today's larger caskets, Arthur had to extend the "Forget Me Not . . . All Seasons Occasion" beyond the walls of St. Louis #1 to the Carrollton Cemetery, where the graves are more spacious. "My mother was a diabetic and big around, so I had to bury her Uptown," Arthur

explains. Here there are no tourists and no glaring shadow of Marie Laveau, just a wide-open cemetery that features a vibrant sprawling gravesite designed by Arthur Raymond Smith.

Arthur seems to unwind in Carrollton Cemetery. He grows quiet as he toils about the cluttered gravesite and invariably breaks into song. Mr. Smith is not one to let you forget that he was once a singer. Extending an artificial rose to his mother's grave, he repeatedly sings two songs—Bobby Bland's version of "I Stand Accused (Of Loving You Too Much)" and The Carpenters' "I Won't Last a Day Without You." To call his singing "inspired" would be a tremendous understatement. Becoming almost meditative here, he advances deeper into a communion with his ancestors, gesturing and talking to his mother's grave as animatedly as he did with the tourists in the St. Louis Cemetery. Because his mother's 1979 death was much more recent than his grandmother's passing, Arthur's sense of grief here is more arresting.

Although Mr. Smith is not in the limelight in this Uptown cemetery nearly as much as in St. Louis #1, he is well known by the Carrollton Cemetery staff. He came to the attention of Superintendent of City Cemeteries Clementine Bean several years ago, and Arthur has made quite an impression on her. Of him, Ms. Bean fondly says:

> I'll never forget the time I first noticed his mother's grave. I said to myself, "What has happened here?" Then I finally saw Arthur out there, placing the pictures around and talking to his mother. I realized he was different. Over time I got to know Mr. Smith and he's a very sweet man who loves his family very much. He's very funny, too.
>
> At some point it was suggested that we clean off his gravesite. I thought about it

and figured that would be wrong. He's not hurting anyone by decorating his plot. As a matter of fact a lot of visitors like it. They see it as an attraction. I'll tell you one thing I like about it—it never has tall grass growing over it. In sixteen years I never saw grass at either of his graves, here or in Holt Cemetery. Days when the rest of the cemetery is high with grass, Arthur's area is under control. Many families don't maintain their plots, so people don't have a right to talk bad about what he does.

> But the thing that truly amazes me about his graves is the way the pictures stay in place. No matter what the weather does, they never get torn up or knocked over. They're always right there looking at you.

As compelling as Arthur's devotion may seem in these burial grounds, his ritual visits are most intriguing in Holt Cemetery. At least his decorated graves in St. Louis #1 and Carrollton contain Arthur's kin. In "the Holt," however, he tends to a plot more sprawling than the one in Carrollton Cemetery, and embellishes it in a more mysterious, even bizarre, fashion. On his two graves in Holt Cemetery, there are no photocopied faces, just a strikingly unusual amalgamation of shapes, images, and castaway objects assembled around grave markers upon plots whose occupants he does not even know. Adding more dimension to this cryptic scenario, Arthur while homeless in 1979 purchased not one but *two* plots in Holt Cemetery, a graveyard where his father lays to rest in an unknown location.

When asked why he made those purchases, Arthur, who is never at a loss for words, was temporarily dumbstruck, responding only, "That's a good question." Upon further consideration, he remembers his initial reasoning: "I was so upset over my mother's death that I could not bear the

thought of having to disturb her grave with more burial if another family member should die and need burial space in the Carrollton Cemetery." One of his two unused Holt plots is reserved for family members. It is decorated in the classic Arthur Raymond Smith style, involving objects that appear randomly strewn but in actuality are painstakingly arranged. The other plot, enclosed in fencing and equipped with lawn chairs, fosters a larger meaning and purpose: It serves as a memorial for all the deceased in Holt Cemetery. He calls this plot his "chapel," pointing out that some cemeteries, such as St. Roch and St. Joseph's, have burial chapels. Arthur explains that his chapel is connected to a short-lived effort at opening his own nondenominational church in 1965, where he was the pastor. Far removed from his speech-making in St. Louis #1 and his singing in Carrollton Cemetery, here in his Holt "chapel" Arthur simply likes to sit and get quiet, to meditate and contemplate, and "to pray for all the deceased in the Holt cemetery and all the dead everywhere."

Although Mr. Smith has many acquaintances in his hometown, he does not get close to many people for, as he puts it, "It's hard for me to trust. Love was not kind. I gave too much of myself." But in the recent past he has become more outgoing, reaching out to people beyond his insular world. Arthur came to the attention of painter Leslie Staub, who took an immediate shine to Arthur and his work. In May 1996 she arranged for Arthur's cemetery creations to be part of an art exhibit at New Orleans's Le Mieux Gallery, where he and his drawings were well received. Mr. Smith may indeed be on the brink of a fertile career as a folk artist. But regardless of what professional success he encounters, "The Annual Forget Me Not Oh My Darling All Seasons Occasion" will always be his top priority and the central motivation of his existence.

Arthur Raymond Smith, a man who constantly addresses death, has boundless energy. He attributes his pleasantly exhausting vigor to the spirits of his grandmother and mother. "They keep me together and give me zest to live," he says, "you're not dead until you die and they keep me living."

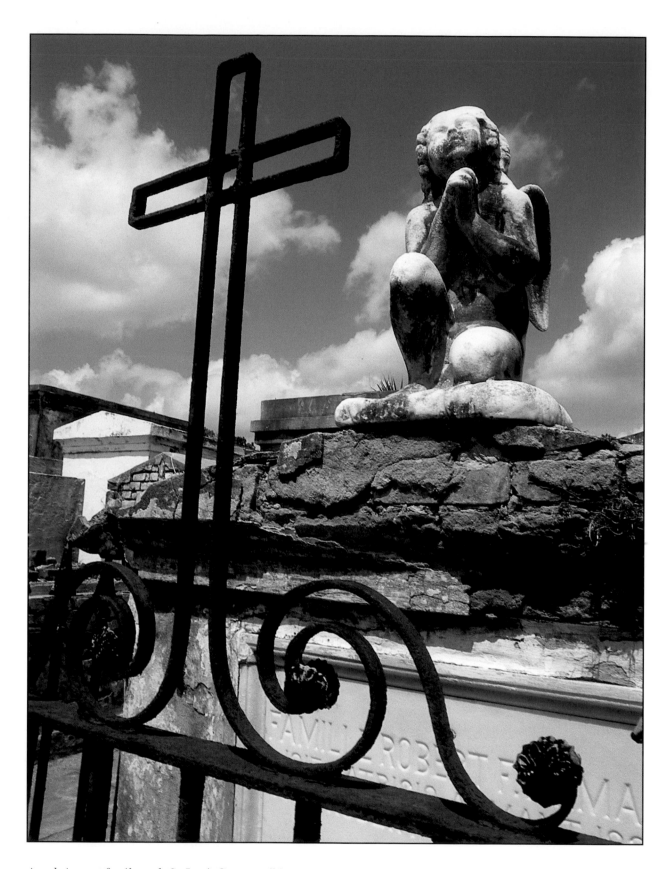

Angel, Armant family tomb, St. Louis Cemetery #1

2

New Orleans Cemeteries

"CITIES OF THE DEAD"

From the Great Pyramids to the Taj Mahal, some of the world's most alluring sites are memorials, and in very few places are cemeteries as compelling as those found in New Orleans. These burial grounds harbor a confluence of cultures, ideas, values, social conditions, physical realities, and artistic sensibilities that are unmistakably New Orleanian. Although symbolic of grief, New Orleans cemeteries transcend sadness and suffering. Though the aboveground construction of New Orleans tombs brings the visitor in close proximity to the remains of the deceased, many people strolling through the paths of these curious burial grounds are not overwhelmed by gloom. Not only are individuals awed by the sublime aesthetic and engineering accomplishments but people also detect an atmosphere of joy and even peace.

Geology and Climate Challenge Burial

The life of many cities is reflected in its cemeteries. Nowhere is this more true than in New Orleans. Because New Orleans cemeteries mirror the city in so many ways, they are actually known as "cities of the dead." These mute graveyards indicate numerous aspects of the city's history, beginning with the earliest form of history—geology. In New Orleans, interment first occurred precisely where the city was born, along the banks of the Mississippi River.

Before the land-formation process was impeded by artificially reinforced levees, spillways, revetments, water pumps, and control structures, the river flooded annually and deposited sediment drained from more than a million square miles of North America. Silt deposits shaped a natural levee, a raised embankment of land alongside moving bodies of water. The city was settled in 1718 on the relatively well-drained riverbank. The first New Orleanians also chose to bury in the elevated levee rather than in ground below sea level.

Riverside interment made perfect sense until flood season arrived, and early New Orleanians learned the hazards of burial in a floodplain. A wooden, buoyant casket forced into the levee would be pushed back up when the water table rose in the spring. Saturated coffins

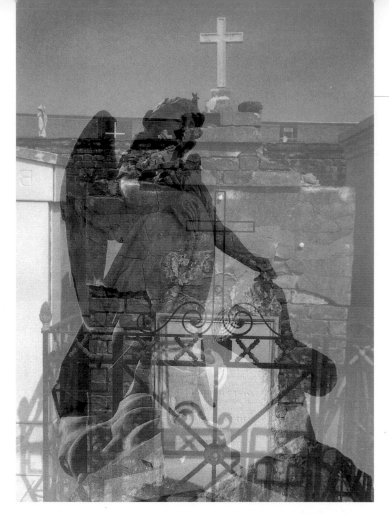

could be broken apart by flood waters, causing human remains to wash away. Several accounts of early New Orleans burials paint this hideous yet intriguing picture. *The Courier*'s June 11, 1833, edition depicts a challenging attempt at early New Orleans burial in a "Catholic Burial Ground":

"The horrid image of this place is still in my mind," wrote one observer. "I cannot drive it from my imagination. The tombs are all aboveground, and those who can afford it will never be buried underground.

This graveyard is all on a dead level and on rainy days inundated with water. It is a morass, a swamp partly rescued from its wilderness. I followed the procession to the grave. The coffin was taken from the hearse.

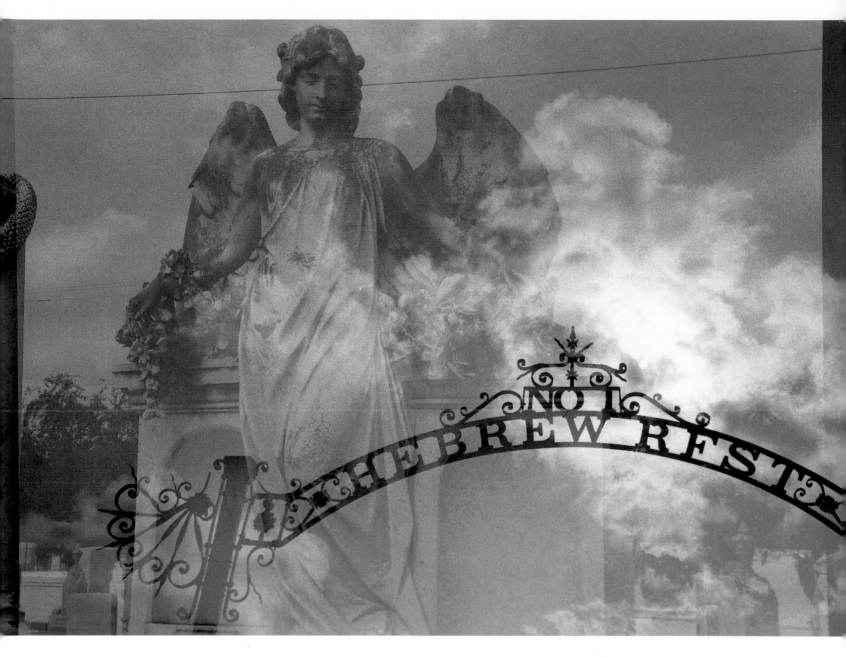

I now watched the process of interment....The body was that of a colored person who had died of cholera (which is an epidemic now). They tarried to see the last of their friend.

The grave was not over two and a half feet deep, I measured it for curiosity. The bottom was soft mud into which could be thrust a stick to almost any depth. The water was within a foot of the top of the grave. The clods of earth around all clay, such as earth would be dug from a bog.

The coffin was put into the grave and it floated so as to be level with the surface."

Such grisly encounters were not confined to Catholic cemeteries. Of the earliest Protestant cemetery in New Orleans, *Gumbo Ya-Ya* reports:

Girod Cemetery reflects in a small way what all New Orleans graveyards once were. In early days burials were all in ground and were terrifying affairs. Caskets were lowered into gurgling pools

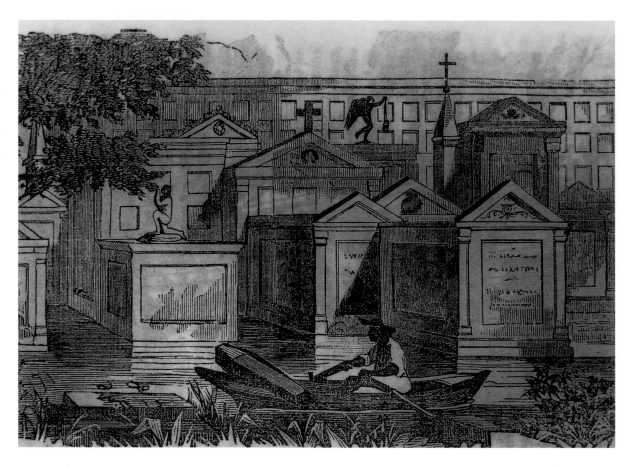

A rowboat transports a casket through flooded Girod Street Cemetery. Courtesy Tulane University Library

of water and were sunk into pits of oozing mud. As often as not, the coffin would capsize as the water seeped within. Heavy rains or a storm would cast newly buried half-decomposed cadavers to the surface.

About the city's most deadly yellow fever epidemic in 1853, this same source wrote, "And by the light of flaring torches, shallow graves were dug and the bodies were hurriedly covered. When the rains came, it was not unusual for these decaying bodies to be washed up."

A contemporary source paints a similarly disquieting picture of a graveyard that is possibly St. Louis Cemetery #3, or another older, now-defunct burial ground close to Bayou St. John: "The great Bayou cemetery is, sometimes, so completely inundated, that inhumation becomes impossible, until after the subsidence of the water, the dead bodies accumulating in the meanwhile. I have watched the bailing out of the grave, the floating of the coffin, and have heard the friends of the deceased deplore this mode of interment." Another account states that "at high tide, the river flows through the streets. The subsoil is swampy. New Orleans becomes famous for its tombs...."

With the city's first burial site poised above the settlement along the river on the levee, which sloped down into the streets, it is easy to conceive ghastly notions of the French Quarter's first inhabitants seeing friends and family float by their front doors during heavy rains. To avoid the sight of runaway coffins, and to prevent digging into the levee (the only structure protecting the fragile settlement from a devastating deluge of water from one

of the world's largest rivers), the Church soon after the city's founding established a cemetery *outside* the limits of the settlement, and ultimately opted for aboveground burial.

Prehistoric Connection

Geology would necessitate aboveground burial, a practice now as associated with New Orleans as red beans and brass bands. The windowless microcosms of buildings that comprise the cities of the dead are practically an archetypal image of New Orleans, seen by many visitors as unique, extraordinary, and exotic. However unusual these aboveground tombs may seem to some, they actually tie into long-established burial practice. It is very appropriate, not surprising or ironic, that tombs should resemble buildings of the living, for man's earliest graves initially served as dwellings.

Archeological evidence indicates that prehistoric humans of the Paleolithic and Pleistocene eras lived and buried their deceased in caves. In *The Atlas of Early Man,* Jacquetta Hawkes characterizes Neanderthal hunter-gatherers with this assessment: "There was still no wish to separate the dead from the living, for most graves were dug in the cave or hut floor." The grotto at Aurignac, France, is one of many sites that demonstrates this ancient burial scheme. The stone age practice of situating graves in geological formations such as caves, fissures, and outcroppings certainly evolved, with early man later "learning in time to make them artificially."

In his book *The Burial of the Dead,* W.H.F Basevi puts forth a more specific theory on how caves made the transition from domicile to grave. He theorizes that if a member of a Neanderthal hunting or raiding party got hurt or fell sick, he would be placed in a protected place under the assumption that he would heal and be able to rejoin his group. Food, clothing, and weapons would be left

with the handicapped hunter-gatherer to see him through his ailment and to give him mobility following recovery. Such artifacts are often found at archeological sites alongside prehistoric skeletons. Some of these cavemen, however, were not so fortunate, and their shelter, intended to be temporary, would often become a grave. "Graves developed from shelters by a natural extension of the original idea. The injured man did not always recover . . . ," writes Basevi. Thus, even prior to the dawn of civilization, human beings were entombing in sheltered structures, "aboveground tombs" that predate New Orleans cities of the dead by some forty to fifty thousand years.

After the advent of agriculture, as migration diminished and population centers emerged, people were faced with a new set of considerations in handling remains of their dead. However, they were long accustomed to interment in shelters, quite often in their own homes. Examples occur in several civilizations. In what archeologist/historian Jacquetta Hawkes claims may be considered "the oldest towns in the world," Jericho and Catal Huyuk (Turkey), the dead were sheltered in the domocile. Hawkes writes that as far back as 8000 B.C., the Natufians of Palestinian Jericho "preferred to bury their dead within or among their houses" and, dating back to 6000 B.C., "while the bones of the ordinary people of Catal Huyuk were buried beneath plaster benches in their houses, the flesh having been removed by vultures or exposure, under the similar benches in the shrines there were often much richer burials." In terms of "richer burials" in ancient shelters, they could be found abundantly in the Great Pyramids of Egypt, history's most sensational funerary tradition. The notion of grave-as-dwelling place was taken to its extreme in the Nile Valley. In reviewing a documentary on ancient Egyptian funerary practice, New Orleans writer David Cuthbert commented:

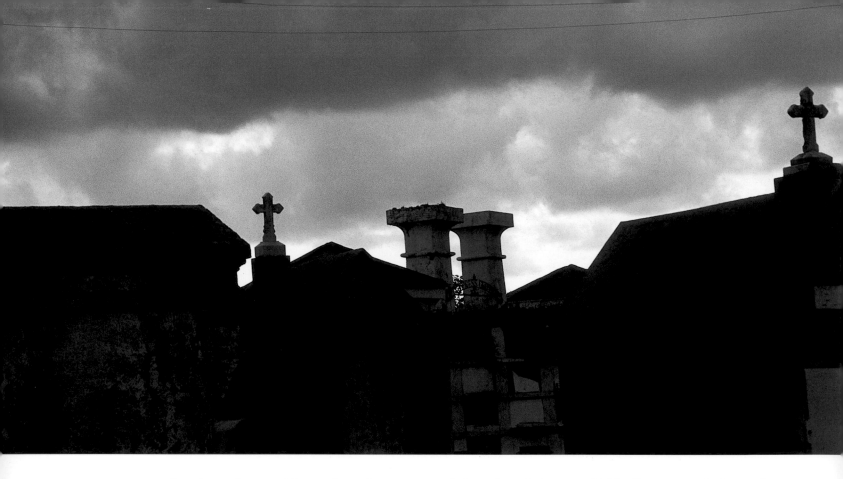

Egyptian-style gates of Cypress Grove Cemetery protrude from above the horizon of Odd Fellows Rest under layers of dismal cloud cover.

"Their great tombs were not just receptacles for the dead, but 'houses of eternity,' where they would live again."

Burial Mound Tradition,
Louisiana Connection

Talbot Hamlin writes in *Architecture Through the Ages* about the Great Pyramids: "The pyramid is essentially an artificial mound and perhaps recalls the very general primitive tumulus burials." Although not necessarily part of an unbroken connection, the Native-American burial mound tradition also has prehistoric origins, dating to a time when people lived, and entombed, in caves and fissures. Starting in shelters provided by nature, early man would ultimately fashion his own graves "by digging into natural hillocks or using the excavated earth to form a mound over the well-like dwelling." Subsequent generations of American Indians also buried in artificially created mounds.

New Orleans aboveground burial practice does assume an ancient air, which is fitting, because in Louisiana aboveground burial is ancient; the regional prehistoric Native-American interment was a burial mound tradition. In an article on archeology in *Louisiana Life* magazine, Terri Brewig wrote: "Louisiana's 'Meso-Indians,' such as those who lived along Avery Island's Banana Bayou, may have been among the first mound builders in the United States (about 2490 B.C.)." Low earth mounds have been found at Saline Bayou in Winn Parish and at the North Louisiana site of Poverty Point (site of a Native-American town laid out in concentric circles that correspond with the movement of sun and moon), where conical burial mounds dating to 1000 B.C. were created to cover cremated remains.

Truncated earth mounds of midden refuse characterized the Tchefuncte and Marksville

14

(Southern Hopewell) Native-American periods until the end of the Marksville and Troyville periods (A.D. 800–1000). At Mounds Plantation, dated roughly A.D. 1000, a truncate mound was raised over a central log tomb. By the Mississippian period, most Louisiana Native-American burial took place in cemeteries, except that of the elite, who, according to *The Historic Indian Tribes of Louisiana,* "were often interred together with family members or retainers sacrificed for burial with them in truncated rectangular mounds."

By the time of French and Spanish settlement in Louisiana, mound building had already begun to decline. But De Soto's expedition did note mound building among the Natchez and Chitimacha tribes, and eighteenth-century French settlers observed Natchez mounds in use. (Today, one mound form is actively used by Louisiana Native Americans: The Tunica-Biloxi Museum in Marksville is shaped like an ancient temple mound.) The frontier encounter of foreign cultures finished off the already declining mound-building tradition in the North American wilderness, and the conquering French and Spanish inherited a legacy of challenging burial endemic to the region, themselves ultimately employing burial facilities artificially raised above sea level.

Rising to the Occasion

Burial was indeed one of this demanding Delta environment's greatest challenges. A cemetery was included in the first Nouvelle Orleans city plan, placing it outside the limits of the city, on present-day St. Peter Street. If human remains were to be washed up and away from here, they would have floated toward an area where no one was then living. The city ultimately expanded away from the river, around this first belowground, at sea-level cemetery. The Catholic Church built a brick wall around this St. Peter Street Cemetery, presumably to contain human remains by keeping floodwaters out. Yet with six feet of annual rainfall and water rising from the ground in the spring, the first Vieux Carre cemetery had the potential to become a swimming pool of corpses during flood season.

St. Peter Street Cemetery became particularly full in 1788, when an enormous fire, a flood, and an epidemic coincided to create a larger-than-normal death toll. The church decided to open another cemetery, once again placed outside the city limits. By that year the city had grown out to Rampart Street. This newly established cemetery, St. Louis #1, was placed on the other side of Rampart, and would be the city's first aboveground burial site. Today St. Louis Cemetery #1 has the distinction of being the city's oldest surviving cemetery, yet it is believed that pieces of the St. Peter Street Cemetery endure; bricks from its wall may have been used to build St. Louis Cathedral.

Since the city began to use aboveground tombs, there have been remarkably few reported instances of graves disturbed by the rising water table, even under conditions of extreme deluge. This is not to say that New Orleans is immune to potential problems, because it lies on a likely path of hurricane storm surges. As placid as the rain-drenched Crescent City cemeteries have been in the recent past, the potential for staggering calamity still exists in South Louisiana burial grounds, particularly those that entomb closer to sea level.

Consider the hurricane experience of former New Orleans news anchor Bob Krieger:

> Perhaps the strangest experience I ever had came during Hurricane Juan, which seemed like a pussycat at first.... Cameraman Charlie Cahill and I were in Lafitte during the storm....We managed to get a ride in a boat because that was the only way to travel. There were no roads — only houses and tops of fences sticking

up out of the water and, in a small ceme-
tery, peaks of marble crosses. It was a dra-
matic shot, so Charlie stood in the boat
and started in tight on one of the crosses,
then pulled out wide to show the scene.
Except for water lapping at the boat, it
was completely silent. Then, suddenly, a
casket came shooting from below like a
submarine, and all was quiet again, except
for the pounding of our heartbeats, which
had replaced the sounds of lapping water.

"If a hand comes out of that thing, you're
here by yourself, pal," I said to Charlie.

Then it happened again … and again.
Caskets were popping up all over the
place. It seems the water had seeped into
the graves and gotten under airtight steel
caskets, causing them to blow off whatever
covered them, be it concrete or mud, and
explode to the surface of the floodwaters.

Other men in boats came by to help
round up the floating caskets and tie them
off to the fence tops. It was all pretty orga-
nized and workmanlike. Humans, I've
found, are very resilient creatures when
they have to be.

Hurricane Juan was only a Category 1 hurri-
cane. The grotesquely peculiar results of such a
low-level hurricane make one wonder what would
happen if, or when, New Orleans is hit head-on by
the proverbial "big one." How would a twenty-foot
wall of water from the storm surge effect the older
walled cemeteries in low-lying areas? Chris
Cottrell, former resident of Saint Thomas, had a
comparable experience, wherein the weird
became life threatening. After a hurricane had
passed through the island, Mr. Cottrell, as he left
his house, got caught in the strong currents of a
flood and found himself washed into a walled,
aboveground cemetery. Fighting the current, his
survival attempt became more difficult when he
noticed floating caskets and corpses surrounding

him. This scenario might approximate the situa-
tion in a New Orleans city of the dead during a
major hurricane.

Architecture and Physical Presence

Builders of the cities of the dead have had to
contend with the same challenges as those found
in construction in the city of New Orleans: low alti-
tude and a high water table, prodigious rainfall
and little drainage, subsidence and a lack of stable
substrata. For these same reasons, tombs tend to
lean, sink, shift, and settle, as do some older build-
ings in New Orleans.

Architecture is a world-renowned signature of
New Orleans, and this city's old cemeteries reveal
many specific and minute features of its neighbor-
hoods: Aspects of Greek and Egyptian Revival,
Gothic, Italianate, and Baroque architectural styles
ornament the structures' facades. Tombs are also
adorned with and surrounded by magnificent
wrought- and cast-iron fences, and facilitated by
drain gutters and chimneylike vents. Their paths
are strewn with white rangia clamshells (because
stone gravel historically has been nonexistent). Like
the buildings in the city, tombs are long and propor-
tionately tall and narrow, and they house many gen-
erations of a family under the same roof.

A design parallel is seen in the structures' rela-
tionship to their surrounding land forms. New
Orleans burial is noted for being "aboveground"
and "multiple," qualities that exist due to regional
geology. Entombment occurs above the ground
because caskets buried below the ground would
have been pushed back up when the water table
rose, and the same tombs are used repeatedly
because of the area's indigenous land shortage.
New Orleans was an island, literally surrounded
by water on all sides before the installation of land-
draining water pumps at the turn of the twentieth
century; therefore New Orleanians could not

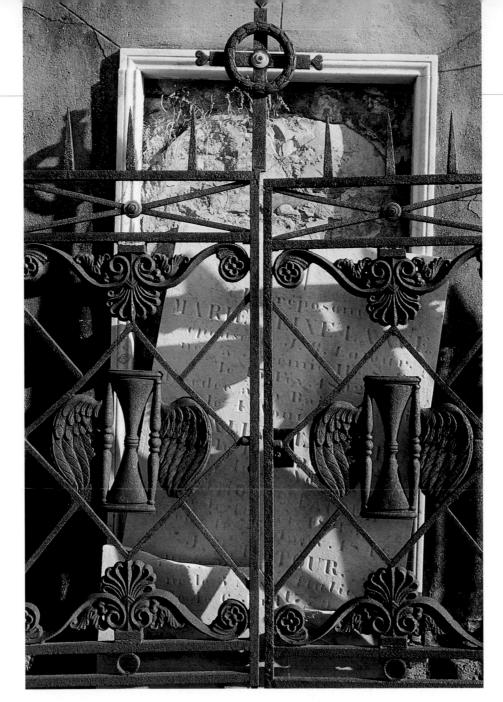

Winged hourglass, symbolic of the passage of time. St. Louis Cemetery #2

afford to use the limited land inefficiently. This is reflected in a crowded city layout. Throughout old New Orleans there are thousands of homes right next to one another. Likewise, in many cemeteries, notice the narrow passages between tombs. If the people of a city, much of which was built during a time when New Orleans was one of the wealthiest cities in the world, did not have ample yards, it stands to reason that there are no rolling meadows through the cities of the dead.

It is significant that once belowground bur-ial was made possible by the land drainage of the A. Baldwin Wood water pump, people in the city overwhelmingly maintained the established tradi-tion of aboveground burial. New Orleans is a city that exuberantly adheres to its cultural traditions, from voodoo to All Saints' Day, and many of these traditions gain momentum in the cemeteries. Aboveground burial is a postmortem cultural prac-tice as regionally identifiable as the jazz funeral.

Another parallel between the city of the dead and the city of the living can be found in geogra-

A bee buzzes around a lantana blossom growing from atop the defunct St. Anne Society tomb, St. Louis Cemetery #1. The surmounted statue of St. Peter pictured in the background fell to the ground from the crumbled brick and mortar in September 1996.

phy, which in New Orleans tends to be confusing. Today people are accustomed to neatly arranged grid patterns in United States cemeteries, but in the earliest New Orleans burial grounds, there exist disorienting labyrinths, because these cemeteries, like New Orleans itself, were not laid out with a master plan. The map took shape piecemeal, as land was reclaimed. New Orleans's streets also dissect the city at odd and extreme angles. In older cemeteries, a new tomb could easily be built

on what was once a path. And during yellow fever and malaria epidemics, when 10 percent of the city could be eliminated in a matter of months, little thought was given to the cemetery's overall configuration. As the bend of the Mississippi River twists New Orleans's streets, cemetery paths approach each other from strange severe angles, melding into a veritable maze.

A widely encompassing trait shared between New Orleans and many of its cemeteries is the instantaneous variation of structures that range from lavish and immaculate to profoundly decrepit. Just as the character of New Orleans's neighborhoods can change from block to block, the tone of a street often varies from building to building. Similarly, in a city of the dead, a visitor can pass one dilapidated heap of a tomb after another and suddenly encounter a grave that gleams.

Finally, one of the most charming ways in which cemeteries reflect the physicality of New Orleans is with the presence of plant life, whether artificially landscaped or sprouted by natural chance. New Orleans is strongly characterized by vegetation and blossom. In the book *New Orleans: Elegance and Decadence,* Randolph Delehanty writes:

> Mild winters and soft springs compensate for the steamy summers. The climate nurtures a lush, profligate evergreen flora that enfolds the old city in ancient-seeming live oaks and drapes it in junglelike vines. It's hard *not* to garden in New Orleans. Mixed in with the prolific native vegetation are imported bananas, bougainvillea, palms, citrus, and bright pink crepe myrtle, among many other showy, exotic plants. Nature here sends seeds to sprout in the most unlikely places. Unattended rain gutters become miniature forests; trees take root on roofs; brick walls are patinated with soft mosses and microscopic plants; resurrection

ferns sprout from trees and tombs.
Everything seems alive.

Note that this acutely accurate description includes "tombs" as one of the "unlikely places"; moisture and minerals in the exposed mortar germinate wind-borne seeds. For anybody paying attention to their tomb, it is also difficult "not to garden" in the cities of the dead.

But the presence of some plant life has a less-than-charming origin: certain fragrant plants were introduced both into the city and cemeteries to disguise foul smells. Decomposing organic matter below the ground emits smells that were once mistaken for deadly "miasmas." And during the colonial period, streets were basically open sewers. Adding dead animals and kitchen slop to the 95-degree temperatures, 100 percent humidity, six feet of annual rainfall, and a high water table, it is no wonder that people spent most of their time in enclosed courtyards, and that fragrant plants were propagated. Sweet-smelling blossoms also rendered cemeteries crowded with unembalmed, decomposing corpses more bearable.

People

Historically a very active port of entry for immigration, New Orleans became home to a dynamic mix of cultures. Indicated in the cemeteries are some of their varied places of origin. Tombs bear many different native tongues and worldwide birthplaces. Note the locations following the French expression "Né à…," "*Born in…,*" on many of the tombs' inscription tablets.

Another human characteristic shared by both cemetery and city is the intermingling of all segments of society. In New Orleans there is no railroad track down the middle of the city dividing rich and poor. Pockets of affluence and poverty are interspersed throughout the city. Third World

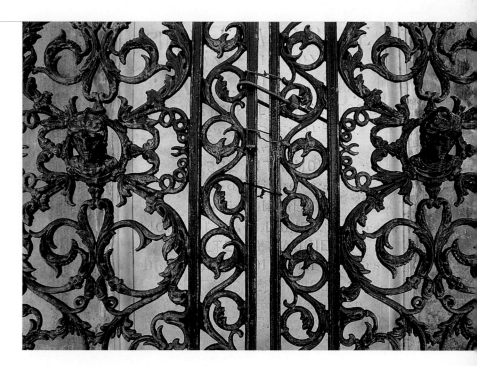

Visages enveloped within cast iron. St. Louis Cemetery #2

conditions exist within a stone's throw of unimaginable nineteenth-century opulence. Likewise, the remains of all economic and social classes lay side by side in the old cities of the dead.

Another sort of merging heavily associated with New Orleans happens along racial lines. In the stage directions of *A Streetcar Named Desire,* Tennessee Williams wrote: "New Orleans is a cosmopolitan city where there is a relatively warm and easy intermingling of races in the old part of town." Although New Orleans is indeed scarred by the same racial strife and problems stemming from discrimination, inequality, poverty, crime, and lack of opportunity found throughout the country, to some extent Williams's characterization rings true. Blacks and whites always lived in closer proximity in New Orleans and shared the city's culture, a fact that seems to have fostered relatively amicable race relations. Many people believe it to be no coincidence that as 1960s race riots inflamed the country from Watts to Newark, New Orleans remained comparatively inactive.

Perhaps traceable to a relatively more permissive and less violent colonial slave-holding environment engendered by the Code Noir (as opposed to enormously severe and brutal institutionalized slavery after the Louisiana Purchase) or to the historically more widespread and commonly accepted miscegenation, New Orleans is a place where races merge more painlessly and gracefully. Visitors often comment that they feel less racial tension on the streets of New Orleans than in other cities. (In *Streetcar*, Tennessee Williams also penned the simple but profoundly true statement that "New Orleans isn't like other cities.") Intermingling also exists in the early cemeteries. Unlike other former American slave-holding areas, New Orleanians were not racially segregated in their graves. Although newly established Crescent City cemeteries separated races in the latter half of the nineteenth century, blacks, whites, and those of mixed race continued to rest side by side, and even within the same tombs, in the old cities of the dead.

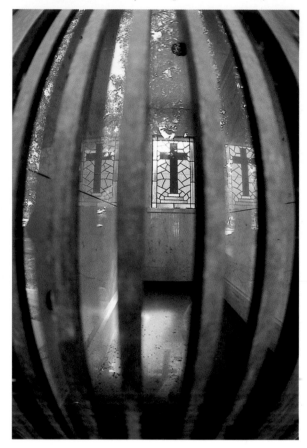

Refracted crucifix seen through a fish-eye lens.
Metairie Cemetery

Spiritual Places

Above all else, the cities of the dead are profoundly spiritual, a characteristic true of much of New Orleans. Although the "Big Easy" is deservedly known as a good-time city, there are many more places of worship than there are nightclubs, and many churches are much more of a "hot spot" than dreary watering holes. An abundance of party and prayer play off each other to create a dynamic very specific to New Orleans. As explained by Miss Noi, the protagonist of Robert Olen Butler's short story *Fairy Tale*, "Then I hear about New Orleans. I am a Catholic girl and I am a bargirl, and this city sounds for me like I can be both those things."

There is a long and fervent legacy of religious life in New Orleans, starting from the city's inception. Unlike the original thirteen American colonies, Creole Louisiana did not mandate a separation of church and state. On the contrary, the Archdiocese governed and Catholicism was the state religion of Louisiana. One of the cornerstones of American life and political philosophy is a strong consciousness of religious freedom, a separation of church and state, whereas in New Orleans it has historically been second nature for religion to be a matter of policy, deeply woven into day to day life.

Another factor that has certainly suffused New Orleans with religious devotion is hard times. Nothing exacts prayer more powerfully than suffer-

ing, and as much high life as this storybook city has experienced, it has also been the birthplace of immeasurable pain and sorrow. To begin with, severe racial oppression existed in the colony of Louisiana even before the founding of New Orleans in the form of slavery, an institution responsible for some of the most profound suffering in human history. And for several generations New Orleans was plagued with raging epidemics of lethal diseases such as cholera, smallpox, diphtheria, yellow fever, malaria, and typhoid. Epidemics of these afflictions could kill 10 percent of the city in a matter of months, inducing unimaginable horrific affliction. The ravages of natural disaster have been no stranger to New Orleans either. Hurricanes, flooding, tornadoes, and oppressive heat and humidity have killed thousands and thousands, and put the fear of God into the survivors. Finally, wartime occupation, crippling economic woes, and the scourge of crime past and present give New Orleans the ability to sing the blues. The pain of day to day life has inextricably linked many a New Orleanian to his or her church—and cemetery.

In a city whose largest cultural influences are Roman Catholic and West African—two traditions that involve an interplay with death—this spiritual disposition naturally imbues the cities of the dead, for cemeteries are one of man's most urgent sites of spiritual reckoning. The spiritually inclined find New Orleans cemeteries not somber and depressing but rather uplifting. Many people in New Orleans are conditioned by their environment and upbringing not to run from and shun death, but to embrace and celebrate it. New Orleans cemetery traditions are joyful; many paths leading there are paved by jazz funerals, and the popularity of New Orleans's All Saints' Day is a definite American anomaly. The cities of the dead are not stark, unhappy, and foreboding places. New Orleanians often go to the cemeteries not so much to mourn and lament but to pray for solace and to achieve communion with deceased friends and loved ones.

In conversation, New Orleans cemetery visitors express a wide range of impressions and feelings, but beyond the fascination and joy, the consensus is a pleasingly overwhelming sense of peace.

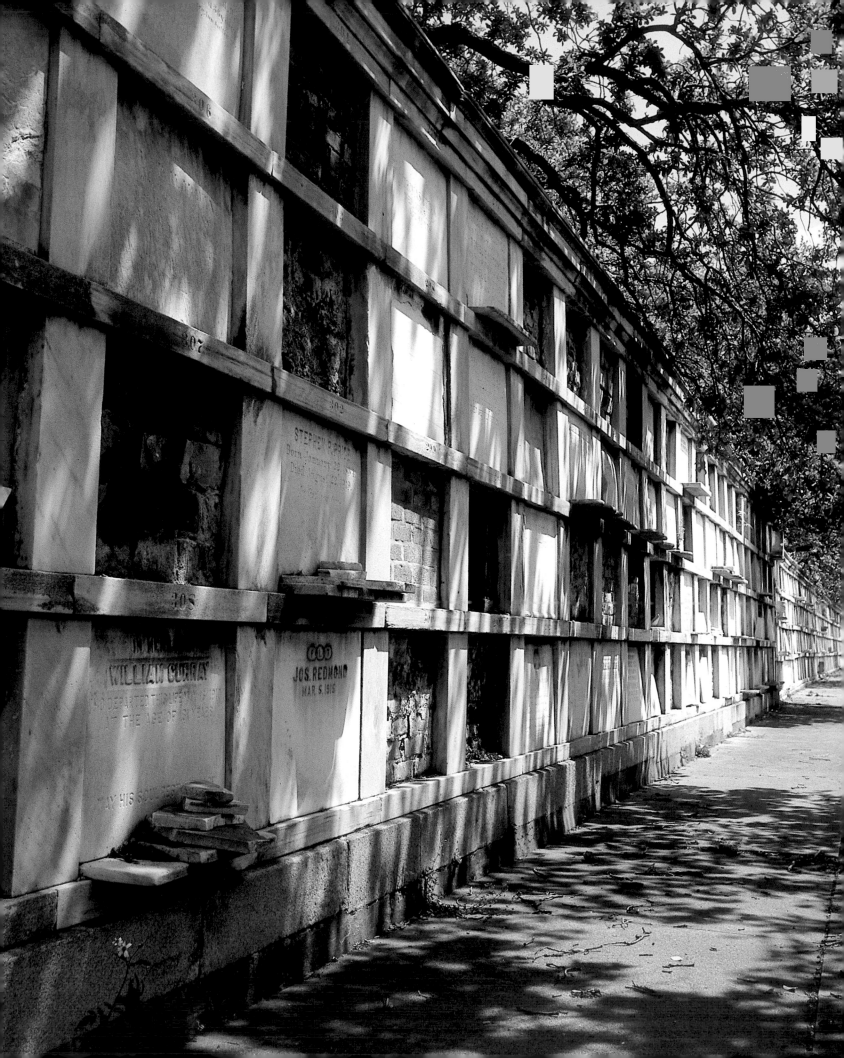

3

Burial Types and Techniques

*T*he aboveground nature of New Orleans burial distinguishes it from most United States interment, as does the fact that the tombs are used multiple times due to geological reasons. Many people are unfamiliar with aboveground, multiple burial, but some have encountered reference to it through great books. Mark Twain once wrote, ``There is no architecture in New Orleans, except in the cemeteries.'' Other literary classics have referred to multiple burial far removed from New Orleans in time and place. William Shakespeare has exposed countless thousands to multiple burial through two of his most celebrated plays. In *Much Ado About Nothing*, Act V, Scene 1, Leonato exclaims to Claudio:

> *I say thou hast belied mine innocent child;*
> *Thy slander hath gone through and through*
> *her heart,*
> *And she lies buried with her ancestors—*
> *O, in a tomb where scandal never slept,*
> *Save this of hers, framed by thy villainy!*

As part of a complex scheme in *Romeo*

and Juliet, Friar Laurence says to Juliet:

> *Now, when the bridegroom in the morning*
> *comes*
> *To rouse thee from thy bed, there art thou*
> *dead:*
> *Then, as the manner of our country is,*
> *In thy best robes uncover'd on the bier*
> *Thou shall be borne to that same ancient*
> *vault*
> *Where all the kindred of the Capulets lie.*

And in the *Holy Bible*, John 19:39–42 reads: "Nicodemus, the man who had come to Jesus at night, came too, bringing a hundred pounds of embalming ointment made from myrrh and aloes. Together they wrapped Jesus' body in a long linen cloth saturated with the spices, as is the Jewish custom of burial. The place of crucifixion was near a grove of trees, where there was a new tomb, never used before . . . ," a clear reference to the practice of reusing tombs. Note that both the scriptural and Shakespearean references are set in Mediterranean locales: Jerusalem and Italy; it was

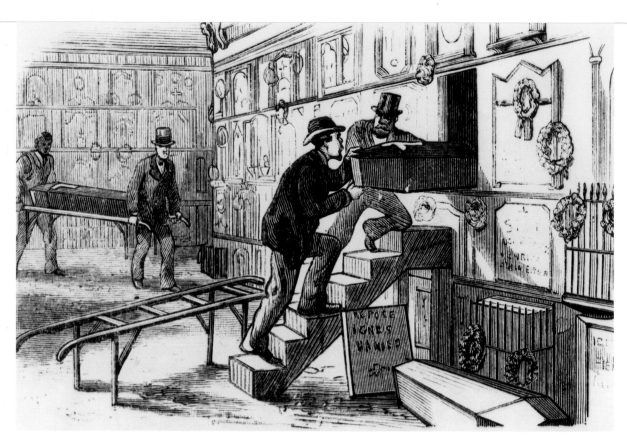

A line forms to inter in a wall vault during a nineteenth century yellow fever epidemic. The removed casket lays on the ground. Courtesy The Historic New Orleans Collection

via the Mediterranean region that multiple, above-ground burial was introduced into New Orleans.

Within the cities of the dead, there are five basic types of graves: the wall vault, family/private tomb, stepped tomb, coping, and society tomb. All forms of multiple burial share the fact that many cemeteries wait a year and a day before reusing the tomb. This may be the minimum amount of time determined that it takes for a corpse to sufficiently decompose. However, this is not to say that after a year and a day the cemetery on schedule clears out burial vaults. That is only if and when a subsequent interment occurs. If no burial follows the end of a year and day, a tomb can stay sealed for generations as its contents break down to pure carbon, literally decomposing to dust. And if after a year and a day the corpse is not sufficiently decayed, the cemetery staff will reseal the tomb and delay moving the remains until a later date. Upon being asked how to know if a corpse is "ready" to be moved, one cemetery worker replied, "You just *know*."

The Wall Vault

Approaching an old city of the dead, the first tomb type to be encountered is the "wall vault," so called for the obvious reason that they serve as the walls of the cemetery. Its interment technique involves removing the inscription tablet and breaking down the layer of brick and plaster behind. The casket is removed, and the human remains extracted from within. Until medical science determined the cause of yellow fever and malaria to be mosquitoes, cemetery workers used to burn the caskets, believing that infected coffins would spread disease. Today coffins are simply thrown away. For someone unfamiliar with South Louisiana burial practice, a casket in a garbage can is usually an eye-catcher. (A very alarmed visitor to Lafayette Cemetery once claimed he had seen "a coffin sticking up out of a dumpster!"; he also had an Anne Rice novel sticking out of his back pocket.) After the casket is disposed of, the human remains are then placed in a canvas or plastic bag

and placed back inside the wall vault to be pushed to the sides or to the back. Therefore, the remains of many people may ultimately mingle in the recesses of the wall vaults.

Wall vaults are also known as "oven vaults," for not only are many of them constructed in a barrel vault shape, which suggests an old brick baker's oven, but more appropriately because these burial chambers actually act like ovens. A year and a day is not an awfully long time for a corpse to decompose, but a body placed into an aboveground tomb between the months of May and September is subjected every day to extremely high temperatures. Other conditions contribute to rapidly breaking down human remains in these seasonally infernal "oven" vaults, such as 100 percent humidity, voracious microbial activity, and insects. (When a tomb's brick seal is opened for reburial, there are often

many cockroaches found within, doing the job performed by earthworms in belowground burial.)

In the past, bodies broke down more rapidly, since embalming was not practiced until well into the nineteenth century. This historic lack of embalming is believed to have caused a regional custom of relatively quick burial. Traditionally, New Orleans interment often occurred within twenty-four to forty-eight hours from the time of death, although such prompt interment was probably more immediately due to legislation Leonard Huber sites in *New Orleans Architecture: The Cemeteries.* In 1833 the City Council outlawed burial after twenty-four hours past the time of death for fear of spreading infectious disease.

People often wonder why New Orleanians did not choose to cremate in light of the troublesome and macabre lengths necesary for burial. Catholic

Discarded coffin

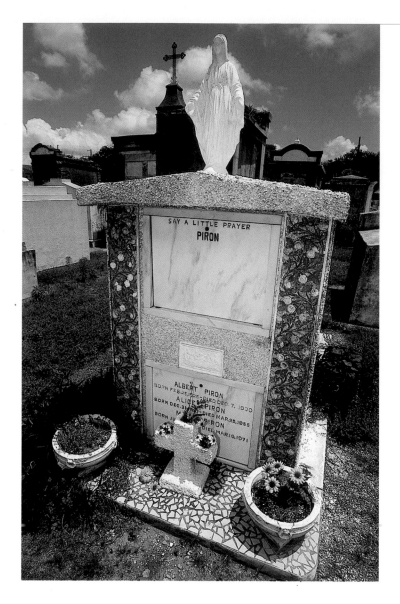

Piron family tomb, St. Louis Cemetery #2, Square 3

cultural influence in New Orleans was the reason: all early cemeteries—and churches—were Catholic because Louisiana was Roman Catholic by law, and cremation was forbidden by the Vatican until quite recently. There are, however, some people who consider New Orleans aboveground burial to be merely a slow form of cremation.

The Family/Private Tomb

The second, and most common, form of multiple, aboveground burial is the family or private tomb. Its name does not suggest that a wall vault cannot be used to inter families; plaques on wall vaults citywide bear thousands of family names. Yet one of the main differences between a wall vault and family tomb is that a wall vault could be rented. Temporarily renting a grave sounds unusual to many visitors, but not everyone could afford a private tomb. Another reason to rent a wall vault arose when a family tomb was full and more than one person in that family died within the same "year and a day" period of time. People would rent a wall vault temporarily and wait for the year and a day to end and then take the remains out of the vault, its temporary resting place, and place them back into the family tomb. Family tombs are not rented, but rather are built on land purchased from the cemetery. Every tomb is therefore custom-designed by its owner, and this is why, in a town with such a flair for the aesthetic, there are so many different styles and designs of tombs throughout the cities of the dead.

When a family tomb contains more than one vault, the first burial goes in the top and subsequent burials displace remains down to the lower vaults until they are all full. Then after a year and a day the remains from the bottom vault can be removed and placed into a chamber in the foundation known as a "caveau," where there is no shortage of space. Bones decompose quickly, but if they do not break down quickly enough, remains can be ground to make room. When faced with the challenge of an undecomposed corpse, the cemetery does not always reseal the tomb until a later date. There are some creative ways to make room. Cemetery workers have found ways to bend the corpse into an L shape around the incoming coffin, and in one case, when faced with a very recent cadaver, an interment engineer picked up the corpse and placed it on top of the next coffin. That may sound extreme, but such drastic efforts

provide burial for people who would not otherwise be able to afford it. Not only does this repeat use of tombs conserve space but it also saves a considerable amount of money; one person in a family buys a tomb and every single one of his descendants has a grave provided free of charge, aside from burial fees. This economical arrangement draws the umpteenth generation of New Orleanians to the final resting places of their forebears.

Families are therefore intimately united after death, individual members all ending mixed up in the same caveau, which houses many branches of the family tree. State law has seen to it that these branches proliferate within one tomb. In Louisiana there exists a legal doctrine known as "forced heirship," recently modified but still on the books. Nonexistent elsewhere in the United States, it is a legacy of French and Spanish civil law. Forced heirship requires parents to leave estates in their family and distribute them among their children. Estates naturally include family tombs.

The Stepped Tomb

Some of the earliest surviving graves in New Orleans are of a form known as the "stepped tomb," a name that refers to the steplike ridges on the top or up the sides of the tomb. There are many variations on this burial technique, the most basic a low-lying grave with "stepped" sides ascending to a flat top. The stepped tomb probably originated in one of civilization's most ancient methods of entombment: to simply throw the corpse on the ground and heap a mound of earth on top. The stepped tomb is certainly an improvement upon this basic idea. A low foundation of brick is laid and the coffin is placed on top. After the funeral service, bricks are stacked in a somewhat triangular shape over the casket.

Stepped tombs, however, sink the most rapidly because they are only used once and therefore do not have a caveau in which to receive prior remains. The caveau tends to stabilize the tomb by creating a wider foundation and distributing weight. Without this added stability, stepped tombs are seen sinking at different levels. Some stand close to their original height while some are entirely submerged, leaving on the ground above only a flat layer of brick. The church will not bury on top of a sunken tomb. Such sunken tombs create gaps among the cemetery rows, further contributing to the old New Orleans cemeteries' irregular layouts. With the tendency of these tombs to disappear, there are relatively few of them; they are found only in the earliest burial grounds such as St. Louis #1.

The Coping

By the time St. Louis #3 was established in 1854, it appears that New Orleans had stopped using stepped tombs. Proven inefficient and prone to

Restored stepped tomb of Antoine Bonabel, dating to 1800. The oldest noted burial site in St. Louis Cemetery #1, consequently the oldest known tomb in New Orleans

sink, they also made multiple burial difficult at a time when the population of an already crowded New Orleans was skyrocketing. Another type of aboveground burial—the "coping"—was put into practice. The coping allowed multiple interment and did not sink. Spread out over more surface area, its weight is better distributed. These graves actually allow burial in soil. The coping is a seeming contradiction in terms: "aboveground" burial that inserts caskets into earth. Copings are uncovered empty chambers framed by stone, brick and plaster, or cinder block. Filled in with earth, they are built off the ground up to three feet high, as Leonard Huber writes, "in a way so that a grave need not be dug deeply below grade." Their limited appearance is deceiving. The coping's form and breadth allow repeated entombment. The burial record of one coping in a historic cemetery notes forty-eight interments! The coping is

highly efficient, but the most effective use of space is found in the society tomb.

The Society Tomb

Of all the types of New Orleans burial, the society tombs are the most striking. Society tombs largely belonged to groups known as mutual benevolent associations. Although far fewer benevolent associations exist today, during the nineteenth century hundreds of BAs throughout New Orleans played a large role in the lives of thousands of people. They were designed to make the already staggering aftermath of death less taxing. Membership in a benevolent association entitled members to defrayed medical costs and offered financial relief to widows and orphans, but the main purpose was to provide burial, ensuring interment in a consecrated cemetery.

People interred in multivaulted society tombs

Copings,
Cypress Grove

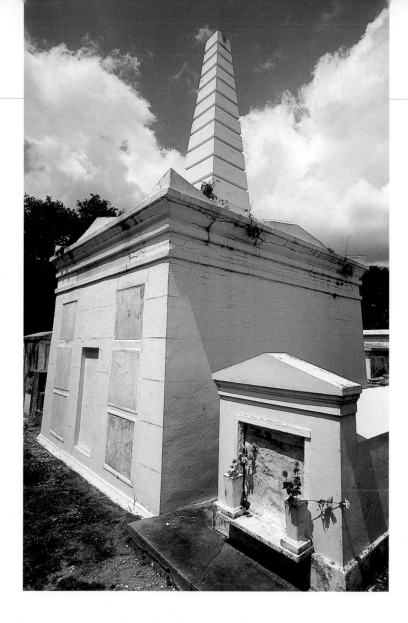

*Obelisk-surmounted
Cervantes Society tomb.
Former burial society of
Spanish immigrants,
St. Louis Cemetery #1*

often did not have the money to spend on a family tomb or wall vault, so they pooled their resources as a form of burial insurance. Benevolent associations were established for individuals representing various professions, religious denominations, fraternal orders, or branches of military service, but one of the most common means of post-mortem group association in these imposing society tombs was by immigrant ethnicity. After New York City, nineteenth-century New Orleans became the second largest port of entry. This history of prodigious multinational human traffic is evident throughout the cities of the dead.

The ability of many individual vaults within one society tomb to simultaneously service several members of a benevolent association makes these monuments highly efficient in terms of saving space. Consider the celebrated Italian Mutual Benevolent Society Tomb in St. Louis Cemetery #1. It contains twenty-four vaults, which means that, adhering to the year and a day tradition, within one century up to twenty-four hundred people could conceivably be entombed here; twenty-four hundred caskets buried belowground horizontally could take up several acres of land.

Not only are society tombs highly efficient but also quite eye-catching. Their ranks include some of the most spectacular creations in the cities of the dead, where aesthetic standards are very high. It is believed that New Orleans society tombs inspired the construction of ornate mausoleums throughout the United States.

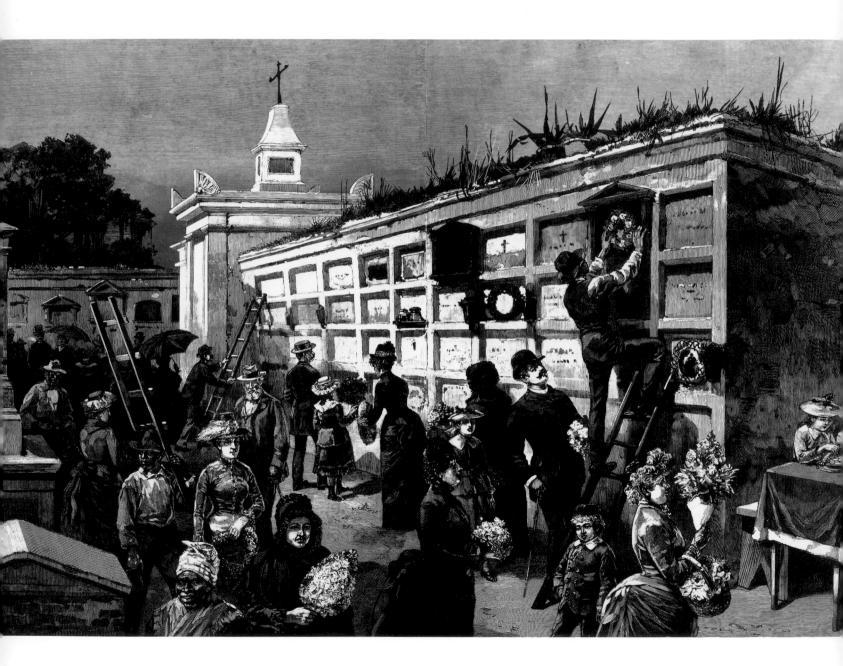

Harper's Weekly print. All Saints' Day 1885, St. Louis Cemetery #2. Pictured here are traditions such as leaving flowers, draping black cloth, hanging immortelles, parading fall fashions, and feasting on sweet food. Courtesy The Historic New Orleans Collection

4

All Saints' Day

New Orleans is a deeply spiritual city, immersed in powerful cultural traditions, many of which are religious. A certain prayerful gusto has been noted from the early days, prompting a newly arrived American observer shortly after the Louisiana Purchase to remark, "They practice the sabbath like we practice the 4th of July!" While Memorial Day in New Orleans is something of a non event, featuring not even a simple parade in a town that boasts hundreds of parades annually, the city observes a more compelling commemoration, All Saints' Day, the Catholic feast day dedicated to the deceased. In *Gumbo Ya-Ya* it is written that "Every provision is usually made for this All Saints' Day, which is probably to the dead what the New Orleans Mardi Gras is to the living of that city." It is not surprising that this Catholic feast celebrating death is embraced in a city which throughout its history has been so steeped in death. In a community whose culture is as Roman Catholic as it is African, West African spiritual beliefs brought into the colonies under slavery place a big emphasis on reverence, and even worship, of deceased relatives.

This ancient Catholic rite was introduced into Louisiana by the same French who legally mandated Catholicism as the state religion. Elsewhere known as "Hallowmas" or "Allhallows," the Feast of All Saints has been a church festival since the dawn of Christianity. Like other Christian holy days—such as Mardi Gras—it stemmed from pre-Christian seasonal religious rites. In *Halloween Through Twenty Centuries*, Ralph and Adelin Linton comment: "The earliest [such] celebrations were held by the druids in honor of Samhain, Lord of the Dead, whose festival fell on November 1. This day was also the Celtic New Year's Day, the beginning of winter and of the time of 'the light that loses, the night that wins.'" Like the Celts, many ancient cultures celebrated nature's springtime rebirth as they experienced blooming flowers and new foliage. Conversely, autumn's falling leaves, dead flowers, and shorter days and nights inspired contemplation of deceased family and friends, and various remembrances of them. Autumnal tomb adornment combined with prayer has been practiced for ages.

In a *Times-Picayune* article, Donald Duffy, pastor of St. John the Baptist Church in Edgard, Louisiana, explains that the Catholic All Saints' Day grew directly out of pagan Rome. The *Picayune* reported that: "The Pantheon was a Roman temple dedicated to 'all the false gods.'" Duffy said, "Pope Boniface IV renamed the temple 'All Saints,' in remembrance of Christ's triumphs over false gods." Ralph and Adelin Linton write that Pope Boniface in A.D. 609 incorporated this pre-Christian ceremonial observance into the Catholic calendar and that "by the end of the thirteenth century, the celebration of All Souls' Day was practically universal in the Catholic world."

European Catholicism developed a religious reverence of the dead to an extreme degree. In Brittany, France, a festival of bonfires was set on All Saints' Eve for the chilly returning spirits to warm themselves. People would visit the charnel houses to find "the parochial skulls, neatly placed in white, black, and blue boxes, with heart-shaped openings, grinned a welcome to the visitors." Accompanied by a priest, these feasting "death-singers" would chant "mournful complaints of the ghosts." The "death-singers" would begin to hear strange sounds as they lay down to sleep, acknowledging the arrival of the beckoned spirits. This European Catholic feast was brought to the New World colonies, undergoing many regional transmutations. Most Latin American countries fervently observe All Saints' and All Souls' days, Mexico being a notable example. "In Mexico the first and second of November belong to the dead. According to popular belief, the deceased have divine permission to visit friends and relatives on earth, and to share in the pleasures of the living," writes Chloë Sayer in *Mexico: The Day of the Dead*.

This tradition debuted in New Orleans during the French colonial period, according to the book *Beautiful Crescent*. "The first All Saints' Day activity celebrated the re-opening of St. Peter's Cemetery in 1742, and the completion of the fence surrounding it," write Joan Garvey and Mary Lou Widmer.

New Orleans's All Saints' Day was a more intense affair in the past, as was the funereal process in general. Traditionally death announcements were posted throughout the city, in stores and on lampposts, trees, and fences, which would announce the time of death and funeral information. Most Catholic churches had a "Death Notice Blackboard." In homes, all clocks were stopped at the hour of death. Stubborn, well-made clocks which refused to stop were sometimes purposefully broken, even family heirlooms. Some families had large prized coffeepots used only during wakes, caffeine combating the energy-drain of passionate Creole mourning. Black crepe was hung on the front door and mirrors were concealed.

The elderly were buried in black coffins, married and middle-aged in lavender or gray, and children in white. The heads of the horses drawing the hearse were bedecked with long black plumes, and the animals were covered with black fabric if the deceased were old, white if young. The horses were usually well conditioned for funeral service, their gait proceeding in perfect time to the brass band's tempo. In his book *A Life in Jazz*, the legendary New Orleans jazzman-historian Danny Barker sites an interesting example of horses as part of the mourning process in the story of a hearse driver named "Joe Never Smile." This stoic-faced driver used two horses that were known to actually cry in funeral processions. People believed the horses' tears signified that the departed was en route to heaven. Barker's grandfather, bandleader and carriage driver Isidore Barbarin, informed Danny that in actuality Joe Never Smile would wipe freshly squeezed onion juice under the horses' eyes before the funeral to trigger a deluge of tears.

Mourning attire. Courtesy The Historic New Orleans Collection

Hearse drivers dressed up in tall black hats known as "beavers," black suits, and frock tail coats. On the other side of beveled glass windows of the hand-carved, hand-polished carriages lay the brilliantly flower-laden coffin. In the old days when people were "funeralized" in their home, rather than in funeral parlors, the sale of mourning paraphernalia such as shawls, thick trailing veils, hair wreaths, and immortelles became a cottage industry. Anguished lamentations were composed and read by the bereaved, followed by unrestrained mourning.

While this scenario characterizes a typical New Orleans funeral process, the situation was intensified on All Saints' Day. "Louisianians are as a whole great cemetery-goers all year around, but even most of those who don't attend all year appear for this occasion. They would as soon allow the family place to appear in a neglected state on All Saints' Day as would a Creole dowager attend a Mardi Gras ball wearing her third-best wrapper and in her bare feet," reports *Gumbo Ya-Ya*.

Traditionally, All Saints' was more than a day, rather something more like a mini-season, as preparation for the feast would begin weeks earlier in mid-October. Day by day the numbers of

devoted tomb preparers increased, adults and children wearing work clothes, their gloved hands bearing scrub brushes, mops, and soap, buckets of whitewash and paint, rakes, shovels, pitchforks, trowels, and pruning shears, scissors, and the ubiquitous dustpan and broom. Many were cheerfully devoted to toiling for numerous obligatory rituals: weeding and grading the plots; amending of soil and planting new vegetation; strewing of additional oyster and clam shells on the paths; forcing of upside-down colored glass bottles into the ground to artfully border pathways and graves; scouring and whitewashing of tombs; cutting and chiseling of new marble; and touching up ironwork and epitaphs.

Within a couple of weeks prior to November first, young boys white and black would hover around the cemetery gates offering their tomb maintenance services for a fee. (New Orleans's most famous native son took part in this tradition. In a 1969 letter Louis Armstrong wrote: "We kids used to clean the graves on decoration days. For the families of the dead. We used to make a nice little taste (Tips)." A few days before All Saints', entire families would appear, every individual assigned a particular task. Along with their tools, they bring picnic lunches, which are consumed while resting from their labors of love on the edges of tombs. The day before (Halloween), glass and marble vases are introduced, and by noon of that day the arrival of the all-important flowers begins and proceeds well into the evening.

In 1885 writer Lafcadio Hearn addressed the presence and significance of flowers on New Orleans All Saints' Day:

> This flower town, on the first day of
> November, has from time immemorial
> closed all her places of toil and trade and

Ms. Celia Bush, having just attended the November first Veterans observance in Holt Cemetery, dons her Veterans of Foreign Wars uniform upon visiting her family tomb in St. Louis Cemetery #2. She brings a cloth owned by her beloved sister to the final resting place of this sister, as well as her mother. She will drape the cloth over the base of the tomb and then kneel in prayer. Her visit is anything but sad; it is cathartic. Ms. Bush explains, "It feels good to pray for the dead. It's actually very peaceful. Like everything else, this will come back to you, and you will feel refreshed."

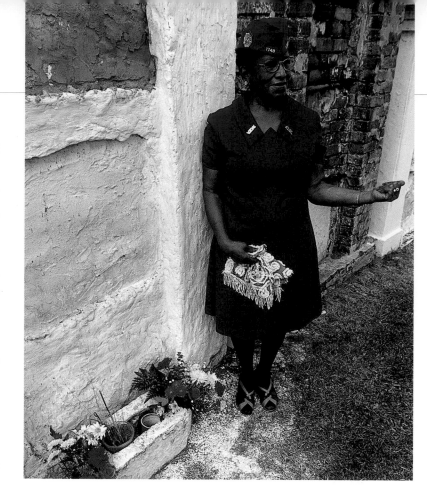

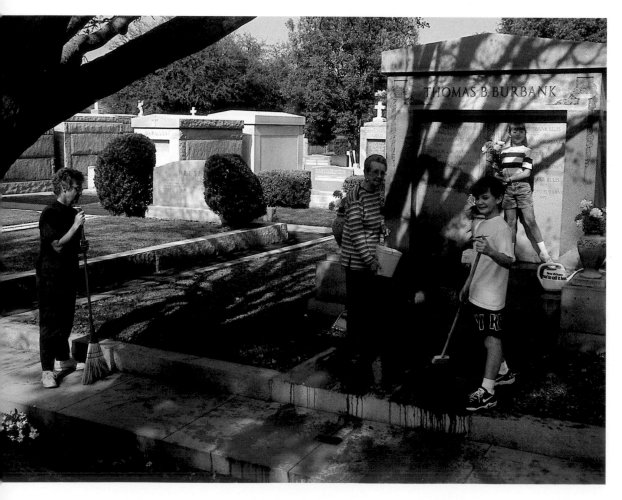

Before sweeping away the debris, Doris "Ducky" Ellis splashes her Metairie Cemetery family tomb with water, a tradition which she herself created. Ms. Ellis is assisted by her daughter, Mary Wise, and her greatgrandchildren, Justin and Lauren Poche. Ducky considers it "an honor" to have several generations of one family contributing to All Saints' Day preparation, although her daughter Nancy Wise mentions that she wishes her daughter Lisa Poche could be there. Ms. Wise explains, "My daughter had to work today. Not as many people come out today because people have to go to work. In the past people used to be let off from work and from school. There was bumper-to-bumper traffic."

Aaron Lavigne carries out an age-old tradition in whitewashing his family tomb in St. Louis Cemetery #1, a practice taught to him by older generations of his family. Mr. Lavigne comments, "I was always taught to respect my elders. They taught me so much. They know a lot more than a lot of people give them credit for. They taught me to love, to love everybody."

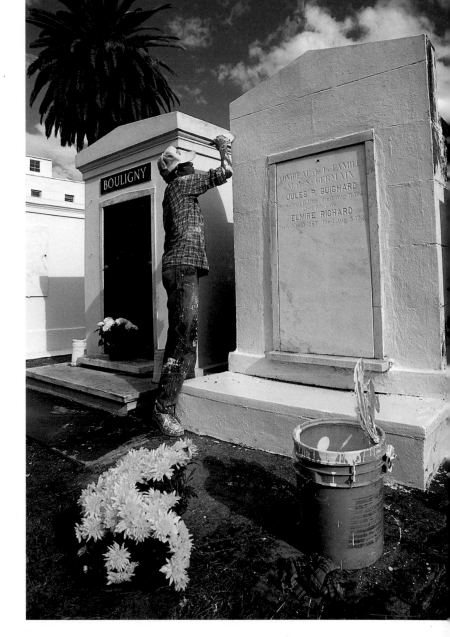

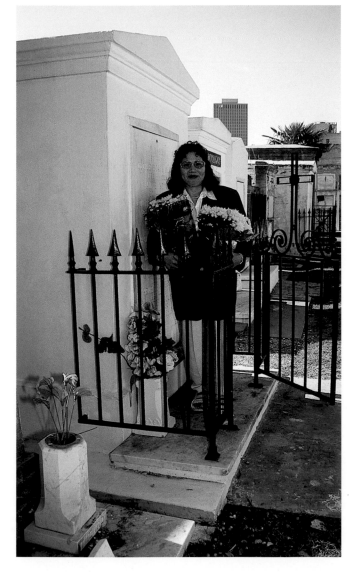

The signature All Saints' Day practice of delivering yellow chrysanthemums to the grave is carried out by Mrs. Joanne Klute at the St. Louis Cemetery #1 family tomb of her late husband Mickey Klute.

gone forth by thousands and hundreds of thousands with baskets of flowers to decorate the graves of the dead. There are flowers in the yards in New Orleans, flowers in the fields, on the walls and in the hedges; flowers of all colors and all kinds. On this particular day it is as if all these flowers, gathered in the arms of a hundred thousand pretty children, had set out to decorate the graves of the cherished dead. Nearly every street is a living, moving mass of fragrant flowers.

New Orleans's fecund environment, in which, as Randolph Delehanty writes, "It's hard *not* to garden," lends a further appropriate meaning to this celebration. The purpose of this ancient autumnal feast, explains Jeanne Arquedas in *All Saints' Day*, is to signify nature bidding "farewell to the last days of her yearly cycle of birth, maturity, and death," with the visible death of plant life inspiring thoughts on the death of loved ones. Through the language of flowers, ideas are derived from nature's color scheme, and blossoms are given as commemoration of the dearly departed; the message is that soon the surrounding vegetation will visibly wither and fade, and the absence of flora acts as a symbol of death until the arrival of new growth the following spring. But this significance is lost in New Orleans, as there is no substantially noticeable death of plant life in the verdant early winter. The subtropical climate affords a virtual 365-day-a-year growing season. Quite to the contrary, autumn actually ushers in the blooming of several popular plants such as the sweet olive, camellia, azalea, hibiscus, bougainvillea, and angel's trumpet. South Louisiana's physical setting does not visually accentuate the idea of death-in-process, but rather notions of fertility, rebirth, and beauty, thwarting a bleak and somber-appearing milieu, turning the notion of a visual-loss-of-life

on its head, and reinforcing this Christian holiday's theme of resurrection. On November 2, 1903, *The Daily Picayune* remarked, "All Saints' is the city's great home festival, and it is always so beautiful, so beautiful that the old Creole term, 'Le Jour des Morts,' seems a misnomer."

The most popular All Saints' Day flower has been the chrysanthemum, so much so that "for a long time, this flower was never used in New Orleans homes, and there is still a widespread aversion to it in decorations or personal flower gifts." Found in abundance are also dahlias, daisies, roses, carnations, and coxcomb, although anything will do. Some people would plant an All Saints' Day flower bed for the express purpose of supplying November first tomb decorations. Others could obtain bouquets at the French Market. The flowers of the old-fashioned bouquet were traditionally "squeezed together tightly in a stiff white collar of lace paper" so that they could fit in the cone-shaped glass and tin vases affixed to the tombs. There were accoutrements of a more permanent nature that were not normally left on the tomb indefinitely, such as beaded All Saints' wreaths known as "immortelles," also fashioned from metal, cloth, fish scales, or waxed paper. Then there was the curious Victorian practice of making not only wreaths but jewelry from hair of the deceased.

After the extensive, heartfelt preparation, All Saints' Day arrives. One of the first sights upon approaching the cemetery were police on horseback and on foot monitoring the crowds and directing traffic. Then closer to the entrance, and throughout the cemetery, were food vendors. During the nineteenth century the vendors offered long-forgotten Creole specialties such as Pain Patate (potato bread), sweet potato pie, or pudding, Estomac Mulatte (mulatto stomach), icing-

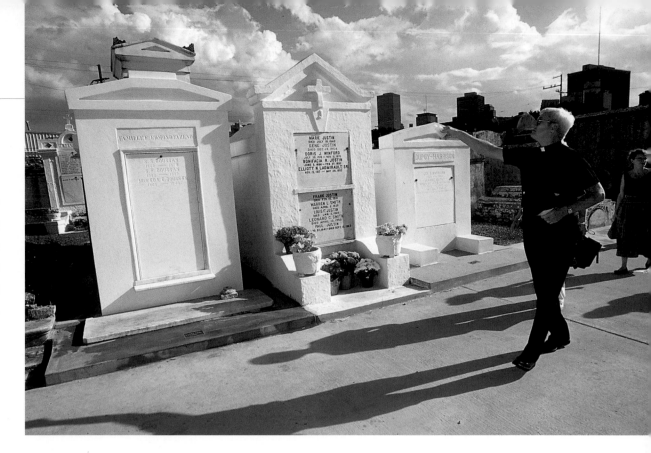

Father Adolph Kaler blesses tombs with holy water during his rosary walk through St. Louis Cemetery #2.

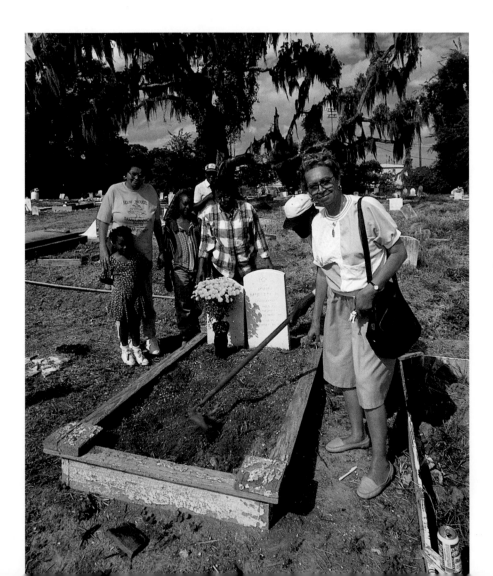

Sisters Cecilia Mullen Fagan and Jean Mullen Lee visit the Holt Cemetery coping of their father, John Mullen. Mr. Mullen himself had an affinity for Holt Cemetery, for as a member of the Eureka Brass Band, he participated in many jazz funerals which ended up here. Also pictured are Cecilia Fagan's daughter Alice Fagan and granddaughter Cecilia Fagan, and Jean Mullen Lee's daughter Mia Lee. Hoeing the grave is Claude Scipio, carrying out an age-old yet nearly forgotten tradition of hiring out his services to visiting families on All Saints' Day. In a 1969 letter, Louis Armstrong wrote, "We kids used to clean the graves on decoration days. We used to make a nice little taste (Tips)." Perpetuating this tradition, the Lee family did indeed tip Mr. Scipio.

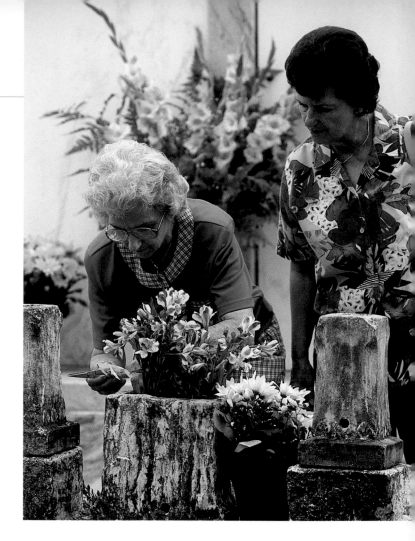

Lizette Arcenaux and daughter, Rita Church, arrange flowers at their St. Roch Cemetery family coping. Ms. Arcenaux, a lifelong observer of All Saints' Day, expressed her views on the changing nature of November first in New Orleans: "All Saints' Day has not necessarily changed for the worse, there's just not as many people out here today. When older people pass on, the younger people don't always cling to the traditions. Life has changed, but all in all, All Saints' is still happening. Today things have to be exciting, front page news, to catch peoples' attention. All Saints' Day may be a little too quiet to hold peoples' attention today. But maybe it's more than that. When you go to the cemetery, you confront mortality, and that might bother some people today. Nobody lives forever. Not here anyway."

A telltale sign of All Saints' Day: police on horseback in St. Louis Cemetery #2. New Orleans Police Department Officer Debbie Weaver and her horse M&M.

covered ginger cake, Candie Tire (pulling candy), and La Biere Creole (Creole beer), fermented pineapple pulp and juice. Naturally there was the still ever-popular pecan and coconut praline. By the twentieth century, pushcarts were offering pralines, peanuts, candy apples, ice cream, caramel popcorn, coffee, hot tamales, and gumbo. Although many people packed their own home-made All Saints' picnics to feast upon within the cemetery, these vendors did a brisk business.

The feasting aspect of All Saints' Day has been central in many other countries, such as in Brittany where people on All Saints' Eve after vespers would "sing a peculiar chant known as the 'gwerz'" at the charnel house and then proceed home to prepare banquets of food and drink by enormous hearth fires "so that the dead may have good cheer and comfort." Likewise in Mexico, a bastion of All Saints' activity, where the Day of the Dead was an established custom long before missionaries introduced it as a Christian holy day, food is central. In *Idols Behind Altars*, Anita Brenner writes:

> This holiday comes on the first and second of November. All Saints' Day is all adult ghosts' day, and All Souls' Day belongs to the children. The spirits return according to their ages, on the first and second eve, to dine with their living relatives. The table is set on an altar. There are beans, chili, tortillas, rice, fruit, other daily dishes, and the specialties of the season: pumpkins baked with sugar-cane, pulque, or a bluish maize-brew with a delicate sugar film, and Dead Man's Bread. For the children, candy skulls, pastry coffins, ribs and thigh-bones made of chocolate and frosted sugar, tombstones, wreaths, and pretentious funerals.
>
> The living do not care to eat of the feast

until the dead have left. They sit up all night with "the little dead ones" (affectionate term for invisible human beings) as if at a wake—a Mexican wake; singing, praying, drinking, making a little love. And it is a wake, except that the prayers are not said for the dead, but to them. Everybody "weeps the bone" picnicking in the graveyards. The tombs are turned into banquet tables similar to those at home. The food is put upon them, on banks of flowers, heavy purple wild blossoms and the yellow pungent cempoalxochitl, ancient and sacred bloom …

> In Mexico City the at-home of November second becomes grotesquerie. Fashionable pastry-shops swing over French confections this urgent sign: Buy your Dead Men's Bread here. They turn their shining displays into ranks and pyramids of skulls, miniature and life-size and bigger than that, lucent white, or creamy, with maraschino cherries for eyes and syrupy grins on their mouths, and rows of fine gold teeth. The funerals are of expensive milk chocolate, the wreaths of tiny candied fruits—and though this wonderful array is for the baby ghosts, no child in the city but awakes demanding on this day "my funeral" or at least "my skull."

New Orleans All Saints' traditions were not quite as morbidly playful as those in Mexico, but a certain circuslike quality did appeal to children. Aside from the sweet confections available, the vendors sold "balloons, toy birds flying gaily from sticks, hot dogs, and *toy skeletons*." *Gumbo Ya-Ya* recorded a child's reaction:

> A young woman with dark hair and a pretty face was silvering a fence around a tomb in St. Vincent de Paul's. Her small son, playing in the walk, called out,

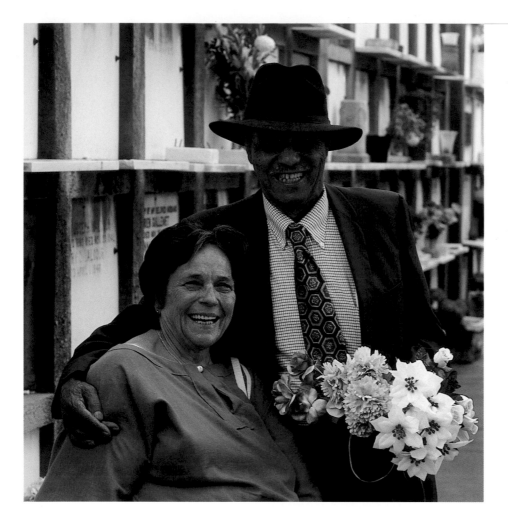

Having driven in from Covington, Louisiana, Leo and Betty Pratts pay their annual visit to family tombs in St. Louis Cemetery #2. Mr. Pratts grew up not far from the cemetery at 2506 St. Philip Street, within a Creole French-speaking household.

Prior to group prayer, the Nguyen family tend to the gravesite of former family elder, Colonel Nhon Nguyen, in Restlawn Park Cemetery, Avondale, Louisiana. A suburban cemetery established after the land was drained, belowground burial is practiced here. As a cultural group steeped in both age-old "ancestor-worship" and their more recent Roman Catholicism, the Vietnamese uphold All Saints' observance as steadfastly as any New Orleanians ever have. Pictured here are Thu Thuy Ding, Donald Nguyen, Daniel Nguyen, Huong Kim Nguyen, and Luat Nguyen.

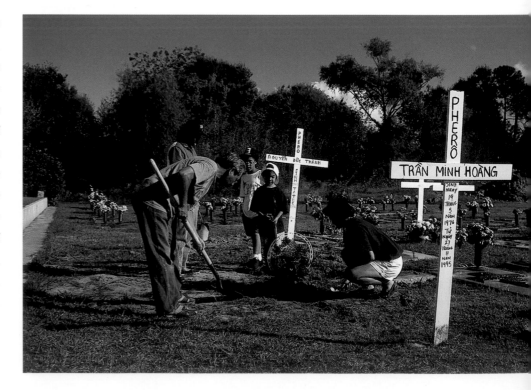

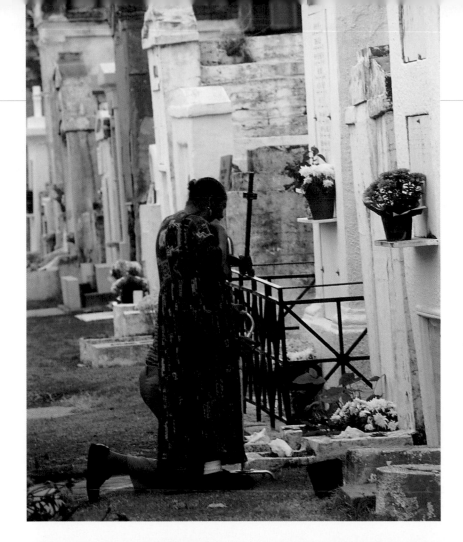

Andrew and Doris Morand pray before their family tomb, St. Louis Cemetery #2.

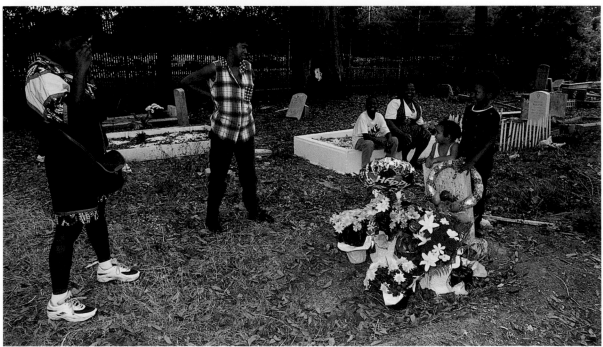

All Saints' is a popular occasion for taking family pictures. Edwina White and family, Holt Cemetery. Angela Smith photographs Jemica White and Elvira Lewis as Sheena Smith, Edwina White, and Johnny White watch. This cemetery has historically been so heavily attended on All Saints' Day that the book Gumbo Ya-Ya reports that one year the sexton had six new graves dug for November first. This sexton explained, "Just in case we have some funerals, nobody wants to stop to dig graves on All Saints' Day."

"Mamma, what time does it start?"

"He loves All Saints," she explained. "He sees all the candy and ice cream men, and he thinks it's a party."

Unfortunately, for some children it was not the happiest of occasions. Accompanied by nuns, orphans stood by the gates asking for donations. Sometimes the orphans would ring a bell or tap the contribution plate with a stick to call the crowd's attention to soliciting silver trays placed on wooden boxes and small tables.

All Saints' Day has traditionally served an important social function as a means for families and friends to catch up with each other. People would picnic and visit on iron benches referred to by some as "cemetery furniture." In describing All Saints' Day in *Interview With a Vampire*, Anne Rice's vampire character Louis refers to these accessories:

It is the day in New Orleans when all the faithful go to the cemeteries to care for the graves of their loved ones. They whitewash the plaster walls of the vaults, clean the names cut into the marble slabs. And finally they deck the tombs with flowers. In the St. Louis Cemetery, which was very near our house, in which all the great Louisiana families were buried, in which my own brother was buried, there were even little iron benches set before the graves where the families might sit to receive the other families who had come to the cemetery for the same purpose. It was a festival in New Orleans; a celebration of death, it might have seemed to tourists who didn't understand it, but it was a celebration of the life after."

Tomb owners would generally be informed of the developments their acquaintances had undergone in the past year. People could annually note the incremental generational changes, not only the tabulation of recent deaths but meeting newborn infants and recently married spouses. In this festive atmosphere, very few All Saints' Day visitors strike a mournful posture; those who do are sympathetically recognized as a "new death." In past and more dapper days, the scene was a full-blown social event during which appeared the fall styles of a very well-dressed city. People put much consideration into "la Robe de la Toussaint"—the All Saints' Day dress. And of course November first offered much grist for the gossip mill. If unknown visitors showed up at a tomb, they were assumed to be the partner in an illicit affair, or if a widower did not appear at the widow's tomb, it was assumed that remarriage was imminent.

At a certain point in time, however, all the buzz of human activity gives way to the primary purpose of the day—the spiritual pilgrimage known as the "rosary procession." A priest leads tomb visitors on a walk through the paths of the cemetery during which he blesses the tombs through spoken prayer and the splashing of holy water. In St. Roch Cemetery a mass is actually conducted among the graves. In rural bayou country the priest blesses tombs on which candles are burnt after nightfall, a very visually moving scene. (Lighting candles on tombs in New Orleans on All Souls' Eve is now a thing of the past.) To many, the religious aspect consummates the entire experience.

Although at the end of the twentieth century New Orleans's All Saints' Day is no longer so zealously observed, the religious elements such as the rosary walk in Catholic New Orleans cemeteries, the mass in St. Roch Cemetery, and the nighttime burning of candles in the communities of Lafitte and Lacombe do remain a stronghold. But as the world has changed, much of the activity around All Saints' Day has ceased. Today it is not so much weeks of

A sign of the times: Father James Tarantino casts holy water from a convertible Jeep down the long roads of St. Louis Cemetery #3.

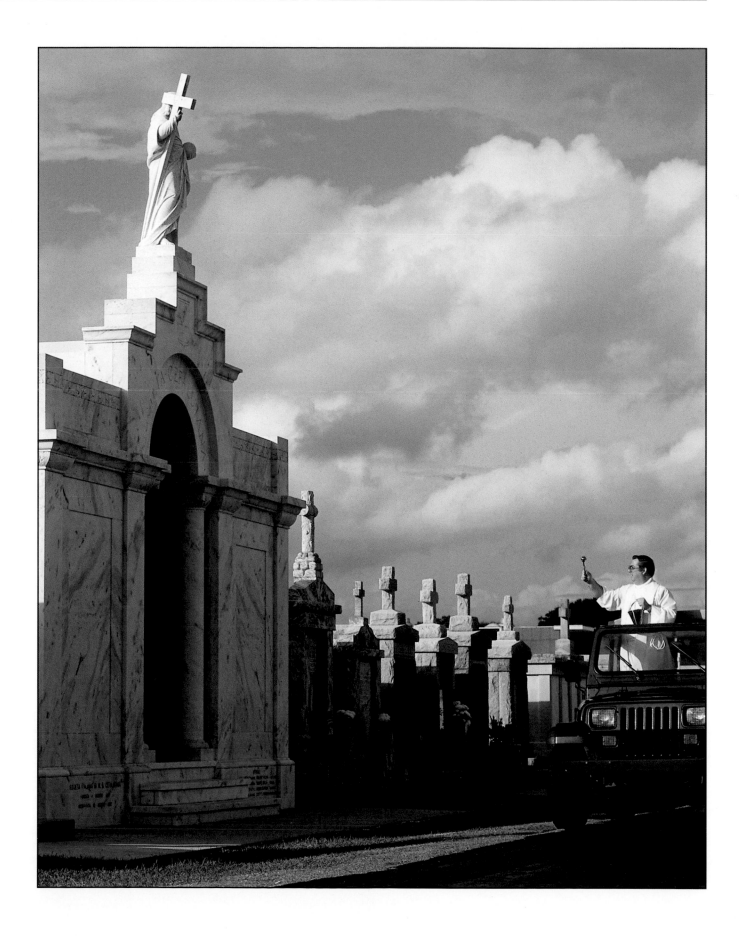

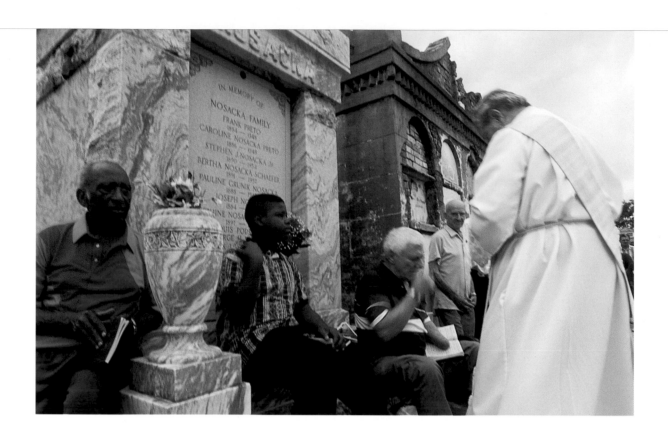

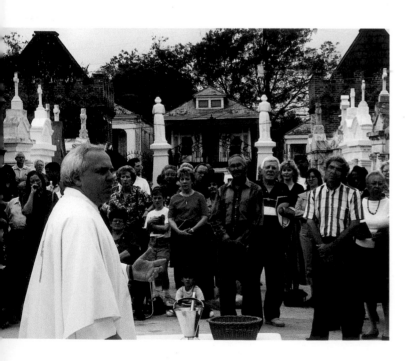

*Father Eugene Jacques passionately conducts
All Saints' Day mass, St. Roch Cemetery.*

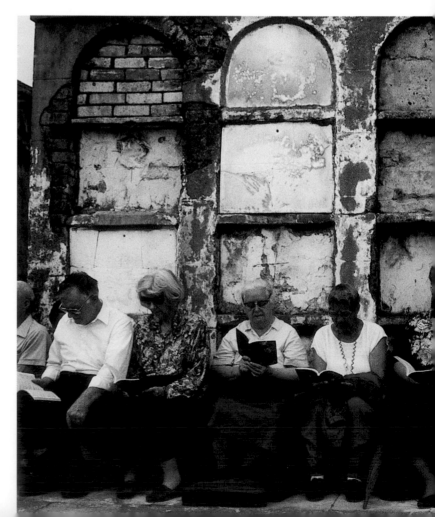

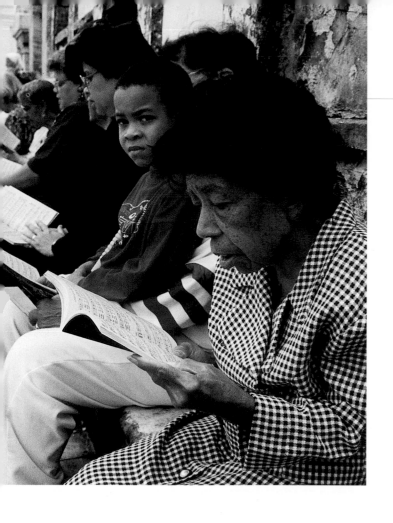

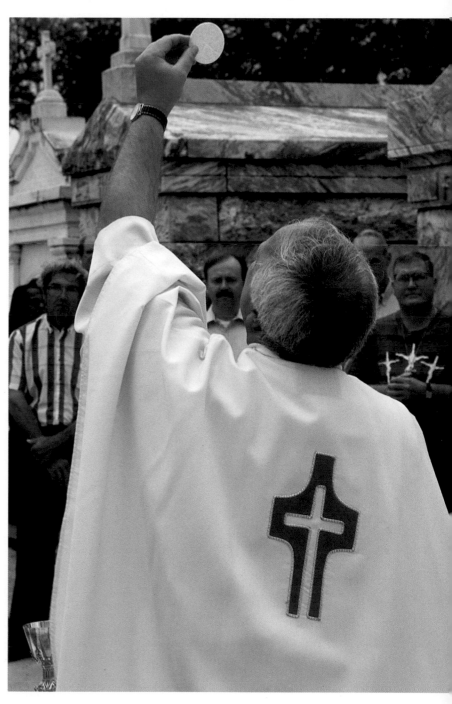

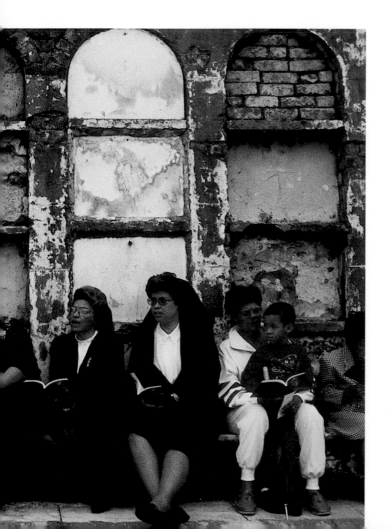

preparation but perhaps a matter of days or hours, and there are no longer orphans at the gate or food stands or a parade of new fashion styles.

However, New Orleans florists still do a better-than-average business on All Saints' Day, particularly in yellow chrysanthemums, and traffic cops are still posted in front of Greenwood Cemetery as are the horse-mounted police in St. Louis #2. Louisiana is still the only state that can boast cities closing municipal offices on November first. You still find a brilliant array of flowers amid people seated upon iron benches visiting old acquaintances. Much hard work still goes into annual tomb maintenance, with few places and situations elsewhere in this country presenting such a celebration of devoted love toward the dearly departed.

The future status of All Saints' Day has been questioned, often as if it is in peril, as if to suggest that it should be placed on a cultural endangered species list. However, as long as there are cemeteries in New Orleans and as long as people lose loved ones, there will always be All Saints' Day. Societal ritual inevitably changes, some for the better, some for the worse, and in New Orleans this rule holds true. Consider how much the practice of voodoo, traditions of carnival, or the procession of the jazz funeral have mutated with time. All Saints' Day too has changed and will continue to change. One of the more amusing recent November first adaptations is the sight of a priest hurling holy water at tombs from a convertible Jeep driving down the long roads of St. Louis Cemetery #3.

The people of New Orleans themselves will ensure the endurance of All Saints' Day. Referring to Mardi Gras Indian traditions, *Times-Picayune* columnist Lolis Eric Elie wrote: "There is much

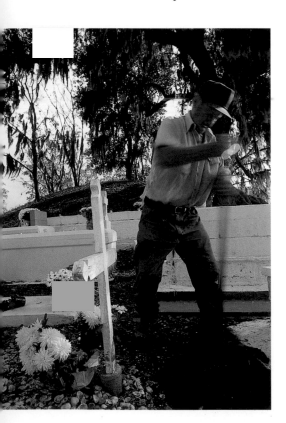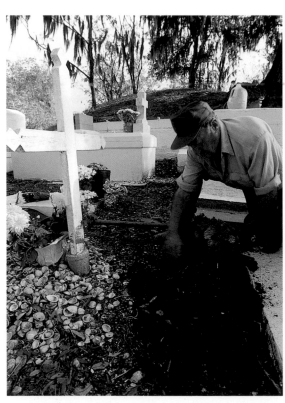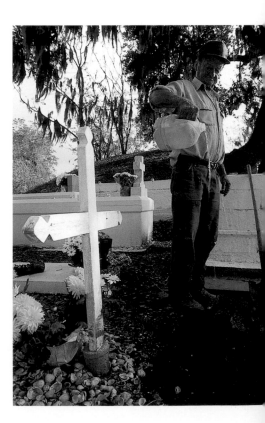

In an age when All Saints' Day traditions regretfully seem on the decline, Edmond Mayfield has instigated his own personal practice of planting the commemorative flowers into the ground on the morning of All Souls' Day, November 2, 1995, Fleming (Berthoud) Cemetery.

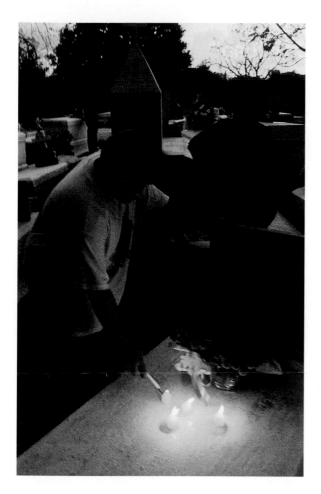

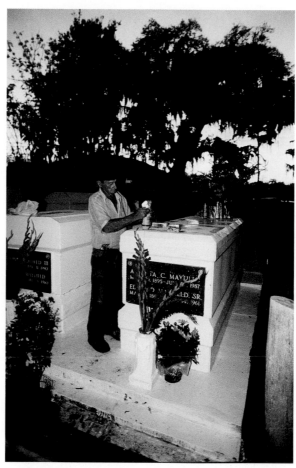

Brooks Malone lights candles on a family tomb as his grandmother, Rita Cobert, watches, Fleming Cemetery.

As the setting sun illuminates a looming live oak that grows from the Indian mound in the background, Edmond Mayfield, Jr., lights candles atop his family tomb.

that is great and wonderful and exceptional about New Orleans, but nothing is more impressive than the fact that the richest elements of this city's culture are participatory." For people interested in participating in one such element, there is much opportunity on All Saints' Day to answer one of human nature's most profound and basic impulses: reverence of the deceased. In a country where often the closest thing to public group ritual is watching the Super Bowl or the Academy Awards, New Orleans is blessed to have such collective

social institutions intact. Even if you do not have a relative entombed in a "city of the dead," if the spirit of the day so moves you, you can participate in this age-old New Orleans tradition by tending to a nameless, unadorned, forlornly neglected-looking grave on November first, just because you feel like it.

As Harnett Kane once wrote in reference to joyous family visits to New Orleans cemeteries, "Aren't there more ways of showing respect than beating your head against a wall?"

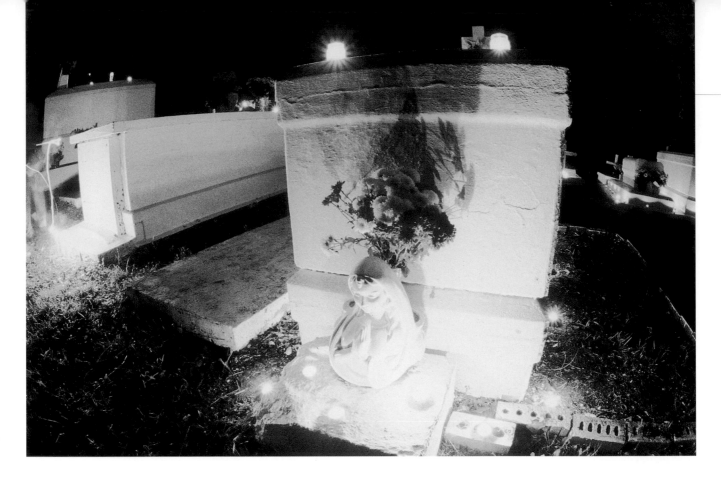

The astounding luminosity of Fleming Cemetery on All Souls' Eve.

The sun sets over Fleming Cemetery, All Saints' Day, 1995. As Gumbo Ya-Ya depicts the scene from the 1940s: "Hundreds of blessed candles being lighted on graves, filling the advancing darkness with weird flickering lights and eerie shadows."

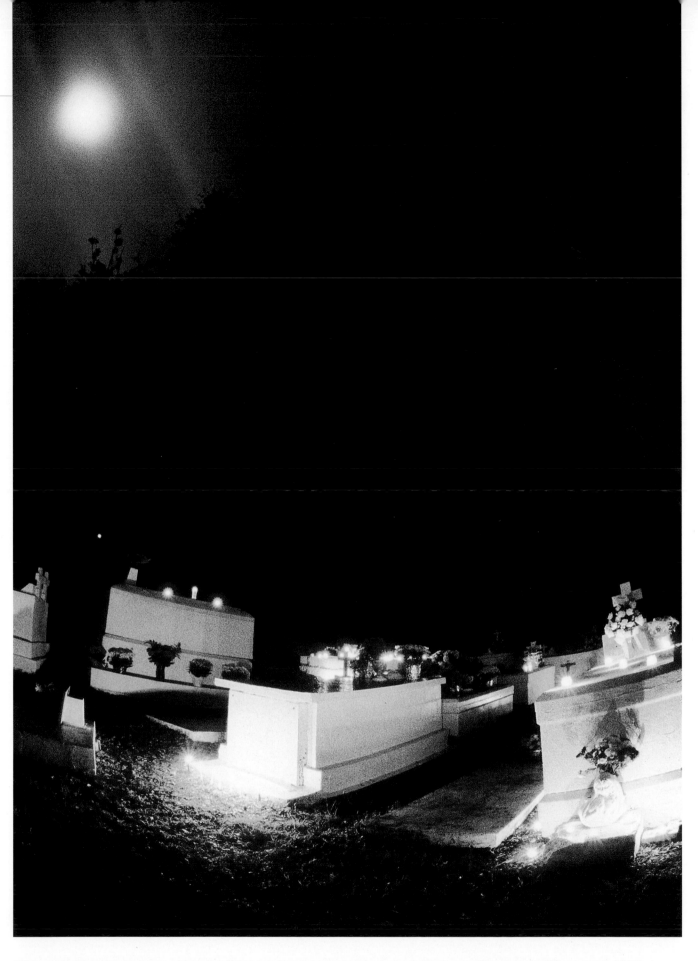

The seemingly surreal nocturnal beauty of Fleming Cemetery under an almost full moon on the evening of November 1, 1995

5

St. Louis Cemetery #1

ESTABLISHED: 1789
OWNER: NEW ORLEANS ARCHDIOCESAN CEMETERIES

*J*ust beyond the edge of a cacophonous French Quarter sits a quiet zone, striking to the eye, captivating to the imagination, stirring to the soul. The St. Louis Cemetery #1 embodies volumes of New Orleans history yet exudes an undefinable mystique.

This oldest surviving New Orleans cemetery was established in 1789, a year after three disasters that cost extensive human life and created a need for more burial space. In 1788 the first of two great colonial fires occurred, destroying eight hundred and fifty-six buildings, more than 80 percent of the city in one evening. There was also a flood and an epidemic, which crowded the city's first cemetery on St. Peter Street, and the necessity arose for a new burial ground. Once again the church decided to place the new cemetery on the edge of the city. By that year the city had grown out to Rampart Street. Consequently, the oldest city of the dead lies just beyond Rampart Street, on the other side of Our Lady of Guadalupe Church, which once served as a mortuary chapel for yellow fever and malaria victims.

Infectious disease was of dire concern in nineteenth-century New Orleans. Dr. Rudolph Matas wrote a vivid account of the effects of yellow fever on the city. This New Orleanian survived the malady as a child and, after becoming an eminent surgeon, he spearheaded the "anti-mosquito campaign" to fight the dreaded disease. The theory of yellow fever being carried by mosquitoes was first proposed by Cuban physician Carlos Finley; Dr. Matas was an early and ardent proponent of Finley's findings. In *History of Louisiana Medicine*, Matas wrote:

> Everywhere white funeral notices fluttered from fences and house fronts, while the only signs of activity were the hearses, carriages, and wagons slowly rumbling through the desolate streets. In the distance could be heard the boom of cannons being fired on orders of the civic authorities in the hope of dispelling the deadly miasma which was slowly stifling the life of the town. Overhead and per-

meating the entire atmosphere were the dark clouds of smoke arising from the hundreds of tar fires whose fumes, it was thought, would assist the gunpowder explosions in eliminating the omnipresent infection.

Dr. Matas also commented that so many bodies piled up at the cities of the dead during epidemics that the cemetery workers had to "fortify them-selves with liquor" to tolerate the smell of decaying human remains in the sweltering summer heat. Not until the twentiethth century did Dr. Walter Reed and his colleagues identify the cause of yel-low fever to be the *Aedes aegypti* mosquito. Prior to this discovery, doctors held misguided beliefs about the cause of yellow fever and malaria, including proximity to corpses.

The present-day Our Lady of Guadalupe

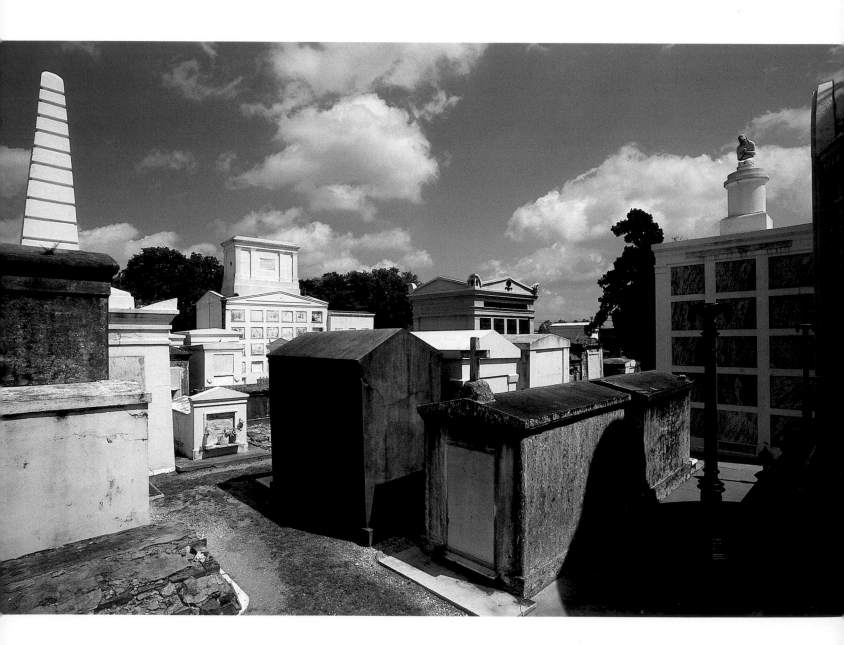

St. Louis Cemetery #1 skyline

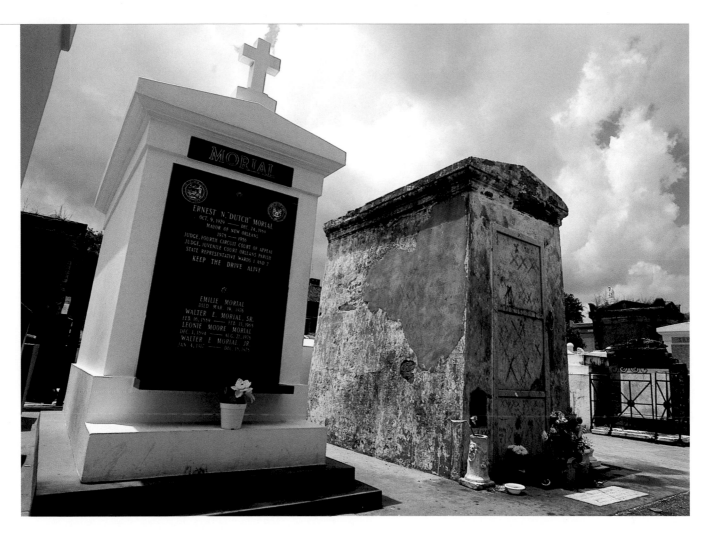

Yesterday and today: tomb of nineteenth-century voodoo queen Marie Laveau alongside former Mayor Ernest "Dutch" Morial, father of current New Orleans mayor, Marc Morial.

Church was originally known as the mortuary chapel of St. Anthony, established due to the fear of contagion. Afraid that disease would be spread by laying out the deceased and then transporting caskets through the streets of the city, New Orleans health officials in 1821 forbade "the placing on view (laying out) of the dead during the funeral service at any church, 'from 1st of July to 1st of December.'" "Any church" basically signified St. Louis Cathedral, for in this primarily Catholic city, "Catholic funerals had to be held at the Parish Church of St. Louis since it was the only Catholic parish church in New Orleans." The mortuary chapel of St. Anthony was then located right outside the city's limits in front of St. Louis Cemetery.

Epidemic-prone nineteenth-century New Orleans kept this chapel and the cemeteries busy. In *Diary of a Samaritan*, William L. Robinson wrote about New Orleans's worst yellow fever epidemic (1853): "The morning train of funerals, as was the evening's, crowded the road to the cemeteries. It was an unbroken line of carriages and omnibuses for two miles and a half. The city's commissary's wagon and carts of the different hospitals with their loads of eight or ten coffins each, fell in with the cortege of citizens." On August 11, 1853, the

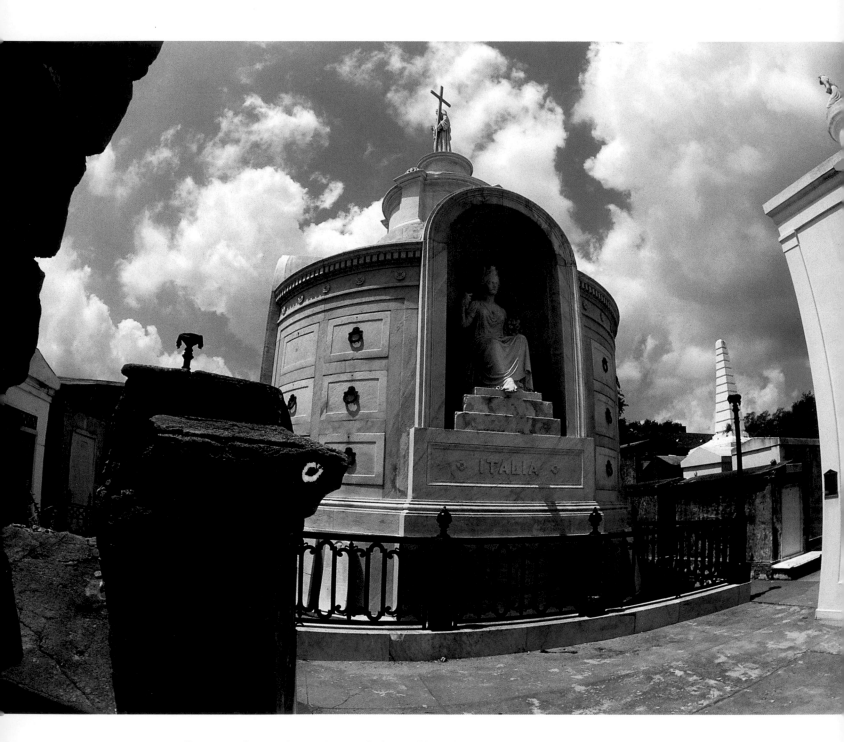

Italian Mutual Benevolent Society Tomb, designed by Italian architect Pietro Gualdi. Tallest structure in St. Louis #1, entire facade made from Italian Carrera marble. Once known as the "Hex Tomb" because Gualdi and the founder of the benevolent society were the first and second persons who died and were entombed within upon its completion. The tomb achieved notoriety as a film site for the movie Easy Rider.

New Orleans Daily Crescent described the effect which this notorious epidemic had on one cemetery:

> At the gates, the winds brought intimation of the corruption working within. Not a puff was not laden with the rank atmosphere from rotting corpses. Inside they were piled by fifties, exposed to the heat of the sun, swollen with corruption, bursting their coffin lids....What a feast of horrors! Inside, corpses piled in pyramids, and without the gates, old and withered crones and fat huxter women ... dispensing ice creams and confections, and brushing away ... the green bottleflies that hovered on their merchandise, and that anon buzzed away to drink dainty inhalations from the green and festering corpses.

The back of the former mortuary chapel today no longer affords an immediate view of this city of the dead. Rather, there are four lanes on Basin Street and a wide median. The initial foreground of the cemetery was eliminated by mercantile development, becoming a byway of commerce after the completion of the Carondelet Canal which linked Lake Pontchartrain to the back of the city. Two blocks down from the cemetery, the canal's turning basin was dug; hence the name Basin Street. The area adjacent to the mortuary chapel was then needed to facilitate trade, and a railroad line was ultimately laid over the former graveyard. Burial in the shadow of the mortuary chapel was curtailed and some graves may have been removed. However, as recently as 1904, railroad excavation uncovered coffins beneath Basin Street.

Celebrated Occupants

In terms of its occupants, St. Louis #1 offers a roll call of Crescent City luminaries. Herein you will find **Homer Plessy** (1862–1925), the plaintiff in the landmark 1896 Supreme Court case *Plessy* v. *Ferguson.* This decision established the precedent of separate-but-equal and legalized segregation in the United States until *Brown* v. *Board of Education* in 1954. The efforts of Plessy and a group of New Orleans political activists known as the Citizens Committee would in effect commence the Civil Rights movement well before the start of the twentieth century. Not far from Plessy lies **Bernard de Marigny** (1788–1871), the aristocratic Creole who lived a life of drama and controversy, an existence which ranged from being an outrageously wealthy business tycoon and national political figure to becoming destitute. Two of his largest legacies include the introduction of craps into the United States, and imaginatively naming several New Orleans streets after his favorite things, such as Craps, Duels, Love, Pleasure, Treasure, Music, and Desire.

People from every walk of life in New Orleans lie within St. Louis #1. All races, nationalities, professions, and social classes that comprise the city are represented in this city of the dead. The only way in which the cemetery separated people was by religion. Because colonial Louisiana was Roman Catholic by law, St. Louis Cemetery was, and still is, a Catholic cemetery. But after the Louisiana Purchase, thousands of Protestant Americans arrived to the region and a Protestant section was established at the rear of the cemetery.

Within the Protestant section hangs a plaque commemorating **Benjamin Latrobe** (1764–1820), founder of the architectural profession in the United States. This designer's body of work defined American Federal architectural style. Latrobe was buried in St. Louis #1, but it seems that his remains may have been lost when many Protestant graves were moved to the first

Protestant Cemetery on Girod Street in 1822. The family tomb of Louisiana's first American governor, **William Claiborne**, is also located in the Protestant section. Although Claiborne's job proved to be challenging, the unfamiliar New Orleans setting took an even greater toll on his personal life, a fact reflected by the Claiborne/Lewis family tomb. The plaques indicate that his wife, **Elizah Lewis**, and daughter, **Cornelia**, died on the same day from yellow fever, and that his brother-in-law, **Micajeh Lewis**, perished in a duel defending Governor Claiborne's honor. The Creole New Orleans social institution of dueling would continue to plague the governor; Claiborne himself actually stumbled into a very embarrassing duel with a man who is entombed a few paces away.

Claiborne then married **Clarice Duralde**, a New Orleans girl whose family tomb strangely lies in the Catholic section right across from the Claiborne/Lewis family monument. The second Mrs. Claiborne also died at age twenty from yellow fever. Governor Claiborne himself was buried in this Duralde family tomb. Although he did marry a third time and was reburied in the Metairie Cemetery in 1880, it never ceases to amaze and amuse people that his first two wives are buried right across from each other over the boundary of the Protestant and Catholic sections.

Next to the Duralde family grave is the tomb of **Daniel Clark**, the man with whom Claiborne had the very embarrassing duel. Clark, a wealthy Irish-born merchant, was the American consul to Louisiana during the Louisiana Purchase. He is credited with having persuaded Thomas Jefferson to make the greatest real estate deal in history. But Clark is well remembered for having shot his nemesis, Governor Claiborne, in the leg during a public duel which started over Governor Claiborne accusing Clark of involve-

ment in the infamous Aaron Burr conspiracy.

Within the same single-tiered family tomb as Daniel Clark lay the remains of his daughter, **Myra Clark Gaines** (1803–1885). Her commemorative plaque reads: "Daughter of Daniel Clark and Zulime Carriere." The fact that Carriere was not Clark's wife throughout most of their relationship, but rather his mistress, would complicate things for Myra. She was born in 1803, and Daniel Clark did not want to jeopardize his involvement in the Louisiana Purchase due to the potential scandal of an illegitimate child. Therefore, an associate of Clark's took the child to Philadelphia and raised her secretly. Although Carriere and Clark were ultimately married, this multimillionaire's will disappeared the night before he died and his business partners procured a "second to last" will, which named themselves as beneficiaries. At age twenty-five, Myra learned the truth about her birth, and in contesting her late father's will she would embark upon the longest lawsuit in the history of the United States. Lasting sixty-five years, the case went through two entire supreme courts and scores of lawyers and judges. Although the emotionally and financially drained Myra Clark Gaines never saw a dime of her father's estate, she did achieve her purpose: establishing her good name.

Around the corner from Myra Gaines can be found the tomb of **Etienne de Bore** (1741–1820), New Orleans's first mayor, and the man credited with being the first to successfully granulate sugar. This grave also entombs Bore's grandson, noted historian **Charles Gayarre**. Past the Bore gravesite is a large family tomb belonging to one of the most significant New Orleans jazz dynasties, **the Barbarin** family. The Barbarins have set the tone and tempo of New Orleans jazz from its beginnings. Turn of the century bandleader Isidore Barbarin is entombed here. Today they are one of the most active jazz families in the city, with the

Blessing of restored Homer Plessy tomb, May 19, 1996, one century and a day after Mr. Plessy's namesake landmark legal decision Plessy v. Ferguson was handed down by the United States Supreme Court. Following a jazz funeral that Homer Plessy probably never had, father Jerome Le Doux, current pastor of Plessy's church, the historic St. Augustine's, consecrates the tomb as Plessy progeny, chroniclers of New Orleans history, the Liberty Brass Band, and national media observe.

current generation—five times removed from Isidore—still carrying the torch. Another St. Louis #1 occupant who had a far-reaching impact was **Paul Morphy** (1837–1884), the most undisputed chess champion in the history of the United States. The workings of Morphy's mind astounded people worldwide. In Paris he once played twelve back-to-back matches of championship chess

blindfolded and won. However, later in life he would lose his brilliant mind, ending up a delusional wreck prone to talking to imaginary people.

Undoubtedly the most renowned and notorious tomb in the State of Louisiana is that of **Marie Laveau**, the Voodoo Queen (1794–1881). Practitioners believe that her spirit is very much alive and can be contacted through ritual around

this tomb. Sources ranging from hotel concierges to tour guides and travel books to tabloid newspapers recommend scratching Xs on her tomb in order to fulfill desires. However, Glapion family members (Marie Laveau descendants and the legal owners of this tomb) refer to the breaking of bricks from other tombs to mark up the Laveau gravesite as vandalism, graffiti, and desecration. And it is almost remarkable that entombed right next to this voodoo queen who is believed to have had political influence is New Orleans's first African-American mayor, **Ernest "Dutch" Morial** (1929–1989). This tomb arrangement juxtaposes two dynamos from two different centuries. The presence of the Morial family tomb brings the historic significance of St. Louis Cemetery #1 to the present; Dutch's son Marc Morial is currently serving his first term as mayor of New Orleans.

One of the most recent interments in St. Louis #1 was the artist **George Febres.** This Ecuadoran-born painter, internationally acclaimed for his wildly imaginative style and humorous "visual puns," was an important part of a dynamic upswing in New Orleans visual arts within the past generation. The banana is a motif which often appeared in Mr. Febres's painting; bananas are now appearing at his grave. The acquisition of this tomb marked the first private transfer of St. Louis #1 property in over forty years, an act that seems to have presaged a revival of New Orleans's oldest city of the dead.

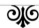

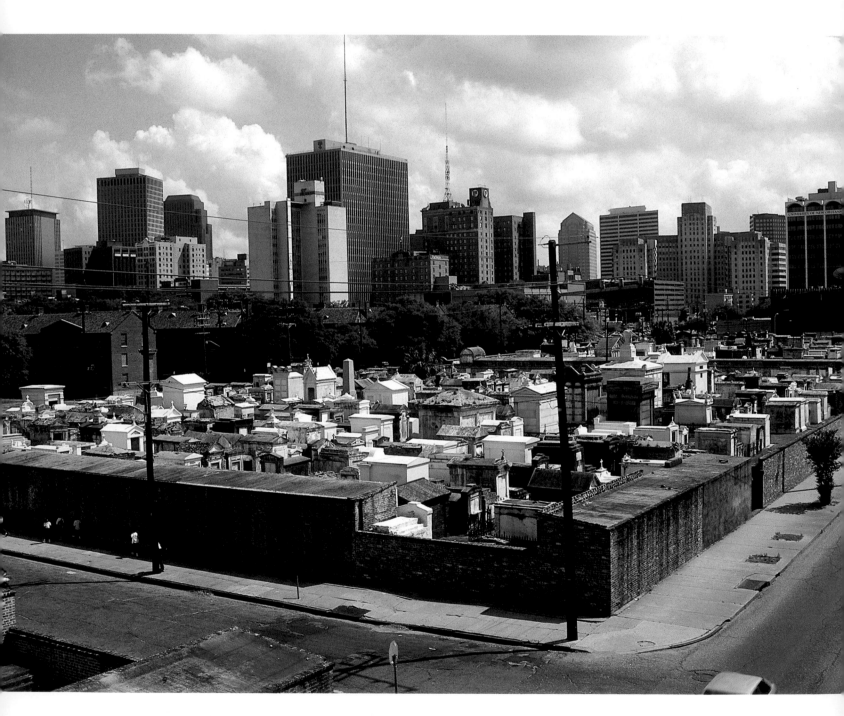

The skyscraper sprawl of New Orleans's Central Business District looms in the background of St. Louis Cemetery #2, the second oldest surviving city of the dead, as children return home from school in the foreground.

6

St. Louis Cemetery #2

ESTABLISHED: 1823
OWNER: NEW ORLEANS ARCHDIOCESAN CEMETERIES

*I*n the dingy shadow of the Interstate 10 overpass, there sits a true jewel, St. Louis Cemetery #2. Although the aesthetic qualities and craftsmanship of its physical presence are dazzling and its historic significance fascinating, this city of the dead seems to be slowly receding into obscurity. It goes practically unnoticed by the swarms of out-of-town visitors and seemingly unheeded by New Orleans residents. In spite of this, the three-square block St. Louis #2 offers a truly amazing experience to those who venture within.

As New Orleans expanded after the colonial period, the cemeteries continued to sit on the very edge of the city. St. Louis #2 is an obvious extension of St. Louis #1, and its establishment was directly prompted by a strong citywide fear of contagion. Two decades into the nineteenth century, New Orleans was grappling with an increasingly devastating series of epidemics. Beyond cholera, typhoid, diphtheria, smallpox, and bubonic plague, yellow fever and malaria had now started to eliminate vast segments of the population.

Here is an excerpt from a description of a yellow fever epidemic by James Parton in *General Butler in New Orleans:*

> Funeral processions crowded every street. No vehicles could be seen except doctors' cabs and coaches, passing to and from the cemeteries, and hearses, often solitary, taking their way toward those gloomy destinations. The hum of trade was silent. The levee was a desert. The streets, wont to shine with fashion and beauty, were silent. The tombs—the homes of the dead—were the only places where there was life, where crowds assembled, where the incessant rumbling of carriages, the trampling of feet, the murmur of voices, and all signs of active, stirring life could be heard and seen....
>
> Here (in the crowded localities of the laboring classes) you will find scenes of woe, misery, and death, which will haunt your memory for all time to come. Here you will see the dead and the dying, the sick and the convalescent, in one and the same bed. Here you will see the living babe sucking death from the yellow

breast of his dead mother. Here father, mother, and children die in one another's arms. Here you will find whole families swept off in a few hours, so that none are left to mourn or procure the rites of burial. Offensive odors frequently drew neighbors to such awful spectacles. Corpses would thus proclaim their existence, and enforce the observances due them. What a terrible disease!

As lethal as the epidemics were, widely held incorrect beliefs as to their cause were as devastating as the diseases themselves. Aside from the notion that "exhalations from the dead at funeral services" spread yellow fever, some thought that "poisonous effluvia from the swamps or from filthy city streets infected the atmosphere." This view tied into a medieval belief that foul odors—"vapors"—caused an imbalance of humors. This theory, based on offensive smells, or "bad air," is where the word malaria, "mal-air," comes from. The smells were known as miasmas, which some people thought were conveying evil spirits that spread the pestilent diseases.

The offensive odors were not actually evil spirits but rather arose from decomposing organic matter belowground mixed with chamber pot refuse, kitchen slop, and dead animals, which paved the streets of the early settlement. And there were also foul smells wafting about the cemeteries, particularly in summertime before embalming was practiced.

The city wanted these malodorous perceived health hazards as far away from the growing settlement as possible and took preventative steps. The municipal government planned to place a new cemetery at least twenty-four hundred feet from the edge of the city, but settled on eighteen hundred feet, a location which is still the site of St. Louis Cemetery #2, consecrated by the church for burials in August 1823. Today when approaching St. Louis #2 from along St. Louis Street, the visitor is struck by redolent regionally characteristic odors: those from the Paul Piazza and Sons Seafood Company, established in 1892, across the street from the cemetery's first square. Not only do the combined smells of raw shrimp, crawfish, crab, and speckled trout say "New Orleans," so does the Piazza and Sons sign, which reads "We Buy Used Mardi Gras Beads."

Celebrated Occupants

Of the many significant people buried in St. Louis #2, one man has left more of an imprint on the cities of the dead than any individual: architect **Jacques Nicholas Bussiere de Pouilly** (1805–1875). Although De Pouilly designed many noteworthy buildings such as the St. Louis Cathedral and St. Louis Hotel, his artistic vision is most evident in the cemeteries. Upon his arrival from France in 1833, New Orleans cemeteries harbored few structures of impressive design, but after his unique execution of revival design styles in St. Louis #1, St. Louis #2, Girod Street, Greenwood, and Cypress Grove cemeteries, a standard of imaginative aesthetic excellence was established in New Orleans burial grounds. In spite of his magnificent legacy, De Pouilly himself is humbly entombed in a simple Square 1 wall vault in the shadow of his own staggering creations, such as the Iberia Society, Delachaise-Livaudais, Plauche, Peniston-Duplantier, Bouligny, and Caballero tombs.

In another modest tomb within Square 2, among this cemetery's most striking structures, lie the remains of **Dominique You**, a native of Santo Domingo, privateer by trade. This reputed former artilleryman of Napoleon Bonaparte was believed by some to be a brother of Jean Lafitte. He joined forces with Lafitte's Baratarians and served as a lieutenant in the Gulf of Mexico's largest pirate

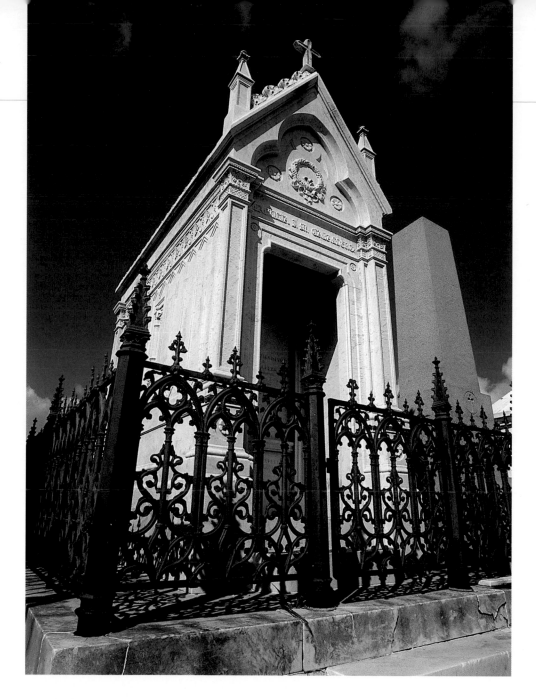

Gothic-style tomb of J. M. Caballero, designed in 1860 by Jacques de Pouilly. The adjacent obelisk is the François Xavier Martin monument.

operation. Having skillfully manned cannons in the Battle of New Orleans, You is credited with giving the American forces a decided advantage in this final conflict of the War of 1812. This veteran pirate and war hero retired to open a tavern and became a popular French Quarter sage and yarn-spinner; Wanda Lee Dickey, a Jean Lafitte National Park ranger and authority on Louisiana piracy, suggests that this may be why we have so many out-

rageous legends about Jean Lafitte. Later in life Dominique You became a ward politician, one in a long line of successful organized criminals to legitimately govern Louisiana. His epitaph reads in French and English:

> *This New Bayard without fear or reproach*
> *Could have witnessed the end of the world*
> *without trembling.*

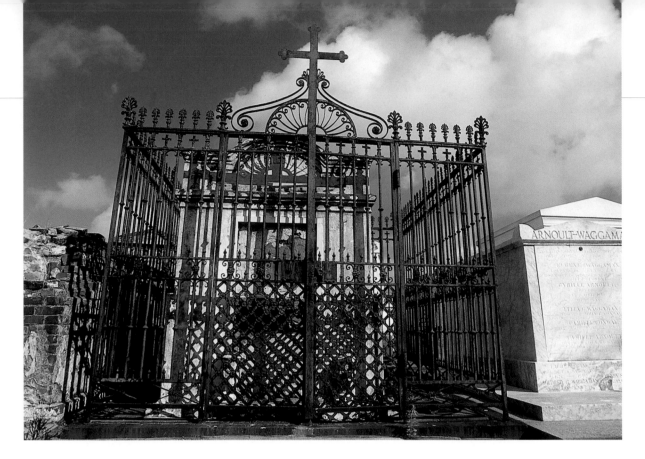

Cast and wrought iron combine to create a spectacular enclosure around the Lanusse-McCarthy family tomb in St. Louis Cemetery #2, Square 1.

Dominique You had political connections with another member of St. Louis #2, Square 2, **Nicholas Girod** (1751–1840), who was elected mayor of the newly American New Orleans in 1812, although he could not speak or read English. (Other historic civic leaders entombed in St. Louis #2 include **Jacques Phillippe Villere** (1761–1830), Louisiana's first native-born governor, and **Paul Capdevielle**, New Orleans mayor from 1900 to 1904.) Legend has it that when Napoleon was exiled to St. Helena, Mayor Girod built a house to harbor the general, but Girod actually enlarged his own house to shelter Bonaparte. This splendid specimen of French Quarter architecture (a three-story building with an octagonal cupola atop a tile-hipped roof) is now the highly atmospheric restaurant, the Napoleon House. Dominique You was to lead a seafaring rescue mission, but Napoleon died shortly before they disembarked for St. Helena to retrieve him.

Napoleon never arrived, but New Orleans did hold a funeral for him, as described in the December 20, 1821, edition of the *Louisiana Gazette:*

SERVICE FOR NAPOLEON BONAPARTE

The adherents of the late Napoleon Bonaparte who reside in this city, having caused a splendid bier or catafalco to be erected in the Catholic Church, which was hung in black for the occasion, they yesterday walked there in procession, and a funeral service was performed by the priests. Mr. Canouge delivered an oration to the crowd who attended the church; and the singers of the French Company of players sang several pieces during the celebration of Grand Mass.

A collection was also made in the church, which produced a very handsome sum for the poor.

One of six death masks cast from Napoleon's face in St. Helena is on display at the Louisiana State Museum.

Within the staggering array of St. Louis #2 monuments, perhaps the most visually arresting belongs to **Alexander Milne** (1744–1838), a Scotsman who began his professional career as a

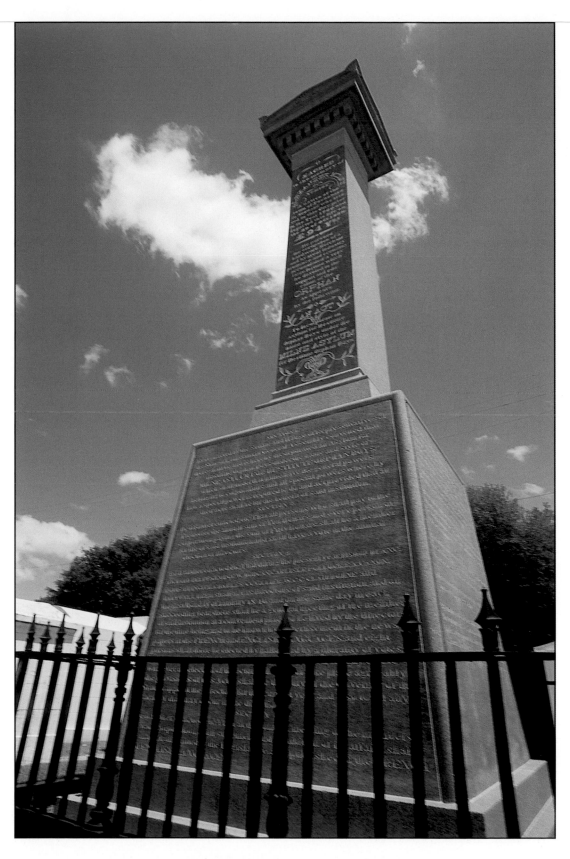

Alexander Milne monument, Square 2. The granite foundation bears this philanthropist's will, wherein he dedicates much of his estate to the establishment of orphanages.

footman for a noble Scottish family. He immigrated to New Orleans and would make a fortune in hardware and brick making. Prior to his death at age ninety-four, Milne willed much of his large estate to establishing orphanages, but due to legal wrangling and epic lawsuits, his legally diminished estate would not open the Milne Homes for boys and girls until nearly a century after his death. His will is now etched into the surface of his imposing marble obelisk—variation tomb. Milne also put his money into twenty-two miles of then swampy real estate along Lake Ponchartrain and there developed the resort community of Milneburg, which became a hotbed of early New Orleans jazz activity, immortalized in the Jelly Roll Morton song, *"Milneburg Joys."*

Regarding early jazz, two legendary New Orleans jazz greats, both personal friends and former bandmates of Jelly Roll Morton, are buried together in St. Louis #2, Square #2, in the Barbarin family tomb—drummer **Paul Barbarin** and his nephew, guitarist/banjo player **Danny Barker** (1909–1994). Two of the largest and most celebrated jazz funerals in the recent past ended up at this tomb, honoring these musicians, Barbarin in 1969 and Barker in 1994. Throughout the dynamic history of New Orleans jazz, the Barbarin family has contributed immeasurably to the city's unparalleled musical genius. This family legacy shows no signs of stopping, as trombonist Lucien Barbarin, great-grandnephew of Isidore Barbarin, when not recording or on the road performing with Harry Connick, Jr., teaches his sons and nephews traditional jazz in the shed behind his Gentilly home, ensuring that this fifth generation of Barbarins keeps the tradition alive.

St. Louis Cemetery #2, Square #3, offers a vivid illustration of New Orleans's racial history, a remarkable counterpoint to that of other American cities. Some reasons for its uniqueness date to the founding of the city.

New Orleans is referred to as "North American's most African city." A strong West African presence has been part of New Orleans from the beginning, with eighteenth-century censuses indicating a large African population. Not only were there always more Africans in proportion to Caucasians compared to early America but the mix of black and white was always proportionately higher in New Orleans than other United States cities. This higher incidence of miscegenation had much to do with "placage," the tradition of wealthy men keeping mistresses of mixed race. At the time of the Louisiana Purchase, 20 percent of the city was composed of "free people of color" *(gens de couleur libre)*. Beyond numbers, a historical factor that gave Africans, free and slave, more liberty and lattitude in colonial Louisiana was the Code Noir, or Black Code.

Under a system of civil law, French and Spanish administrations implemented this legal code which spelled out policy regarding slavery. Intended to regulate and control slaves (some of the language of the Code Noir is frighteningly brutal), many articles established a relatively more relaxed slave-holding environment. In colonial Louisiana, for example, it was much easier for a slave to purchase freedom. Freed slaves could own property and run businesses, borrow and lend money. Blacks could go anywhere; there was no exclusion from churches, theaters, social institutions, and cemeteries. Families of slaves could not be separated through sale, and slaves could sue owners for mistreatment. Although antebellum New Orleans became the largest and one of the most severe American slave markets, less restrictive colonial Louisiana law, among other factors, embued people of African descent with a self-reliance and determination that persisted into and beyond the Jim Crow era.

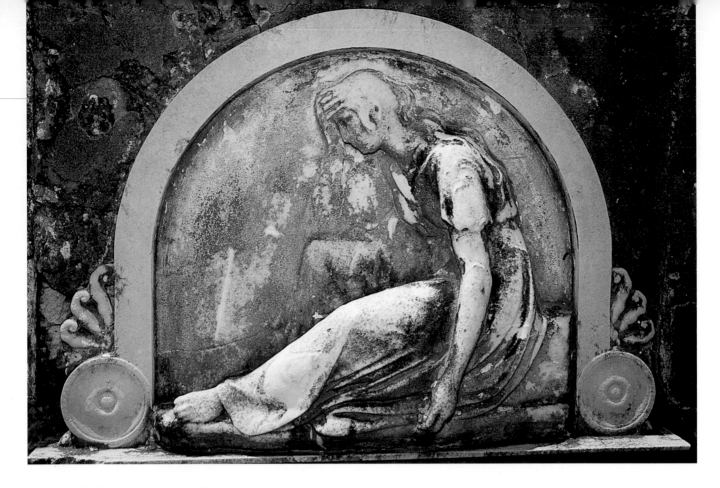

Bas-relief, Sylvanne Brunette tomb, Square 3

Aftermath of Danny Barker's jazz funeral at the Paul Barbarin tomb in Square 2. Regards left by, among others, the Dirty Dozen Brass Band, drummer Shannon Powell, and the Rebirth Brass Band. This stirring funeral was executed in the old traditional style, which some people fear is disappearing. The planner of this funeral, trumpeter Gregg Stafford, was pleased to see multitudes of people turn out to honor Mr. Barker in the time-honored fashion, and he hopes that the younger generations of New Orleans brass bands will carry the tradition into the twenty-first century and beyond. "The flame must continue to burn," insists Mr. Stafford.

Photo by Paula Burch

Although the social and legal climate surrounding race and slavery was at its least restrictive in colonial times, pre–Jim Crow nineteenth-century New Orleans still fostered more humanity compared to slave-holding antebellum and Reconstruction-era America. Although the entire St. Louis Cemetery #2 is integrated, official cemetery policy was by then heading in the direction of segregated antebellum America. As opposed to the earlier established St. Louis Cemetery #1, St. Louis #2's burial policy was more race oriented. The *New Orleans Black History Tour of St. Louis Two Cemetery, Square Three* states that "by the 1820's church authorities may have begun to accede to the Anglo-American segregated order." Segregation did happen in St. Louis #2 through the assignment of races to individual squares, but there were still white and black in the same cemetery. Total cemetery segregation did not occur until the latter half of the nineteenth century. Although St. Louis #2 reflects the formerly more integrated Creole New Orleans's transition into the segregated antebellum period, this cemetery has always stood as one of the most integrated historic burial sites in the United States. It poignantly conveys part of the venerable and extraordinary African-American New Orleans history. Some of the triumph and tragedy of this remarkable human experience is told through the biographies of several Square 3 occupants.

Herein are the remains of **Oscar James Dunn** (1821–1871), the first black lieutenant governor of the United States. Born free to an emancipated slave mother, this formerly poor apprentice plasterer taught himself to read, write, and play the violin, and learned oratory skills from actors who roomed in his mother's boardinghouse. During the Civil War occupation, Dunn became a captain in the Union Army's first black regiment. In the politically tumultuous Reconstruction Era, Oscar

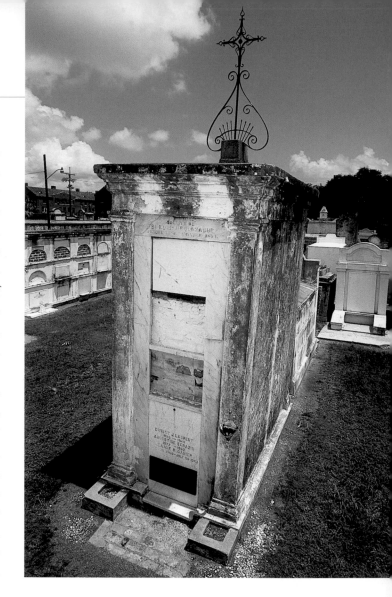

St. Louis de Gonzague Society tomb, St. Louis Cemetery #2, Square 3.

Dunn was elected to the City Council, and in 1868 was elected Louisiana's lieutenant governor. Due to his highly principled, ethical, and straightforward leadership style, he was a leading contender in the upcoming gubernatorial election, yet he mysteriously died after abruptly leaving a political dinner in his honor, wracked with debilitating stomach cramps. Some believe he was poisoned. Fifty thousand people thronged Canal Street for Dunn's funeral (until then the largest ever conducted for a black man in the United States), which proceeded to St. Louis Cemetery #2. Although the coroner's office determined Dunn's cause of death to be a stroke, Senator Pelius

Pinchback (entombed in Metairie Cemetery), who subsequently would for a short time become Louisiana's first—and, to date, only—black governor, commented on Dunn's death that "there are secrets that would harrow your soul."

Henriette Delille (1813–1862), buried in St. Louis #2, Square 3, also demonstrated leadership as courageous as Lieutenant Governor Dunn, and rests close to him. In 1842, during an era when convents were not open to blacks, Henriette, daughter of free woman of color Marie Joseph *"dit"* Pouponne and white businessman Jean Baptiste DeLille Sarpy, founded the second oldest order of black nuns in America, the Sisters of the Holy Family, with her childhood friend Juliette Gaudin. They were later joined by Josephine Charles. They operated a church/school/orphanage in a magnificent French Quarter building donated by her cousin Thomy Lafon (entombed in St. Louis Cemetery #3), a philanthropic free black man of substantial means. In 1847 the nuns founded the first Catholic nursing home incorporated in the United States, which still exists as the Lafon Nursing Home of the Holy Family. The order educated and administered charity to blacks slave and free, young and old, male and female.

The Sisters presently operate throughout the United States, Central America, and Africa. More than two hundred of its members have been buried within St. Louis #2, where there are three Sisters of the Holy Family society tombs. In 1988 Archbishop Philip M. Hannan presented the cause for Henriette Delille's canonization to church leaders in Rome and she is now being considered for sainthood. She would be the first black saint from North America. The Sisters of the Holy Family anticipate being able to proclaim St. Louis #2 as one of the only cemeteries in the United States that entombs a saint.

The education level was relatively elevated among Africans of old New Orleans, literacy being higher than that of whites throughout the nineteenth century. Many esteemed writers lie in Square 3, such as **Rodolphe Desdunes** (1849–1928), seminal member of the Citizens Committee, author of the poignant early history of the "gens de couleur libre," *Nos Hommes et Notre Histoire,* and columnist of *The Crusader* newspaper, which was published in pursuit of nineteenth-century civil rights. Founder of the first black American daily newspaper, *The New Orleans Tribune,* **Jean Baptiste Roudanez** is entombed here. He devoted much of his life to the struggle for African-American voting rights. The first volume of poetry by all black writers in America, *Les Cenelles,* written in French, was published in New Orleans in 1847. One of its contributors, **Joanni Questy** (1818–1869), is interred in Square Three, as is poet **Lucien "Lolo" Mansion**, who made a fortune as a cigar manufacturer. On the same aisle lies **Leblanc Mansion**, who following the Civil War conducted a black symphony orchestra. Along with these artists can be found the highly proficient Paris-educated mathematician, **Basile Crocker** (1800–1879), who displayed prodigious artistry as a swordsman, opening his own fencing academy which both whites and blacks attended.

Many free and enslaved blacks achieved honor through service in the armed forces, contributing to military action of tremendous historic consequence. Entombed here is **Jordan Noble** (1796–1890), the African American who at age fourteen served under Andrew Jackson in the Battle of New Orleans, drumming orders throughout the conflict. Surviving to age ninety-four, he was considered emblematic of the battle. Two battalions comprised of more then six hundred free people of color were instrumental in this crucial engagement which ended the War of 1812 and, for the first time, established the United States as a world military power.

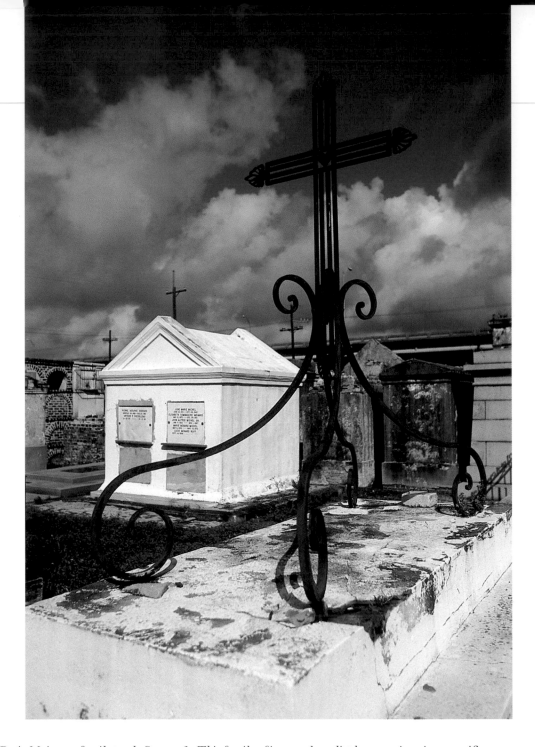

John Desir Maignan family tomb, Square 1. This family of ironworkers displays a unique iron crucifix.

In this same St. Louis #2 square can be found two black Civil War officers representing both sides of the conflict. **James Lewis** was a captain in the Union Army, who, along with St. Louis Cemetery #2 occupant Oscar Dunn, was one of the very few African Americans to attain the rank of officer. Following the war he became a captain in the Metropolitan Police and a colonel in the state militia.

And although **Eugene Rapp** would side with Union forces once the city was occupied, he initially served as an officer in the New Orleans Confederate militia, which included black soldiers and officers.

Not only did blacks achieve high military rank in nineteenth-century New Orleans but many operated businesses, some amassing sizable for-

tunes. Their legacy continues to impact the city. A 1996 political controversy involved the Marriot Corporation attempting to persuade New Orleans City Councilman Oliver Thomas to allow the razing of four nineteenth-century town houses to make way for a new hotel. The deal never went through, and of the African-American councilman's role, *Times-Picayune* business reporter Coleman Warner wrote: "Preservationists, mounting an intense lobbying campaign, softened Thomas' support for the demolition by emphasizing that the Greek Revival buildings' first owners in the 1840's represented a diverse ethnic mix, including two African-American merchants, Joseph Dumas and Julien Colvis."

One of the most remarkable features of the New Orleans "Creole of color" class was the amount of property they owned. Not only was it unusual for blacks to then own property in America but for women as well. Many New Orleans women, from the Baronness Pontalba to Marie Laveau, were substantial property holders. This was a remnant of the colonial civil law carrying over into antebellum times. Elsewhere in the United States, women did not generally own property until the twentieth century.

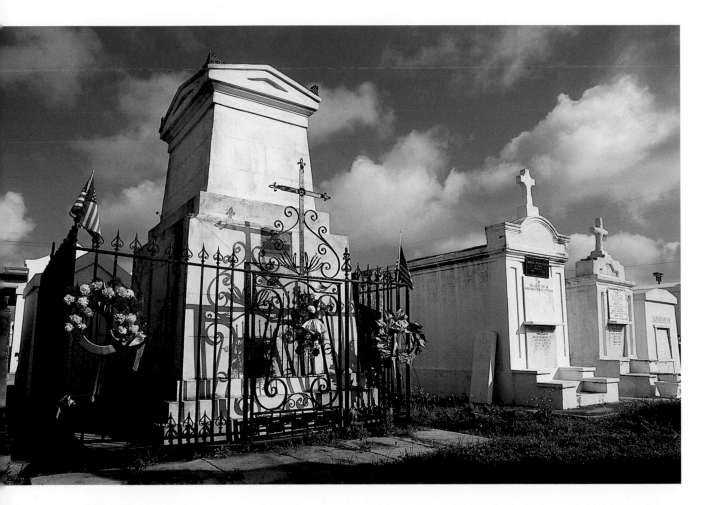

The magnificent iron enclosure around the Square 1 tomb of United States Marine Corps Major Daniel Carmick is patriotically adorned in 1996, although he died one hundred and eighty years before from injuries sustained in the Battle of New Orleans.

71

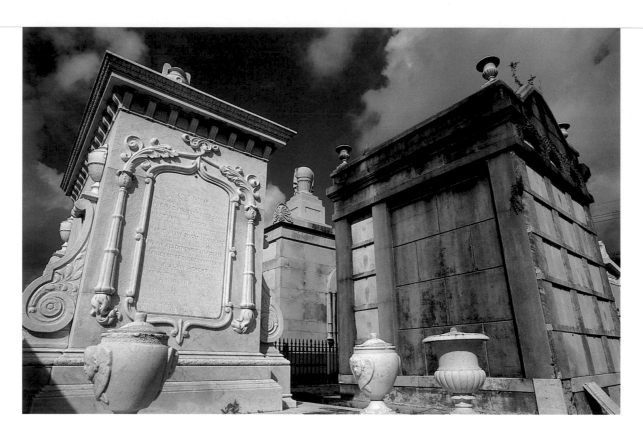

Delachaise-Livaudais family tomb, Iberia Society tomb, and Young Man's Vidalia B.M.M.A. tomb, Square 2.

Square 3 Haydel-Rivarde family tomb surrounded by exquisite ironwork produced by black artisans.

Perhaps the most notable example of a black woman owning property involved **Marie Justine Ciraire Couvent**, now entombed in St. Louis #2, Square 3. Born in West Africa and brought to Louisiana as a slave, Marie Couvent inherited her free black carpenter husband's savings and property upon his death in 1832. Marie's will specified that her estate found a school for black orphans, and with the financial support of Creole of color philanthropists Thomy Lafon and Aristide Mary (entombed, along with Thomy Lafon, in St. Louis #3), the Institution Catholique des Orphelins Indigents was opened in 1847, which employed the greatest minds of the highly literate free black community.

Haitian-born businessman and Citizens Committee president **Arthur Esteves** (1827–1908) presided over the Couvent school board of directors, and poet **Joanni Questi** acted as principal; both men are also entombed in Square 3. A public school was named for Marie Couvent in 1939, but its name was changed to the A. P. Toureaud School in 1994 after the eminent civil rights attorney who was considered a better example for the students because Couvent held slaves.

In terms of prodigious property acquired, probably the richest black planter in nineteenth-century America, **Antoine Dublucet**, is buried in Square 3. His Iberville Parish property was worth more than $200,000 in 1860, and he was the owner of ninety-five slaves. And also within Square 3 is a tomb of the **Casanave** family; successful as undertakers, members of this wealthy free black family were closely connected to cities of the dead.

Perhaps the most fascinating free black business person was the legendary voodoo queen, **Marie Laveau**. The location of her tomb—allegedly in St. Louis #1—is the subject of much dispute. It is believed that her daughter, Marie Laveau the Second, lies in a Square 3 wall vault. Although the daughter's approach to the practice of voodoo was seen as a disgrace to the legacy of the mother, there are those who believe that the spirit of Marie Laveau the Second lingers in a St. Louis Cemetery #2, Square 3, wall vault.

Square 3 families are still thriving in business and are politically active. The Chase-Tennette family tomb of Dooky Chase Restaurant fame continues to provide All Saints' Day visiting opportunities to this prominent New Orleans family. This two-tiered tomb lists seventeen separate interments, demonstrating multiple burial's efficient use of space, and also some interesting intergenerational mingling of New Orleans family remains. Tomb owner Leah Chase learned that one of this tomb's earliest owners was a white family who passed the grave to the Chase-Tennette family, members of whom this white family employed. When the Chase family recently restored the tomb, they included the name of the unrelated white family on the new inscription plaque. "We saw no reason to remove those names," Mrs. Chase explains, "because you never know when some relatives down the line will want to research the history of this tomb."

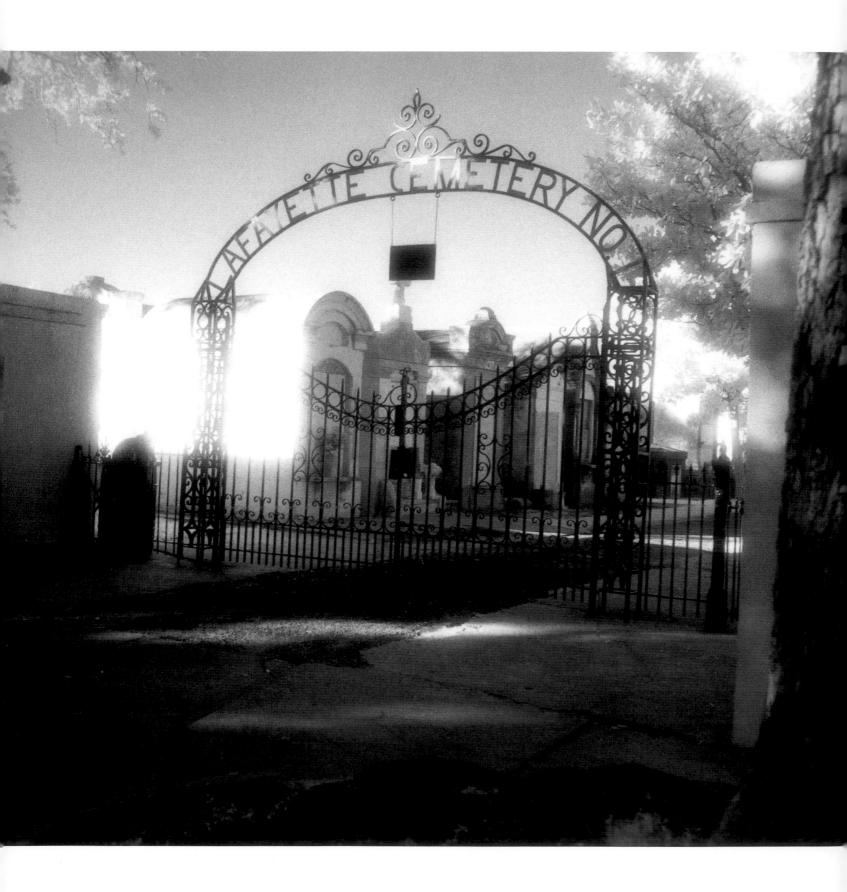

7

Lafayette Cemetery #1

ESTABLISHED: 1833
OWNER: THE CITY OF NEW ORLEANS

*P*oised precisely in the center of the Garden District is one of New Orleans's most provocative cities of the dead, Lafayette Cemetery #1. In terms of attracting the attention of passersby, this is the only New Orleans cemetery that faces serious competition from its immediate surroundings—one of the world's most striking and distinctive residential neighborhoods. This cemetery, however, contains as captivating a collection of structures as do the surrounding streets.

Lafayette Cemetery's aesthetic qualities and master craftsmanship also stand up to New Orleans's earlier burial grounds, although it is not as much of a cultural reflection of its inhabitants as are the Creole St. Louis cemeteries. Physically, the Garden District has always stood as a stark contrast to the earlier French Quarter, which is a reflection of Creole culture. Aboveground burial technique coupled with artfully rendered facades is a facet of Creole New Orleans, since it was introduced under Spanish rule and initially perpetuated by Roman Catholics mainly of French descent. In spite of Lafayette Cemetery's lack of resemblance

to contemporary American burial grounds, the surrounding Garden District was designed by a specifically non-Creole people, "Les Americaines."

Although now exaggerated through the lens of popular New Orleans history, friction did exist between Americans and Creoles. A keen sense of one-upsmanship seems to have characterized the relationship; Creoles considered the newly arrived United States citizens to be crass opportunists while Americans viewed Creoles as Old World snobs. But in terms of triggering a citywide schism, their differences ran deeper than this mutual snobbery.

To begin with, there was a language barrier. Post-Louisiana Purchase New Orleans did not instantly coalesce because part of the city spoke French while others communicated in English. Perhaps equally divisive was the religious difference, colonial Louisiana having been Roman Catholic by law while the newly arrived Americans were largely Protestant. This discrepancy not only caused social division but gave the United States government considerable conster-

nation trying to separate the church and state in a community contentedly administered by the Archdiocese. But the biggest conflict naturally arose over the competition for business. Compared to their new American neighbors, Creoles of means lived a more relaxed lifestyle; festivity seems to have been as much a priority as productivity. The newly arrived Americans, on the other hand, were enterprising, industrious types embued with the Protestant work ethic. They made no secret of the fact that they were arriving at the brink of a boom time to make fortunes. This economic prosperity would fuel the construction of New Orleans's grand upriver homes, creating a

zone of residential opulence that extended for miles, from the Garden District through the Carrollton Avenue section.

This raging economy was in large part based upon the Mississippi River. At the time of the Louisiana Purchase, there was no railroad or Erie Canal, therefore all trade from the interior of North America flowed through the port of New Orleans. Add this traffic to the fact that the United States lifted former colonial trade restrictions, and the city became an international seaport. The invention of the steamboat also caused shipping to grow exponentially. Another significant source of revenue was agriculture. Fueling the bonanza

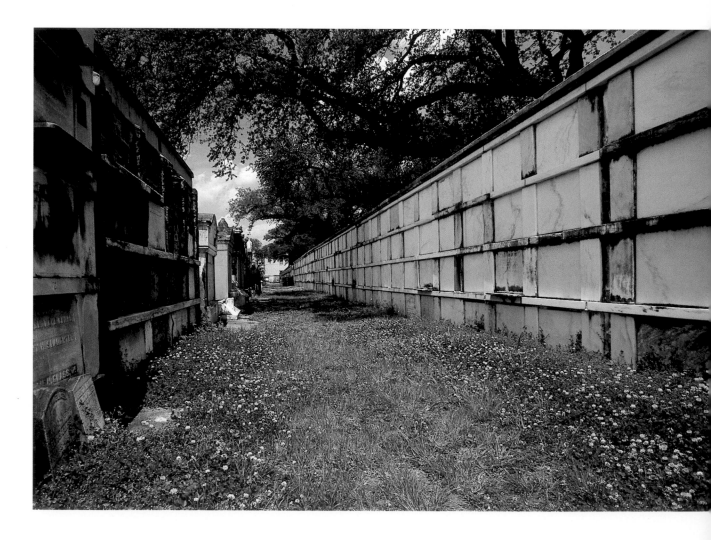

Wall vaults facing family tombs

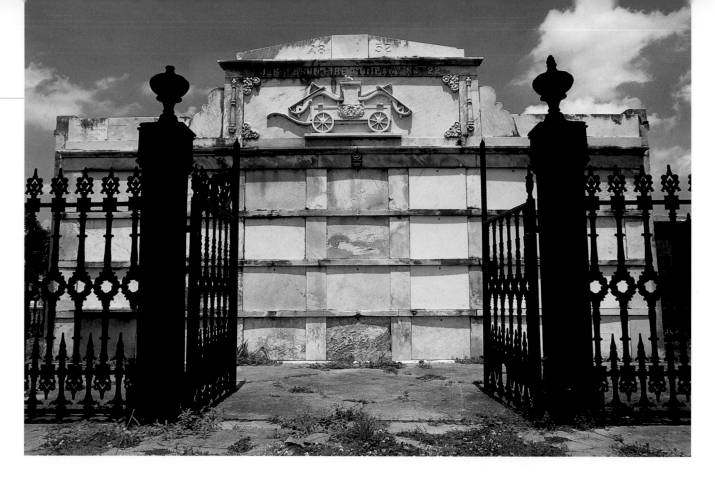

Jefferson Fire Company No. 22 society tomb

were such cash crops as sugar, indigo, cotton, and tobacco, and, aside from the steamboat, such technologies as the invention of the cotton gin and the first successful granulation of sugar on a commercial scale, which occurred in New Orleans on the Etienne de Bore plantation.

Slavery played no small role in the economic equation. This institutionalized atrocity was extremely lucrative, not only in terms of slavery being a cheap form of labor but also in that slavery was an industry in itself. Antebellum New Orleans quickly became an international trade center, and this city, whose colonial era fostered a relatively permissive slave-holding environment, became the largest slave market in the United States. Not only was it prodigious and highly organized, with some 135,000 slaves sold between 1804 and 1862, but it was also severe beyond description, a quality that gave rise to the chilling expression, "to get sold down the river."

Aside from shipping, agriculture, and slavery, a wide profit margin was garnered from real estate, shipping insurance, and pre-Civil War national banks. New Orleans temporarily became one of the wealthiest cities in the world. Creoles recognized that this economic climate was irresistible to the waves of incoming ambitious Americans who, with better business experience, organizational skills, and education, would soon likely force them out of business. This perceived threat, which was ultimately realized, prompted Creoles to keep Americans out of an already overcrowded older section, today's French Quarter. These snubbed Americans consequently made a conscious attempt to distinguish themselves from the original New Orleanians through architecture familiar to them and nonexistent in colonial Louisiana. As a result, the Garden District would appear to be part of a city separate from the French Quarter.

But death acted as the great equalizer. Belowground burial in the Protestant section at the rear of St. Louis Cemetery #1, "American"

A rose grows in Lafayette Cemetery.

New Orleans's first actual burial site, has left us with legends of caskets during heavy rain thumping up against the top of the inscription slabs. And the first actual Protestant cemetery, located on Girod Street, is the source of many reports of floating caskets during floods. (The Girod Street Cemetery was deconsecrated and demolished in 1957, its former location situated between the main branch of the New Orleans Post Office and The Superdome. There is a popular theory that

the New Orleans Saints have never won a playoff game because they built their home stadium over a disturbed cemetery. One disgruntled fan swears that the Saints have a harder time scoring in the endzone labeled "Girod" as opposed to the Poydras Street endzone.) Just as the newly arrived Americans needed to use certain local building techniques to adapt to South Louisiana's climate and environment, they also needed to adopt the local practice of aboveground burial.

Ultimately, it was a marriage of Creole and American influence that resulted in cemeteries known worldwide for their dazzling character. If the aesthetic ideas were brought from Europe, particularly the French nineteenth-century cemetery designs introduced by architect Jacques de Pouilly, the money to finance such lavish tombs came from the American boom. Making money was something that antebellum "American" New Orleans excelled at, and the abundant resources spilled over into the cities of the dead.

Under the American flag, burial and the funerary arts became big business in New Orleans. Funeral contractors did a tremendous trade and marble cutting became a thriving industry. Some of the most successful in these fields were free people of color, such as mortician Pierre A. D. Casanave, whose thriving undertaker's business contributed to a personal worth of $100,000 in 1814. Some credit him with starting the traditions of the jazz funeral and second lining. Today his descendants still run the businesses he founded. African-American sculptor/marble cutters Prosper and Florville Foy (entombed in St. Louis Cemetery #3) were very successful. And brothers Eugene and Daniel Warburg, the highly educated sons of a Jewish-German father and Afro-Cuban mother, were world renowned for their skill in working marble.

In 1831 a French traveler commented on the

high art of funerary practice spurred on by the American economic prosperity of antebellum New Orleans via the highly vile form of death by epidemic. Mr. P. Forest wrote:

> The Americans have found a way to profit by the epidemic. There are, in New Orleans, as many funeral contractors as there are building contractors. Americans have developed the habit of dealing with them before hand—concerning their death to come. At least every street has its own store furnished with all kinds of mortuary ornaments. One's hair stands on end as one passes in

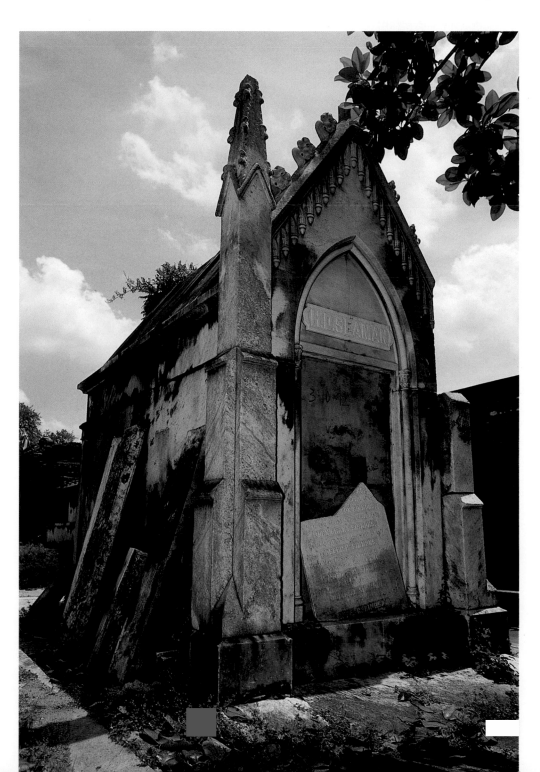

Gothic tomb of
H. D. Seaman

front of these stores, where coffins of all sizes and shapes are offered for the appreciation of onlookers. Some are made of richly sculptured mahogany, others are painted and decorated with large polished copper nails. Several have cushioned interiors made of black velvet. At night these stores exhibit, for advertising, above the door, the skull and cross bones, quite tempting for those bored with life.

Cast-iron Karstendiek tomb

Upon entering the walled Lafayette Cemetery, one encounters an aboveground city of the dead similar to the previously established St. Louis cemeteries, but with some significant differences. Two wide roadways perpendicularly dissect the cemetery, forming a perfect cross through the middle of the graveyard, along which are lined healthy, shade-providing magnolia trees resplendent with blossoms every spring. And the inscription plaques bear many more Irish and German names than are found in the French and Spanish-laden St. Louis cemeteries.

Interred within Lafayette Cemetery are thousands of people who were drawn into the burgeoning nineteenth-century American New Orleans. One such arrival, **Samuel Jarvis Peters** (1801–1855), along with actor James Caldwell (entombed in Cypress Grove Cemetery), was instrumental in transforming the city above Canal Street from an uninhabited wetland into a thriving hub of commerce and palatial residential zone. As a city council member, Peters had sidewalks laid, city streets paved, and levees shelled and graded. The "Creole vs. American" conflict was played out through a rivalry between Samuel Peters and the proud Creole, Bernard de Marigny (entombed in St. Louis Cemetery #1).

Marigny's relatives, the French Creole Livaudais family, had previously owned the Garden District as part of a sugarcane plantation. They sold their large tract of upriver land to Peters and his partners for $490,000, initiating, as S. Frederick Starr writes in *Southern Comfort*, "a land boom of staggering proportions, comparable to John Astor's real estate bonanza in New York and the Chicago land rush of exactly the same years." This transaction was partially a revengeful swipe at his rival Marigny, who was cousin to Mme. Livaudais. "By taking over her plantation and transferring it into a suburb of his own, Peters settled his old score

with the renowned Creole," writes Starr. This "old score" ran deep.

Peters, who had previously been defeated in an election for state legislature by Marigny, once approached Bernard proposing to develop downriver Marigny family land. James Caldwell outlined Peters's plan for Creole/American joint development of Marigny District warehouses, shops, hotels, and theaters. Marigny, who sensed an American challenge to the already diminishing Creole dominance, feigned agreement with Peters until the point of having to sign the papers. Marigny then made sure that his wife, whose signature was necessary, did not show up at the signing. Outraged, Peters declared: "I shall live, by God, to see the day when rank grass will choke up the gutters of your old Faubourg!" Today Mr. Peters is most well known for having founded the New Orleans public school system. He was the namesake of two schools and each year on Founders' Day, a group from Samuel J. Peters Junior High School delivered flowers to his Lafayette Cemetery tomb.

In such a musical city, this is the only city of the dead dedicated to a musician. (It is actually the only New Orleans cemetery dedicated to anyone.) Above the Washington Avenue entrance hangs a plaque dedicating Lafayette Cemetery to composer **Theodore von LaHache**, the founder of the New Orleans Philharmonic Society who compiled the Catholic hymnal. Not far from him lies the compiler of the Baptist hymnal, **Staunton S. Burdette**.

There are figures of Confederate significance within Lafayette #1. Confederate General **Harry T. Hays** (1820–1876) is buried here, as well as Civil War luminary **Charles W. McLellan** (1892–1964), who died defending Richmond, Virginia. Then there is the tomb of Louisiana's Civil War–era governor, **Henry Watkins Allen**. His confusing epitaph might receive an award in

"Died of Yellow Fever." Three children from one family, who all died within two days. The first listed was one day old.

the "Most Cryptic and Unintentionally Humorous" category. It reads:

> Your friends will be proud to know that Louisiana had a governor who, with an opportunity of securing millions in gold, preferred being honest in a strange land without a cent.

If you can make sense of this statement, it is probably true. A figure of national historic significance from the post–Civil War era entombed in

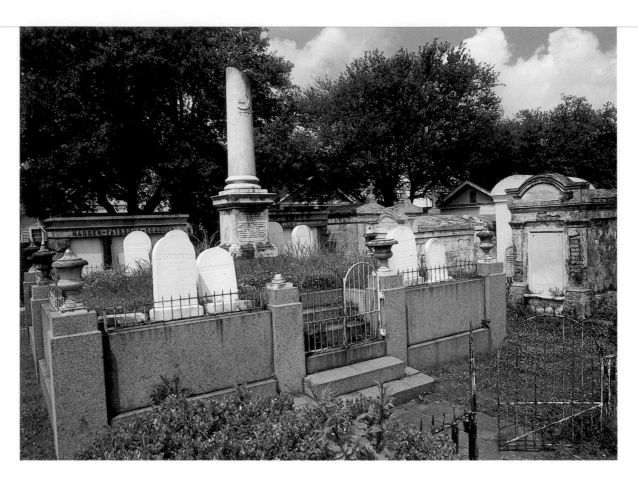

Broken column bears C.S.A. (Confederate States of America) within a crescent moon memorializing Captain Charles W. McLellan who died while defending Richmond, Virginia, June 1, 1864. Legend has it that his family from the state of Maine wanted him buried "in Maine soil" and therefore had this elevated plot built and filled with earth imported from Maine.

Lafayette #1 is Judge **John Ferguson**, who presided over the infamous case that bore his name, *Plessy* v. *Ferguson*. In 1890 Creole of color New Orleans shoemaker Homer Plessy (now entombed in St. Louis Cemetery #1) got himself arrested for defying a Jim Crow law by sitting in the "white section" of a segregated train car. The pretrial hearings were held in New Orleans in 1892 and the case went to the Supreme Court in 1896. Ferguson's legal triumph over Plessy would legalize segregation in the United States for the next sixty years. Its resultant doctrine of "separate but equal" was nullified by *Brown* v. *Board of Education* in 1954.

Perhaps the most well-known person ever asso-

ciated with Lafayette Cemetery is not even entombed yet, although she seems to be very much in touch with spirits from the afterlife. The neighborhood-born novelist **Anne Rice** was raised around the corner on St. Charles Avenue on the periphery of the Garden District. She constantly passed through the district during her childhood to attend school and church and to visit her family in the Irish Channel. On her frequent strolls through the Garden District, she absorbed the dreamy, fantastical landscape found in many of her novels, and for much of her life has had a strong connection with this city of the dead, a place which biographer Katherine Ramsland, in

Prism of the Night, calls "the deteriorating Garden District graveyard of her childhood wanderings." As a young girl, Ms. Rice would visit Lafayette Cemetery #1 with her father, a man who appreciated its alluring qualities.

Anne Rice still lives around the corner from Lafayette #1 and has by now forged a creative connection with this city of the dead. This cemetery serves as a setting in her novels. For example, the Vampire Lestat hides his valuables in the vaults of these tombs, a scene from the movie *Interview With A Vampire* was filmed here, and the Mayfair family tomb is situated here. The large number of visitors who seek out this fictionalized tomb is remarkable, and their curiosity is an indication of how *real* Anne Rice's characters have become to her readers. Legions of her fans come to New Orleans looking for her creations, and Lafayette Cemetery is one of the first places they comb to find them.

One of the most remarkable public events to have ever occurred in a New Orleans cemetery was perpetrated in Lafayette #1 by Anne Rice on July 14, 1995, the release date of her novel, *Memnoch The Devil.* The author was holding her first book signing at the Garden District Book Store, diagonally across the street from the cemetery. As a prelude to the signing Ms. Rice arranged for a horse-drawn glass hearse accompanied by black-clad mourners and the Pin Stripe Brass Band to meet her in the cemetery. At 4:00 P.M., she made her entrance into Lafayette Cemetery, wearing an antique wedding dress in 100-degree heat. The pallbearers withdrew a black casket from the hearse and opened it for her. As she stepped into the casket, somebody asked her whether she was afraid. Ms. Rice announced that she was happy to be doing this, for most people do not get a chance to do it until they are dead. In the funereal style, she crossed her hands over her chest. As the lid was lowered, she smiled and asked the crowd, where else could one

get away with this besides New Orleans, and then mused that it would be a bad career move if she were to die in that coffin.

Under the trance-inducing swelter of full-force New Orleans summer conditions, the pallbearers lifted the dry-ice—lined casket into the hearse. The brass band commenced a funeral dirge and proceeded toward the cemetery gate. The image was almost surreal in the humidity-laden heat, a funeral procession *starting* in a cemetery and leaving the graveyard with a full casket. As the band passed the Lafayette gate they commenced playing "When the Saints Go Marching In" and the second-line exuberantly proceeded down Washington Avenue to the Garden District Book Store. A beaming Anne Rice emerged from the coffin to a line of fans numbering in the thousands. She proceeded to sign books for several hours to the joyful music of the Pin Stripe Brass Band.

Anne Rice is not the only person to execute a humorously unusual public stunt in Lafayette Cemetery. On July 13—a Friday—1980, a Texas couple got married among these aboveground tombs in an attempt to "bury the past." Four black limousines transported the bride, groom, and wedding party from the airport to the cemetery. A single trumpet blew *Summertime* as the ceremony started in this city of the dead.

Some of the best news to come from a New Orleans cemetery in recent memory involves Lafayette #1. In June 1996, the venerable preservation group Save Our Cemeteries received a $20,000 grant from the World Monuments Fund to develop a Lafayette Cemetery conservation plan. Not only does this endow the cemetery with preservation resources but it lends deserved status to this and all cities of the dead. Via the World Monuments Fund, a New Orleans cemetery has now joined the ranks of Angkor Wat, Pompeii, the Taj Mahal, and the Haghia Sophia.

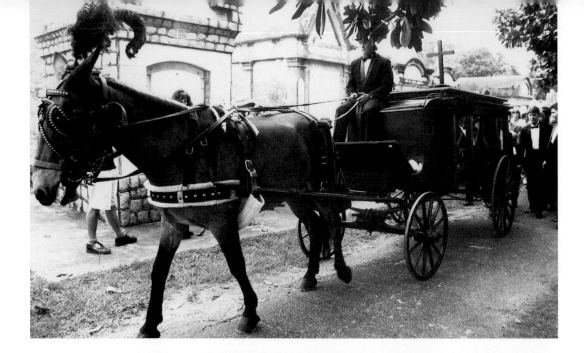

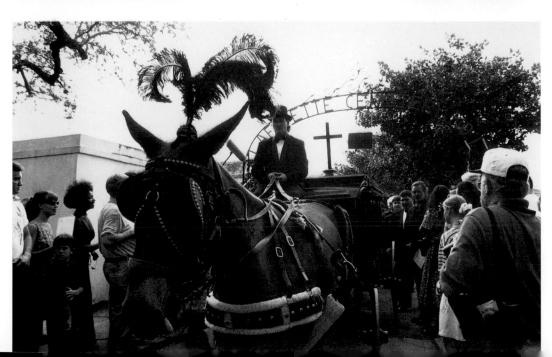

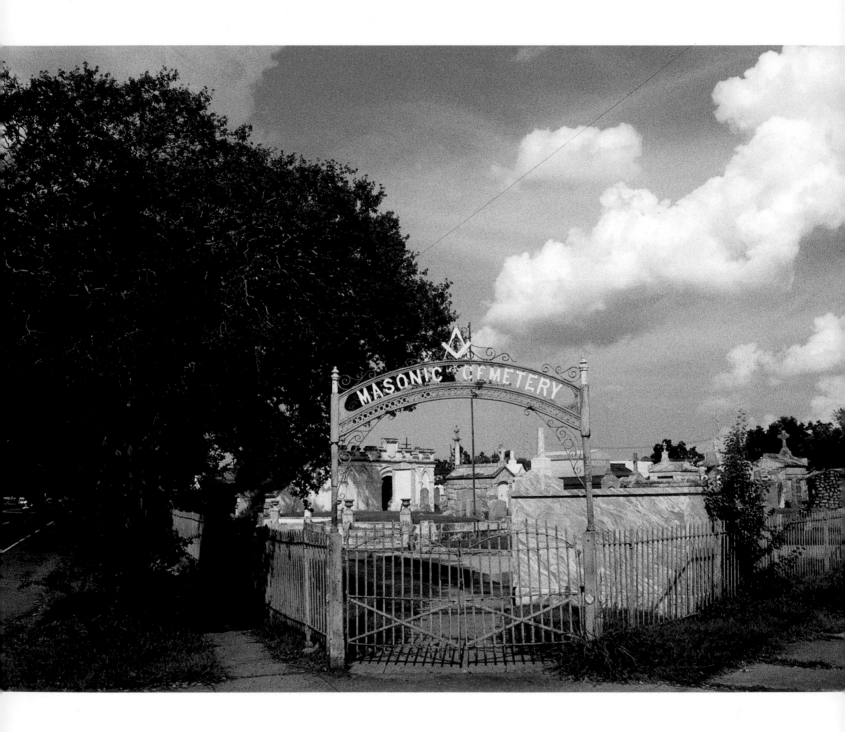

8

❧

Masonic Cemetery

ESTABLISHED: 1868
OWNER: MASONIC FRATERNITY, GRAND LODGE OF THE STATE OF LOUISIANA

On St. Louis and Bienville streets—two of the same streets that border New Orleans's oldest cities of the dead, St. Louis Cemeteries #1 and #2—sits the Masonic Cemetery. Facing City Park Avenue, Masonic Cemetery's two quiet sections form shapes that only a geometry professor could identify. In a town where features of the myriad cemeteries can at times seem redundant, this cemetery distinguishes itself in understated visual ways and in larger historical ways. As is true with many other groups and institutions, the Masonic Fraternity has experienced an exceptional and singular history in New Orleans.

Fraternal societies have existed throughout civilization. In some cultures they are the sole means through which tradition is passed on. Societies that initiate their members teach a moral science some groups call "mysteries." While instilling their value system, they develop alliances. Burial of members is one of the society's chief responsibilities. The most well-known fraternal organization in the United States today is the Freemasons, through which members advance in a series of stages called degrees.

Although many recognize the Masonic fraternity as having medieval origins, and others trace it back before Christ, even to the early society of builders in Egypt, the fraternity in its present form is said to have originated with the organization and establishment of the Grand Lodge of Masons in London in 1717. The order's name was derived by following stonemasons' guild practices from the Middle Ages. Their stated principles feature political compromise and religious toleration, which is why totalitarian governments have often tried to prohibit them. Some illustrious European Freemasons include Voltaire, Garibaldi, Haydn, Goethe, and Mazzini. Most of the signers of the Declaration of Independence, including George Washington, were Masons. The order was very active in the American Revolution and has continued to be a strong national political entity. By the early nineteenth century an "Anti-Masonic Party" was founded due to a belief that the Masons had achieved too much political power. American Freemasonry has had its hurdles to surmount, but this resolute group faced a set of challenges and

Regarding issues of race, it seems that New Orleans Masons were historically more permissive and relatively more integrated. Historian Joseph Logsdon explains that in the antebellum period, the York Rite had dual black and white lodges. It even appears that the French, Scottish Rite lodges admitted black members before the abolition of slavery. Indeed, following the Civil War, white Scottish Rite Masons proclaimed the ideal of universal brotherhood and announced the creation of integrated lodges. In 1903, at the height of the Jim Crow era, this rite elected a black grandmaster.

Louisiana's first black lieutenant governor, Prince Hall Grandmaster Oscar J. Dunn, garnered much political support through his masonic membership, and members of the Citizens Committee (Comité des Citoyens) were Masons. This Creole activist group who championed civil rights as far back as Reconstruction included Mason Homer Plessy (entombed in St. Louis Cemetery #1, with no masonic symbol), plaintiff in the landmark Supreme Court decision *Plessy* v. *Ferguson*, whose Fourteenth Amendment arguments were later upheld in *Brown* v. *Board of Education*.

Founded in 1865, New Orleans's Masonic Cemetery was one of several cemeteries to be established immediately following the Civil War. The Grand Lodge of the State of Louisiana petitioned to establish a cemetery in March 1865 while the city was still occupied by Union forces. A resolution signed by Union Captain Stephen Hoyt granted permission, but the Masonic Order questioned its validity. Wanting to ensure its legitimacy, they waited for a new resolution to be passed in January 1868 to establish their cemetery.

In the Masonic Cemetery there are many curious tombs belonging to specific lodges. The most noticeable and most likely the oldest is the Perfect Union Lodge, a lodge founded in 1793. The roof of this unusual Gothic design structure is accessible by a large stairway. Inside there are vaults flanking a corridor and a three-dimensional metal masonic symbol hung from the ceiling. The second oldest lodge in New Orleans, Etoile Polaire (1794) has a tomb in this cemetery as well. The George Washington Lodge No. 65 features a broken col-

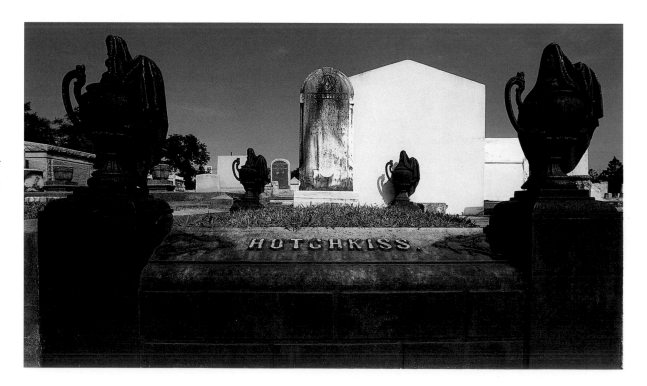

Cast-iron coping of the Hotchkiss family

umn, a symbol frequently seen in New Orleans cemeteries, which signifies "life cut short." Quite often people see a row of broken columns in a city of the dead and mistake it for vandalism. Across from the George Washington Lodge #65 tomb, the cemetery boasts a society tomb for the Red River Pilots Association. A steamboat steering wheel adorns the tomb's pediment. The Red River Pilots Association no longer exists, nor does the prodigious steamboat profession which their tomb once serviced. Of the mere six steamboats that today ply the waters of the Mississippi, most are no longer steered by the wheels pictured on this tomb, but rather by electronic devices.

Most Masonic lodges bury in copings. One of the most notable is that of the Osiris Lodge No. 300, ornamented by two columns salvaged from the old St. Charles Avenue Masonic Temple, demolished in the 1920s. The **William G. Bedford** plot employs a unique cast-iron coping. Most of this cemetery's property is owned by Masons or their families. Entombed here are such esteemed Masons as **Samuel Todd**, grandmaster of Louisiana Masonic Lodges for five years during the mid- to late-nineteenth century, and **L. P. de la Houssaye**, grandmaster of the state from 1904 to 1905. Swiss businessman **R. G. Holzer** is also buried here. His name is still seen on the sign of the enormous French Quarter sheet metal works he established in 1872. This enduring business is another welcome indication that the Vieux Carre is a living, thriving neighborhood and not, as William S. Burroughs once called New Orleans, "a dead museum."

In *New Orleans Architecture: The Cemeteries*, Leonard Huber in the early 1970s reported: "The land in Masonic has been nearly all sold, and there is the problem of maintenance since obligatory perpetual care was begun only lately." This assessment no longer applies; this burial ground is one of the cleanest and most well maintained in New Orleans.

9

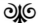

Hebrew Rest

ESTABLISHED: 1872
OWNER: THE CONGREGATIONS TEMPLE SINAI
AND TOURO SYNAGOGUE

*J*ews had been entombed in the Catholic St. Louis Cemetery #1 during the eighteenth century. They also were buried in the now defunct Protestant Girod Street Cemetery and the nondenominational Metairie Cemetery. (Henri Gandolfo writes that the 1886 Metairie Cemetery funeral of Rabbi James Koppel Gutheim, Temple Sinai's first rabbi, "was said to have been the largest in New Orleans prior to the burial of Jefferson Davis.") But the first Jewish cemetery in New Orleans was established in 1828. The earliest Louisianians of the Jewish faith were largely Sephardic—of Spanish and/or Portuguese descent—and the most well-known Sephardic Jew of New Orleans history is philanthropist Isaac Delgado, now entombed in Metairie Cemetery.

Nineteenth-century New Orleans Jews found a way to adapt the ancient Hebrew custom of in-ground burial to an environment whose high water table and annual rainfall posed a serious challenge. But adapting to local burial condition was not the only problem. The Jewish American experience has been something of a counterpoint,

a unique story in United States history, with its own set of considerations and demands. Although being Jewish in the American South has been considered exceptionally challenging, in South Louisiana this group would face a wholly different set of cultural, legal, and religious circumstances amid a social fabric unparalleled elsewhere in the United States.

To begin with, there was the Code Noir, French (and subsequently Spanish) colonial legal policy regarding slavery. By edict of the French crown, its first article stated: "We enjoin the Directors General of the said Company, and all our Officers, to drive out of the said country all Jews who may have established their residence there. These, as declared enemies of the Christian name, We command to leave in three months . . ." The rationale for this rather hostile statement is twofold. First, there was a theory that appeared in a company of the Indies (the trading company of Scottish entrepreneur John Law, who held the first proprietorship of the French colony of Louisiana) bureau documents, which promoted banning Jews from

Louisiana. It stated that Jews "would be politically unreliable and economically too aggressive." Second, Article 3 of the Code Noir mandated that Catholicism be the state religion. As Bertram Korn demonstrates in *The Early Jews of New Orleans,* Article 3 was rooted in "a missionary concern for the souls of the Negro slaves." He explains:

> If Jewish landowners could practice Judaism, they might feel free to convert their slaves to their own religion. Only a

double edged denial of the right of Jews to settle, and of the freedom to practice any faith other than the Catholic, would guarantee the proper Catholicization of the slaves. Since the time of the Emperor Constantius (339), legislation of the Roman Empire, of the Church Councils, and of individual states, had sought to support the spread of Christianity by prohibiting the holding of Christian slaves, and even of potential slave converts to Christianity, by Jews, as well as the conversion of slaves to Judaism by their Jewish owners.

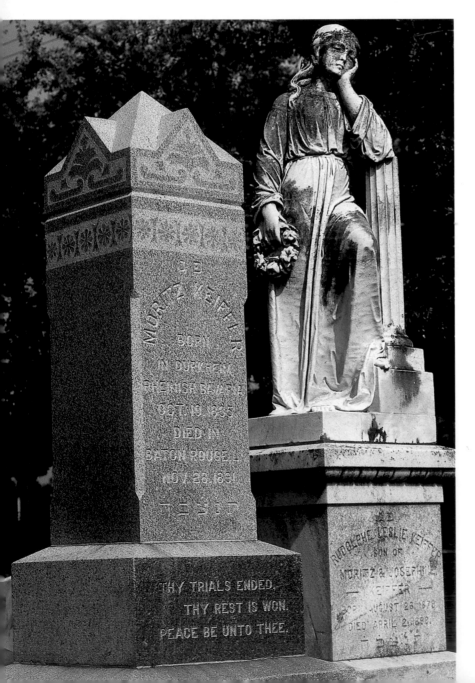

Although the Code Noir did distinctly forbid Judaism, there was a Jewish presence in colonial Louisiana as early as the eighteenth century. However, it was not until the mid-eighteenth century that Isaac Rodrigues Monsanto became the first documented Jew to permanently settle in New Orleans. This Sephardic merchant from Curaçao wound up in New Orleans after the complicated high seas pirate hijacking of a sloop, the *St. Joseph,* he had chartered led to a lawsuit which was tried in New Orleans. Monsanto then decided to transfer his business operations to this burgeoning port city. French colonial Governor Kerlerec flagrantly defied Article 1 of the Code Noir by not evicting his industrious merchant friend Monsanto and other Jews from New Orleans. As Jews lived in colonial Louisiana, they also died there, and records of Jewish burial exist within the Catholic St. Louis #1 Cemetery as early as 1794, only five years after this oldest of New Orleans cemeteries was established.

Enforcement of the Code Noir's first article does not appear to have been a great concern to colonial authorities, since there were not multitudes of Jews attempting to immigrate to early Louisiana, a place characterized by Edwin A. Davis as being "in a state of confusion, with quarreling factions,

◄ *Cast metal memorial of Henriette Dreyfus Levi*

abandoned concessions, habitations and farms, and an immoral and generally worthless French citizenry." It was not until after the Louisiana Purchase, when New Orleans became a bustling international seaport, that there was substantial Jewish immigration. In fact, some of nineteenth-century New Orleans's most active movers and shakers, such as Judah Touro, Isaac Delgado, and Judah Benjamin, were of Jewish extraction.

No longer existent, the first Jewish cemetery in New Orleans was Gates of Mercy on Jackson Avenue and Saratoga Street, established by the Israelite Congregation Shanarai Chasset ("Gates of Mercy"). Following this first Jewish city of the dead, the Dispersed of Judah (named for its benefactor Judah Touro) was placed amid the teeming mass of cemeteries at the end of Canal Street on the 4900 block. Across the street, Temmeme Derech Cemetery was opened in 1858, which was eventually expanded and renamed after the congregation "Gates of Prayer" ("Beth Israel" and "Chevra Thilim").

From 1860 to 1861, the founders of the first New Orleans Jewish cemetery on Jackson Avenue, the

Congregation Shanarai Chasset (the German congregation who in 1881 united with the Portuguese Congregation Nefuzoth Yehudah to establish Touro Synagogue) opened the Gentilly neighborhood Hebrew Rest Cemetery on Elysian Fields. They enclosed two squares within brick walls that do not contain vaults and built a *metaher*. The Congregation Temple Sinai bought half interest from Shanarai Chasset in the Hebrew Rest Cemetery. To manage the graveyard, these two congregations formed a joint board. In 1894 they purchased land across Frenchman Street making Hebrew Rest Cemetery the largest Jewish burial ground in New Orleans.

Entering Hebrew Rest through one of its skillfully crafted iron gates, one sees well-manicured grounds and adherence to the Jewish custom of eastward-facing graves. Another Jewish tradition maintained is below-ground burial. "According to Jewish belief," explains the Louisiana State Museum exhibit *Disease, Death, and Mourning,* "the body must return to the soil and thus was usually buried in the ground in a wooden casket without

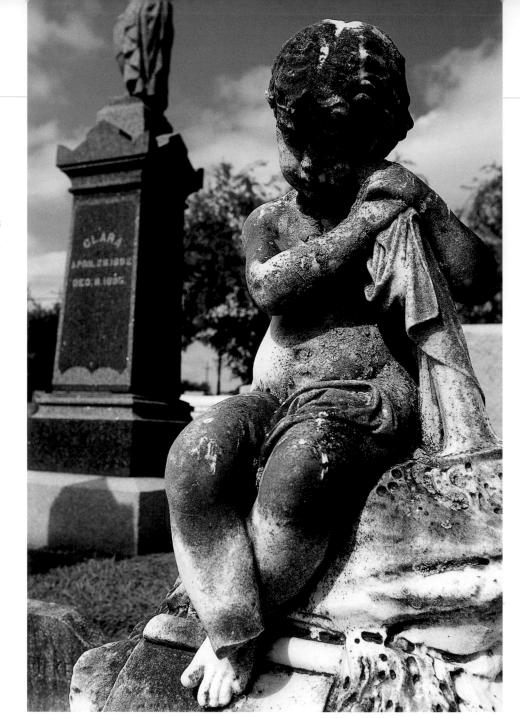

A child leans on an inverted torch.

nails." New Orleans Jews were able to bury in-ground during the nineteenth century by the use of copings. With elevated frames filled with soil in which to bury the deceased slightly below grade, the coping is technically "in-ground" burial.

Rabbi Murray Blackman explains that the Jewish preference for in-ground burial stems from an age-old Hebrew belief that the body should naturally return to its elemental state, "ashes to ashes, dust to dust," as directly as possible. Orthodox Jewish tradition does not employ wakes and embalming, but rather quick burial in unceremonious coffins, and many Jewish cemeteries have traditionally been spartan. Hebrew Rest Cemetery, however, belongs to congregations of Reform Jews, as opposed to Orthodox or Conservative Jews, and features many superb aesthetic qualities. Particularly striking are its depictions of the human figure, which would not be found in Orthodox Jewish cemeteries.

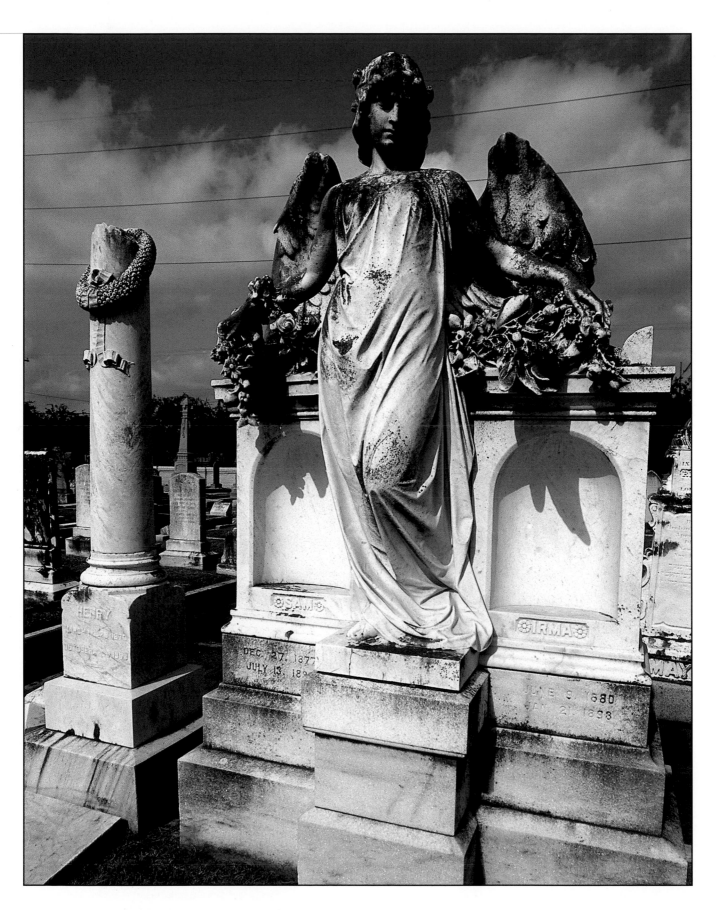

Angel casting flowers down upon the Isaac Levy plot.

10

St. Louis Cemetery #3

ESTABLISHED: 1854
OWNER: NEW ORLEANS ARCHDIOCESAN CEMETERIES

Wedged within some of New Orleans's most momentous milieus is St. Louis Cemetery #3. This burial ground sits at the confluence of sites which are more historical institutions and cultural well-springs than mere geographical locales.

To begin with, this cemetery's address reads Esplanade Avenue, a street that runs on an ancient naturally occurring high ridge of land. This Esplanade Ridge is referred to by some archeologists as "the oldest road in North America" because Indians used it as a portage for centuries. Native American groups who had been in the Delta region for thousands of years chose not to permanently settle on the present-day site of the French Quarter, but they did carry their canoes and goods across the Esplanade Ridge. This portage started at the Mississippi River and led out to Bayou St John, which is connected to Lake Pontchartrain and consequently to the Gulf of Mexico. A regional tribe showed this shortcut to the first French settlers, who decided to settle here in large part because of this connection which bypassed the formidable downward flow of the

Mississippi River. Today Esplanade Avenue is significant as a boundary to the lower end of the French Quarter and also as a showcase of intriguing old New Orleans homes which were the "Creole response" to the nineteenth-century American building boom on St. Charles Avenue.

Another site abutting St Louis #3 is Bayou St. John, a storied natural body of water. Bayou St. John is not only significant for linking the river to the gulf and hence triggering the settlement of New Orleans but it also served as a recent thoroughfare for commerce. Skiffs docked along its banks well into the twentieth century. The bayou was also used as the site of clandestine nineteenth-century voodoo rituals. At that time, this area was remote and secluded, and voodoo was much more than a Hollywood gimmick or a cheap tourist trick. Today Bayou St. John is one of the most picturesque and placid sections of a city laden with storybook vistas.

Just beyond the bayou is City Park, one of the country's biggest and most distinctive urban parks. This sprawling sanctuary boasts not only an

impressive art museum, botanical garden, and a vast collection of WPA design structures but also the largest grove of live oak trees in the world. And finally, on the other side of the cemetery, is the New Orleans Fairgrounds, a racetrack whose original location is now home to Metairie Cemetery. This Fairgrounds hosts an event which now rivals Mardi Gras in worldwide popularity, and maintains an integrity that seems to be rapidly disappearing from New Orleans Carnival: The Jazz and Heritage Festival. A St. Louis Cemetery #3 visitor once remarked that he could hear strains of Snooks Eaglin's guitar blending with a Cajun accordion on top of a Mardi Gras Indian chant as he placed flowers on his family tomb. St. Louis #3's proximity to the Fairgrounds has prompted some out-of-town festgoers to refer to this city of the dead as "the Jazz Fest cemetery."

The site of St. Louis #3 was once known as "Leper's Land," because in the late eighteenth century Governor Galvez exiled the city's lepers to that location. There the subsequent governor, Miro, actually built a residence for them. At first, this burial ground was known as the Bayou Cemetery. In an article about cemeteries, the *Times-Picayune* commented: "There's even an example of a cemetery on top of a cemetery: St. Louis #3 was built on the site of a late eighteenth century graveyard for lepers." This graveyard, which was initially developed to combat leprosy, ultimately became a burial ground that, like so many old New Orleans cemeteries, was closely connected to another dreaded skin-altering, metabolism-ravaging disease, yellow fever.

St. Louis Cemetery #3 opened its gates in 1854, a year after the most devastating yellow fever outbreak in New Orleans history. Because the notorious 1853 epidemic created an urgency to provide additional burial space, St. Louis #3 was steadily utilized from its inception, creating crowded corridors of burial. However populated it is, St. Louis #3

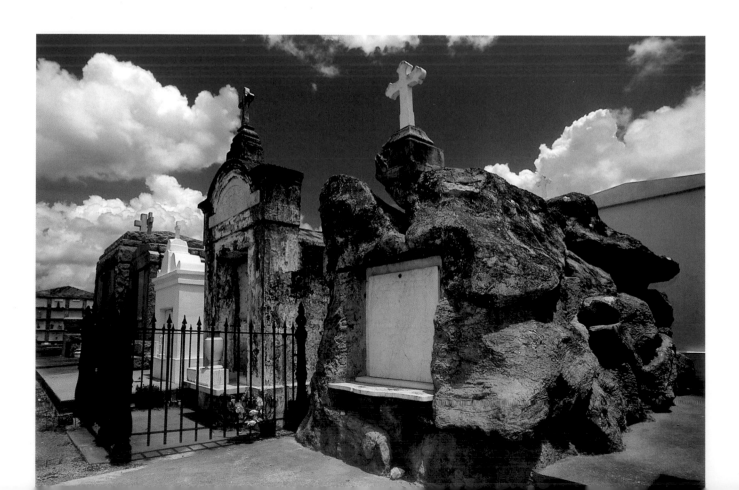

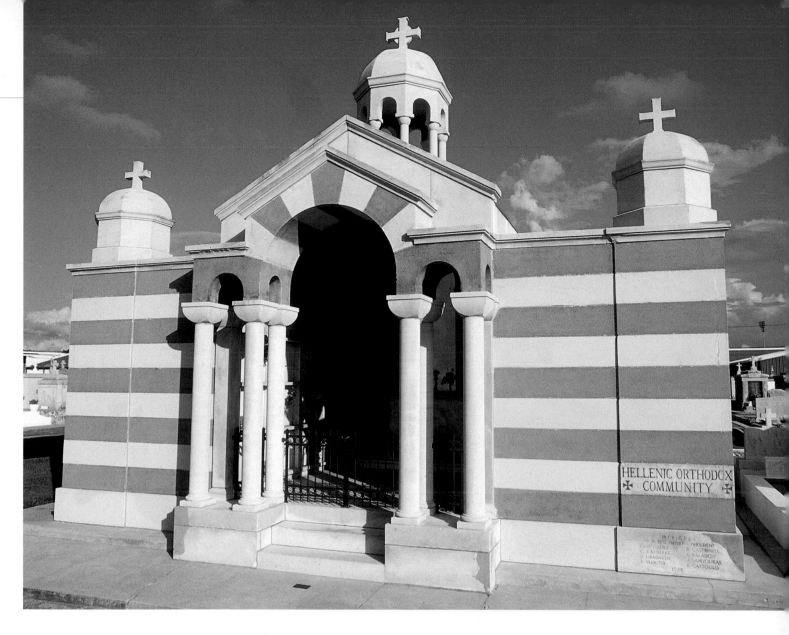

Byzantine-style tomb of the Hellenic Orthodox Community

does not feel claustrophobic, for its main aisles—all named after various saints—are very wide, giving the cemetery, as Samuel Wilson and Leonard Huber describe, "a rather uncrowded appearance despite its multitude of closely built tombs."

Its wide open appearance, however, is deceiving; St. Louis #3 today is one of the most well-traveled cemeteries in New Orleans. With more than four hundred interments a year, there is a waiting list to purchase burial space. Sometimes there are several burials a day. Funeral processions—usually automotive but occasionally even a horse-drawn jazz funeral—down the mysteriously majestic Esplanade Avenue are not uncommon occur-

rences. Frequent interment is a reason for St. Louis #3's well-maintained condition.

Through the decades many significant and interesting New Orleanians have been entombed in St. Louis #3. One of the most notable is **Father Adrian Rouquette, aka Chahta-Ima** (1811–1887). Born to a wealthy New Orleans family and educated in France, this aspiring scholar became concerned with the foreboding situation of Native Americans across Lake Pontchartrain and thus retreated to St. Tammany Parish where he lived with the local Indians. Developing a deep sense of reverence, he wrote a novel about the Choctaw (and chronicled their "day of the dead" obser-

YOU ARE A PRIEST FOREVER

1886 RT. REV. MSGR. JOSEPH J. BOUDREAUX 1969
1891 REV. ALLARD M. DOMSDORF 1976
1927 REV. DUDLEY J. DARBONNE 1977
1916 REV. JAMES J. SKELLY 1980
1908 VERY REV. ARTHUR M. FINNEGAN 1983
1906 REV. F. LYLE KENNEDY 1984
1911 REV. PETER E. PEACOCK O.F.M. CAP. 1986
1917 REV. MSGR. JOHN E. PREGENSER 1988
1901 REV. J. MARION JORDA 1988
1913 REV. MSGR. HENRY C. BEZOU 1989
1943 SUPERINTENDENT OF SCHOOLS 1968
1917 REV. MSGR. CHARLES PLAUCHE 1990
REV. JAMES COUNAHAN 1991
REV. JOHN G. McCUSKER 1991
MSGR. JOHN J. ADAMS 1992
V. MSGR. PATRICK J. QUINN 1992
EV. STEVEN R. McINTOSH 1993
JOHN B. BAHAN 1995
ROME A. DROLET 1995
KARL M. PETERSEN, JR. 1995

You Are A Priest Forever.

vances). He was ultimately given the name Chahta-Ima, which means "he who is like the Choctaw."

Rouquette fell in love with the chief's daughter, Osoula, whose name means Bird Singer. Upon her devastating death, Chahta-Ima decided to become a missionary priest. He established five missions throughout St. Tammany Parish, and unlike other

clergy and encroaching European settlers, he saw the Indians not as pagans in need of enlightenment but rather as individuals full of wisdom and valuable lessons. After five decades with the Choctaw, the infirmities of age forced Rouquette to return to New Orleans. His subsequent funeral service was memorable; scores of Choctaw gathered at the Ursuline Convent and, as Mel Leavitt writes in *Great Characters of New Orleans,* "formed two rows alongside Chahta-Ima's coffin. Bearing pine wreaths woven from the cathedral of his beloved forests, they marched him to the cemetery, chanting their own special Te Deum." Rouquette was initially buried in St. Louis #2 but later moved to the tomb of the priests in St. Louis #3. A marker and stone cross were placed at the site of his Lacombe area chapel.

Another celebrated humanitarian lying in St. Louis #3 is **Thomy Lafon** (1810–1893). Although this free person of color made a fortune through real estate, owning some of the city's most coveted houses, he himself lived in a humble dwelling. Highly educated and trilingual, this ardent aficionado of classical music was close friends with violinist Edmond Dede, a free black who later became conductor of the theater orchestra in Bordeaux, France. Lafon donated a French Quarter building to his relative Henriette Delille and her order of black nuns, the Sisters of the Holy Family. Through Lafon's munificence, this building which once housed quadroon balls became a church, school, and orphanage for people of color. When Thomy Lafon died in 1893 he willed more than $600,000 to altruistic causes and became the first Creole of color for whom the city sculpted a bust. (A comrade of Thomy Lafon's, fellow nineteenth-century free black philanthropist planter **Aristide Mary,** is also interred in St. Louis Cemetery #3.)

Another influential nineteenth-century New Orleanian resting here is architect **James Gallier**

Gallier cenotaph, designed by James Gallier, Jr., in memory of his father, architect James Gallier, Sr., and mother Catherine Maria Robinson, who perished when their steamship, the Evening Star, sank en route to New Orleans from New York, October 3, 1866

Weeping mother, Fourchy family tomb

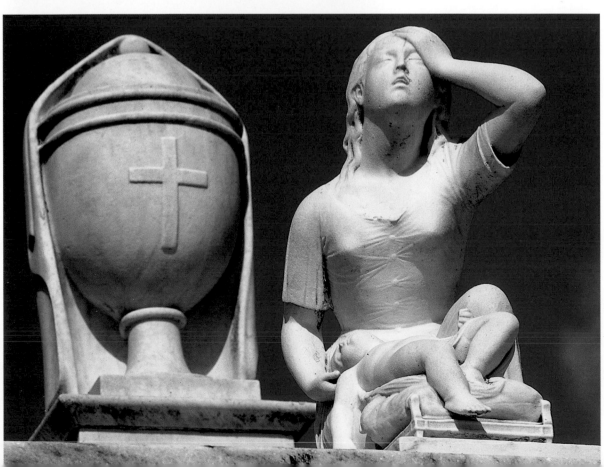

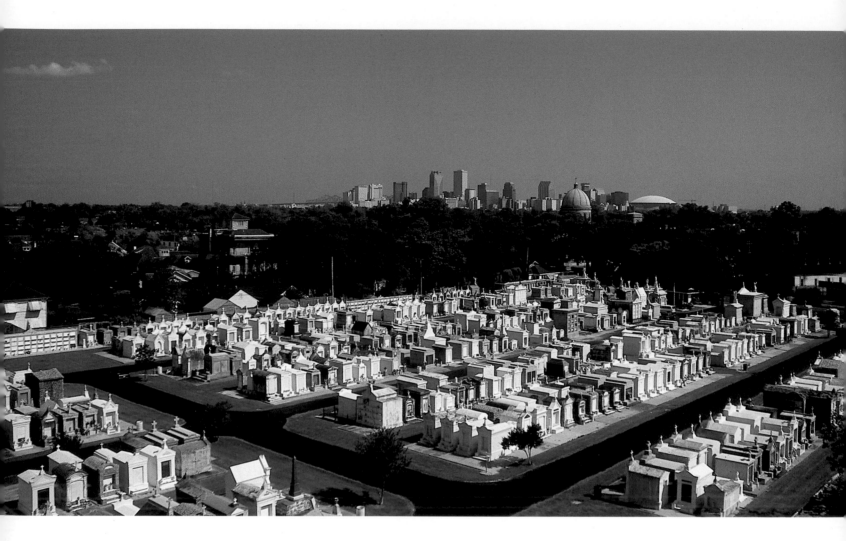

(1798–1866). In a city renowned for architectural achievement, this Irishman may be the most influential New Orleans architect from a time when the city's building proliferated tremendously. Gallier and his wife died in a raging sea storm on the steamship *Evening Star*. His son, architect James Gallier, Jr., erected the family tomb. The inscription reads: "Lost in the steamer Evening Star which foundered on the voyage from New York to New Orleans October 3, 1866." The Galliers perished along with hundreds of people, including a French opera troupe en route to New Orleans for a performance. Gallier Hall is this architect's most outstanding surviving building; most of his

notable structures were destroyed through natural deterioration and by fire.

Two other noteworthy New Orleans designers with a cemetery connection entombed in St. Louis #3 are **Prosper Foy** and **Florville Foy**, free people of color who were two of nineteenth-century New Orleans's most outstanding tomb builders. And two highly significant chroniclers of New Orleans history are also laid to rest here: the legendary Storyville photographer **Ernest Bellocq** and the respected historian **Charles "Pie" DuFour**.

The prosperous antebellum era produced many luminaries who are entombed in this cemetery, including **Valcour Aime** (1798–1867). This

St. James Parish sugar planter's claim to fame was that on his property he could raise everything required for a gourmet meal, not excluding the wine and cigars. Entombed in St. Louis #3 are contemporary historic figures enveloped in Confederate mystique, including **Colonel Charles Dideus Dreux**, the first southern officer to lose his life in battle. Initially buried in St. Louis #3 and later moved to Metairie Cemetery, Dreux is flamboyantly commemorated by the rollicking Kreux of Dreux Mardi Gras parade in the Gentilly neighborhood. Another notable Confederate entombed in St. Louis #3 is **Father François Turgis** (1805–1868), the Confederate chaplain who ended his career serving as the pastor of St. Anthony's Church (the former Mortuary Chapel, today's Our Lady of Guadalupe Church), which became a Confederate veteran's chapel following the Civil War.

Dante Lodge of Masons society tomb. Life-sized bronze bust of Dante was executed by Milan-born artist Achille Perelli. A Lodge member since its inception in 1866, Perelli would not accept payment for this work. He is also credited with the Stonewall Jackson statue on the Tomb of the Army of Northern Virginia in Metairie Cemetery and the Confederate Monument in Greenwood Cemetery. Mr. Perelli was entombed in St. Louis Cemetery #1.

Wayne Schaub, Sandra Harden, and Kenny Condon set up in the early morning.

11

Wayne Schaub

FOOD FOR COMMEMORATION

New Orleanians have long lamented the disappearance of treasured All Saints' Day traditions, such as vendors selling food outside the cemetery gates. But this institution so nostalgically associated with All Saints' Day of the past can be viewed and experienced every day of the week in front of St. Louis Cemetery #3. Yet here there is a twist to this tradition of pushcarts and stands contributing to the cemetery feast. While in the past the November first purveyors of delectables were peddling edibles such as pralines, pies, cookies, cakes, candies, tamales, and beer, in today's more diet-conscious age there appropriately sits a supplier of the world's most healthy food right in front of a city of the dead.

Along the perimeter of one of the city's most popular and prominent cemeteries there looms a traditional New Orleans-style fruit stand, the kind with propped-up handwritten signs announcing the presence of fresh produce from strawberries to mangoes, from satsumas to sugarcane, signs some

of which could pass for folk art. As attention-grabbing as these signs are, nothing catches the eye more than the dazzlingly colorful array of fruits and vegetables which can stop on a dime a driver passing at thirty-five miles per hour. Such foolproof advertising keeps a steady stream of people coming and going around Wayne Schaub's fruit stand in the shadow of St. Louis Cemetery #3.

Streetside fruit stands are as identifiably "New Orleans" as a Creole cottage or second line parade, and Mr. Schaub's family is largely responsible for perpetuating this tradition. With the exception of a handful, every stand in New Orleans is operated by members of his family. Some of Wayne's earliest family memories are of his father transporting produce down the streets in a mule-drawn wagon, and he has heard all about the days before he was born when his daddy worked out of a wheelbarrow. His father started him working in this trade at the age of

eight. Leaving McDonough 11 school every afternoon, young Wayne immediately caught a streetcar on the two thousand block of Canal Street and rode to Carondelet where Wayne, Sr., had fresh strawberries waiting, stacked up alongside a certain post for him. "I used to go down, school books and all, just go open up and sell the strawberries. When I sold out, I went home," he explains while arranging cartons of strawberries that look like they were picked just minutes before.

The original Schaub family fruit stand stood for roughly thirty years on Canal Street by Krauss Department store, right across the street from the former New Orleans Hotel, and for the past fifteen years Wayne and his brother, Danny, have operated here at the end of Esplanade Avenue, where Wayne can look back upon a lifetime of vending Louisiana's bounty. Compared to the past, today's business is not as abundant for a few reasons: the decline in small truck farmers who used to sell directly to the stands, the advent of "speculators" (vegetable middlemen), and the growth of large supermarket chains. However, Wayne relishes certain advantages that the larger stores cannot touch. First, there is freshness from a lack of refrigeration. Wayne's customers know all too well that refrigerated and iced produce rapidly loses its flavor. Then there is the fact that people like to stop by and shoot the breeze. The open-air fruit stand somehow encourages a barbershoplike free exchange of ideas. And, finally, he is able to keep up with the franchises because, as Wayne puts it, "I got the cemetery on my side."

St. Louis #3 is one of New Orleans's most frequently visited cemeteries and Wayne is convinced that tomb visitation can drain a lot of energy. Cemetery visitors have been known to replenish sapped physical, emotional, and spiritual energy by slurping a satsuma or sucking on a stalk of sugarcane. There are also the tour buses that briefly leave visitors off at St. Louis #3 as part of a long and tiring citywide tour. More than one tomb peruser from out of town has commented to him that it is extraordinary to visit a cemetery and then buy fresh fruit. "One guy recently commented to me that this whole scene fits in with the cycles of life," Wayne smiles.

It is not only cemetery visitors, however, who frequent Wayne's stand. Being a fifth generation New Orleanian, Wayne knows numerous people throughout the community and friends from various phases of his life who stop by this conveniently located site just to sit on his folding chairs and see how he is doing. One recent afternoon, as Wayne was practicing his golf swing alongside the stand, a childhood friend stopped by. They began strolling down memory lane and wound up in a cemetery. Wayne and his friend had grown up in the Iberville housing project and they made the neighboring St. Louis Cemetery #1 their playground. Kenny Condon, an employee of Wayne's who also spent part of his childhood living in the Iberville project, explained: "The adults, if they caught us playing in the courtyards, they thought we were gonna tear up their gardens, so they chased us out of there. We *had* to play in the cemetery."

The friends recalled childhood games they used to play in New Orleans's oldest city of the dead, such as "fate" (catch), "nuddit" (tag), and "sardines" (hide-and-seek). In sardines, a peculiarly New Orleanian version of hide-and-seek, one person would hide in a decrepit tomb, which was open through ancient, crumbled brick and mortar, and the rest of the group would disperse throughout the cemetery. The first person to find the entombed playmate would hide inside with him

Wayne takes a break from practicing his golf swing as tour guide Mitsuko Kennair explains the tradition of the roadside fruit stand to a busload of cemetery visitors.

and the next person and the next person did the same and so on until everybody was jammed in the tomb (hence the name sardines). The last person to find the group was the loser. Not too many years later, with the arrival of adolescence, the open vaults became a place for amorous boys and girls to steal some privacy.

Wayne claims that he was the one who discovered the tombs' potential as hiding places, and quite by accident. One day they were playing "nuddit" and he was "it." As a friend was chasing him across the top of a wall vault, Wayne plunged right through a layer of rotten brick. "It scared the hell out of me," Wayne recalls. "Because as I leaned down to push myself out of the vault, I grabbed right onto a human skull. I never did that again."

Playing in the cemeteries did indeed have its hazards. Wayne often saw his friends get jabbed by the pewter points on the ironwork. This is unusual, because the points, although very sharp, are not meant to be protective, but merely ornamental. Leave it to a bunch of rowdy kids to go to great lengths to get in harm's way. Wayne also saw people trying to elude the police jump the cemetery wall. Although it would seem a foolproof place to hide, Wayne reports seeing fugitives in their haste get stuck on those vicious little metal points and get themselves apprehended.

In the course of conversation, Wayne puts down his golf club and sits by his buddy in a folding chair. His friend glances at the nearby St. Louis #3 wall vault and asks Wayne if he remembers sitting on the walls and chewing tobacco. "How could I forget?" Wayne laughingly replies. "One of the most memorable times in my life was when I first tried chewing tobacco, up on the wall vault. I was nine years old. I'll never forget the brand name of it—Spark Plug. Some kid said,

'Swallow the juice. It's good for you.' So I swallowed the juice and GAWD!, my insides were on fire!" Asked if he threw up, Wayne responded, "Did I throw up? I had to clean off some of the tombs!"

From his fruit stand, the type of extracurricular activity Wayne witnesses in the cemetery today is not fate, nuddit, sardines, making out, and chewing tobacco, but rather something slightly more esoteric. "I've seen some weird stuff in there, either devil worshipers or something to do with voodoo, because I've seen painted chickens come running out of there in the morning with ribbons and bells tied to their ankles. And I've seen people climb out of there over the fence in the evening after the cemetery closed. These are people who obviously didn't get locked in there by accident, the ones who I think are practicing voodoo or something. Now I've always known people practice voodoo in cemeteries, but these people today aren't what I think of as voodoo people. These are young kids. Punk rockers or hippies or something."

"I've also seen 'em try and climb in after hours. One time I saw a guy with long hair and a long black gown trying to climb the fence. I was sure he wouldn't be able to do it with that gown on, but he managed to get in there." Wayne disapproves of people trespassing around a private and sacred place at night. Even though he claims his own childhood was "fast and wild," that was something he would never do. "We actually used to *sleep* out in the Iberville project courtyards at night in cardboard boxes, but we drew the line at going into the cemetery after dark."

After contemplating his childhood, Wayne pauses to remark, "It's unbelievable that I grew up every

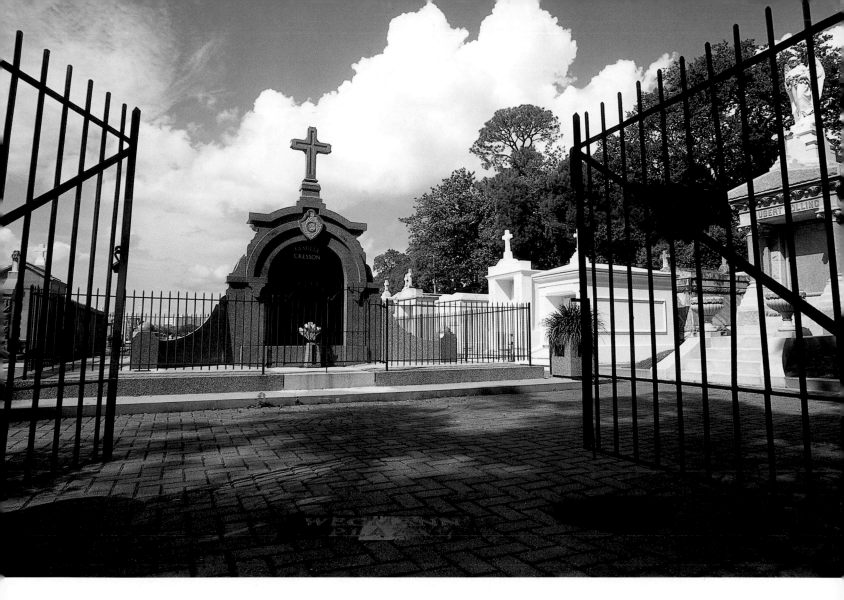

Cresson family tomb in St. Louis Cemetery #3

day around an old St. Louis Cemetery and now today I'm working every day right outside one. That's somethin', ain't it?" But he is snapped out of his momentary reverie by a customer approach-ing from the cemetery gate.

"We got fresh strawberries," Wayne informs him. "Real fresh...."

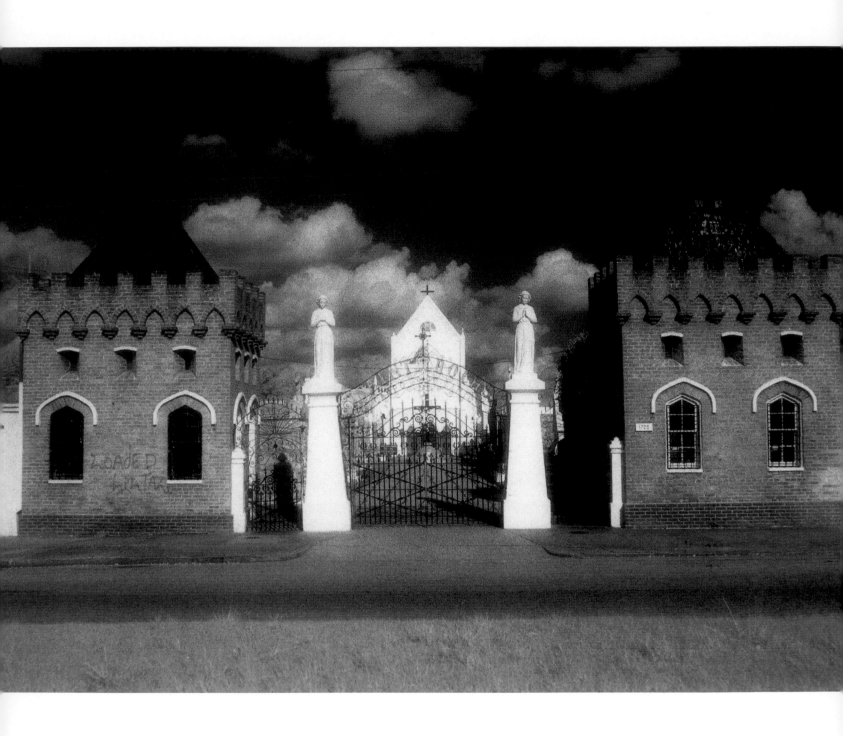

12

St. Roch Cemetery/Campo Santo

ESTABLISHED: 1872

OWNER: NEW ORLEANS ARCHDIOCESAN CEMETERIES

*E*ach New Orleans cemetery is a world unto itself, but one of them is something of its own universe. There is definitely a removed sense of place and time within St. Roch Cemetery. It is walled like many of the old cities of the dead, but dividing its front wall is an ornate gate of exquisite wrought iron flanked by angels atop Egyptian pillars through which flow a steady stream of visitors. At intervals throughout the enclosing wall vaults are enclaves in which are situated life-size carved marble statues imported from Italy depicting the stations of the cross. In the midst of a captivating array of well-kept and some partially crumbled above-ground tombs and copings bedecked with flowers, below an enormous crucifix with a life-size figure of Christ nailed to it, lies the marble statue of a child. And past this point, ensconced in this heady cemetery is a medieval-seeming Gothic chapel, which includes a small room from whose walls dangle facsimiles of human limbs and interior organs.

This is the cemetery and chapel of St. Roch, a saint whom most people in the United States, even devout Catholics, have never heard of. His cemetery, like so many old New Orleans cities of the dead, had a close relationship with deadly epidemics. St. Roch himself is reported to have performed miracle cures during epidemics seven centuries ago, and his moving saga lives in New Orleans today.

Although no authoritative history of his life has been written, it is popularly believed that St. Roch was born in 1295 in Montpelier, France. When he was fifteen years old his parents died. He gave his inheritance to the poor and this devoutly religious young man set out for Rome in the guise of a panhandling pilgrim. In Tuscany during the Black Plague, he dedicated himself to treating the afflicted, "healing many with the sign of the cross," writes Roger Baudier. He continued his vocation for many years, caring for the sick in Cesena. It is believed that Rome was spared from the plague due to his prayers. Ultimately, he contracted the plague at Piacenza and hauled himself into a secluded forest to avoid spreading his sickness to other people. The story goes that there a dog car-

Vista of St. Roch Cemetery. Marble figure of healed girl lies at former site of wishing well. In the background is the St. Roch burial chapel, site of ex-voto shrine.

ried him food and a spring arose from a rock, enabling him to survive.

St. Roch then roamed for seven years and ultimately returned to France. But upon his homecoming nobody recognized him, including his uncle, who at the time was governor of Montpelier. St. Roch was then jailed in his native land, falsely accused of spying for the king of Majorca, who was at war with Aragon. After five years in prison, he sensed his own imminent death and called for a priest. The father arrived and saw a bright light around the imprisoned St. Roch. After his death, reported miracles were attributed to his sanctity. His governor uncle investigated and, through a birthmark, the uncle's mother identified the deceased prisoner as her grandson.

Centuries later, the legacy and prayer cult of St.

Roch was brought to New Orleans by another pilgrim, Reverend Peter Leonard Thevis. In 1867 Father Thevis arrived amid a ferocious yellow fever epidemic. During another outbreak the following year, Father Thevis remembered his homeland's recourse during plagues to St. Roch as one of the "Fourteen Holy Helpers." He and his parishioners prayed to St. Roch for protection from pestilence. It is reported not one member of his church died from the raging epidemic. Father Thevis would then fulfill a vow he made to build a chapel honoring St. Roch, which would also serve as a mortuary chapel. Basing it on the Campo Santo dei Tedeschi near St. Peter's in Rome, Father Thevis designed the Gothic Chapel and, with his parishioners, participated in the carpentry and brick-laying. Thevis is now entombed within the

chapel's marble floor which he himself laid.

The aisle of Father Thevis's marble floor leads to a hand-carved and painted wooden Gothic altar with a figure of Christ lying below the altar table. Within a niche in the middle of the reredos is a statue of the pilgrim St. Roch carrying a gourd-topped staff, accompanied by the dog who fed him in the wilderness. The saint's finger points to the mark on his leg that identified him following his imprisoned death. The small room off the sanctuary inspires profound homage from the faithful and also arouses endless curiosity from visitors. In the 1950s Catholic historian Roger Baudier wrote: "The visitor sees one of the strangest collections of objects he has probably ever laid eyes on, except if he has visited ancient European shrines: . . . a wide array of almost weirdly realistic objects." From the walls are suspended leg braces and crutches, false teeth, artificial limbs, hands and feet, heads and ears, even lungs, brains, livers, and eyes. Baudier explains that these objects known as "ex-votos" are intended to "testify to the cures attributed to prayers offered to St Roch," and that they indicate "the suffered affliction or disease in some part of the body or other had been cured, who came back and placed at his shrine a replica of the afflicted part of the body that had been healed . . ." The words "Merci" or "Thanks" are inscribed into marble tiles that pave the floor of this seemingly surrealistic room.

Aside from the Campo Santo's physical curiosities, this burial ground is distinguished by the intense human activity that occurs within its walled confines. St. Roch Cemetery has always regularly attracted legions of people suffering from every imaginable affliction, but three days on the calendar swell the ranks of visitors. St. Roch's feast day is popularly observed on August 16. All Saints' Day in Campo Santo is probably the most well-attended New Orleans "day of the dead" and most

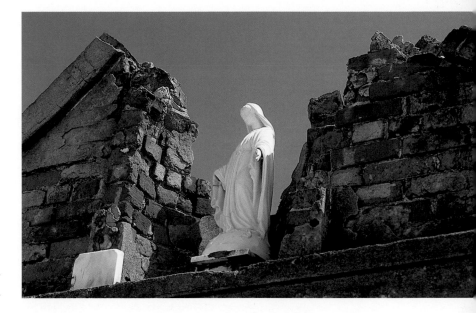

bedecked with flowers because a priest conducts a full mass in the middle of the cemetery prior to blessing the tombs. And on Good Friday numerous New Orleanians participate in an age-old tradition, a pilgrimage known as "making nine churches." Many people make a special wish as they visit nine churches throughout New Orleans on Good Friday, and throngs of the devoted conclude their journey at St. Roch's Campo Santo close to 3:00 P. M., which is believed to be the time of Christ's death. At the chapel, the priest commences a prayer service and then leads the people through the Way of the Cross, a meditative visit to the cemetery's fourteen open-air Stations of the Cross. Many then enter the chapel to light a candle and pray to St. Roch, and finally congregate around the crucifix in the center of the cemetery to show devotion.

Among unmarried girls, this novena culminating at the Campo Santo has developed into a New Orleans tradition: praying to St. Roch to help find a husband. Young men have also been known to use St. Roch to find a wife. Upon leaving the cemetery, the spouse-seekers are supposed to try to pick

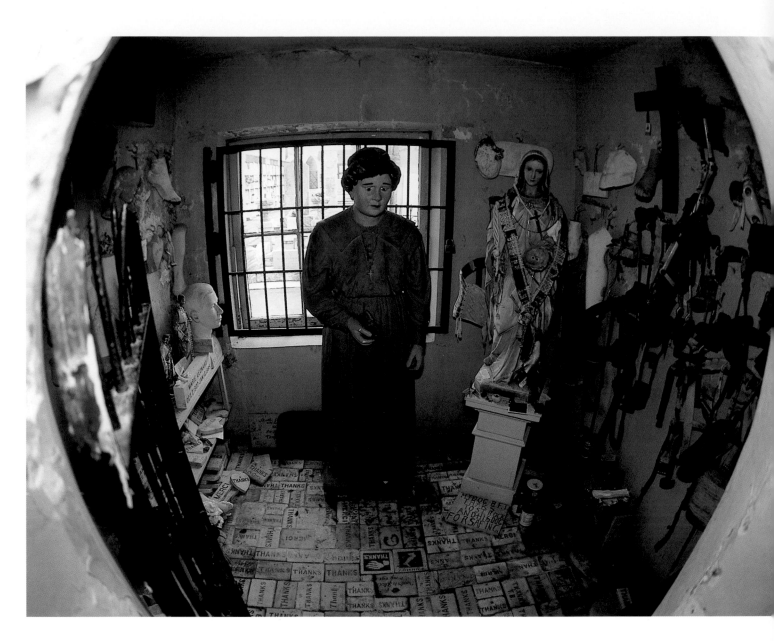

The Threshold of Healing

a four-leaf clover. One source reports that the church frowned upon this practice but that Father Thevis opined, "Why shouldn't they pray to God to direct them in the most important step of their lives?" In the past some young women included in this ritual placing "gravel or beans in their shoes as penance and to make their prayers more meritorious," writes Roger Baudier. It was also common for some of St. Roch's more penitentially spirited clients to arrive at the cemetery to pray in bare feet.

Aside from demonstrating Christian devotion, part of the reason why the Way of the Cross wish-seekers wind up around the central crucifix is that they believe it is a good spot to pray for the desire in question. This is because there was once a well at this location which supplied the Campo Santo with water, and it was formerly used as a wishing well. On this site today lies the marble infant statue. There was once a belief that the figure was not actually a statue but rather the petrified body of the first child entombed in Campo Santo. Visitors used to confuse the porous appearance of the marble from the statue's broken foot for petrified human flesh. However, the statue is in reality an ex-voto imported from Italy by a mother grateful to St. Roch for a healed baby.

During the 1930s reports of a ghost in St. Roch cemetery became widespread. Cemetery sexton Louis Haley claimed he saw the apparition of a girl who would leave her grave every night and sit on the tomb. Haley would approach the phantom but she would invariably disappear into the grave. The newspapers got hold of this story and thousands of people would gather at the cemetery walls at night in hopes of a sighting (similar to the phenomenon of the Josie Arlington tomb in Metairie Cemetery). However, the curtain came down on this sideshow on July 10, 1937, when the *New Orleans Tribune* reported "that the ghost-woman was only a peculiar shadow caused

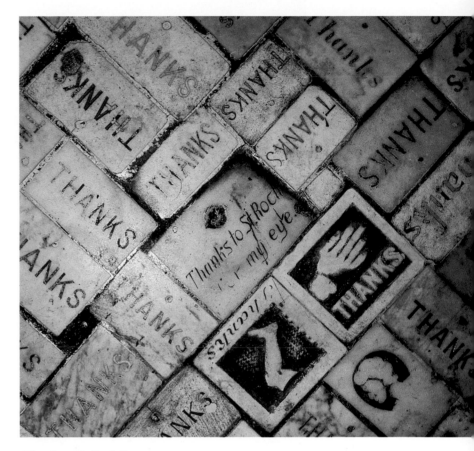

Thanks to St. Roch for my eye

by the combination of a white urn and two trees."

St. Roch Cemetery has indeed become a legendary place, a definite world unto itself. Its namesake may not be widely known outside New Orleans, but, then again, the joyous embrace of Catholicism familiar to New Orleans seems likewise nonexistent throughout the United States and even beyond. St. Roch's name has spilled immediately beyond the cemetery walls, as the adjoining street and park is named after St. Roch. Moreover, his name has transcended New Orleans through innumerable fascinated cemetery perusers. Although Campo Santo is not full of well-known names on its tombs' plaques, it is full of some of the most devout worshipers and enthralled cemetery visitors possible.

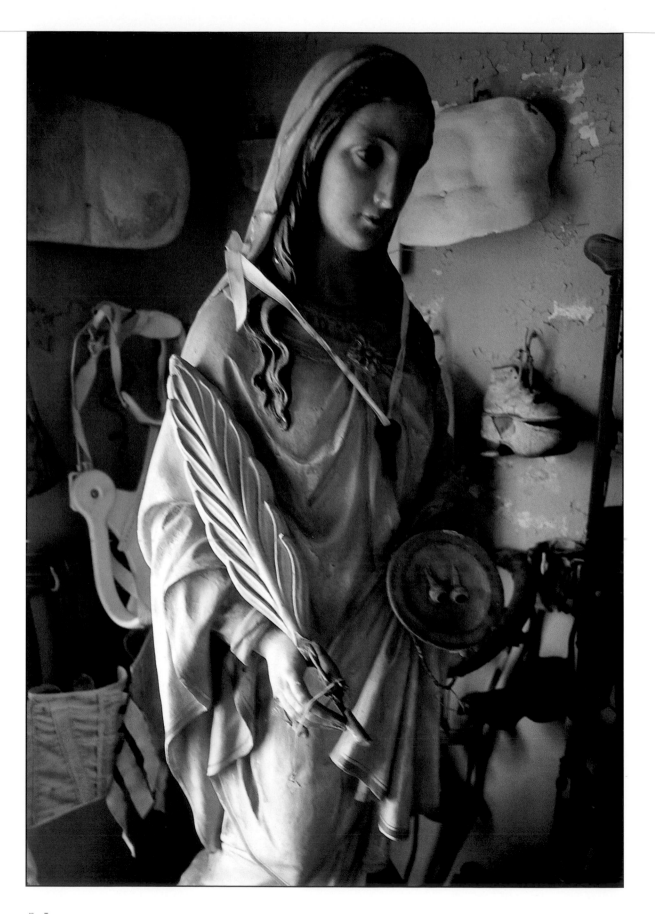

St. Lucy

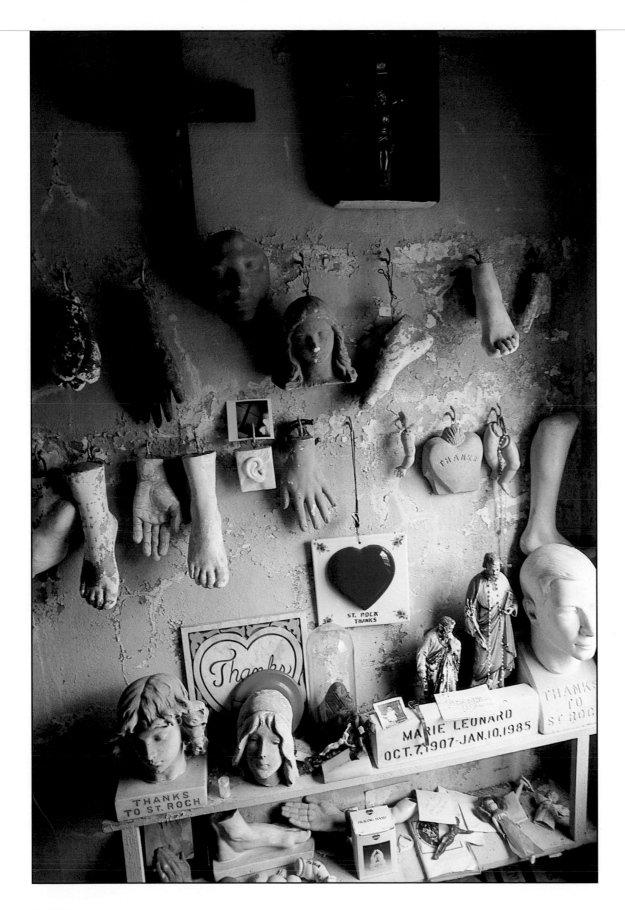

Ex-Votos

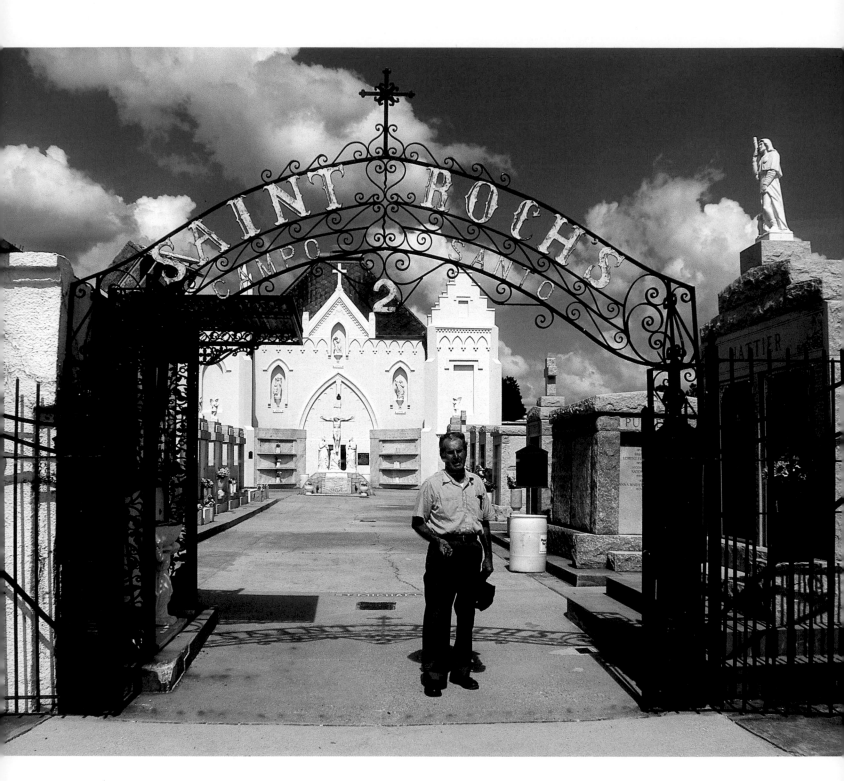

Albert Hattier, trowel in hand

13

Albert Hattier

IN THE NAME OF THE GRANDFATHER

"Y' see, St. Roch took care of us," says Mr. Albert, as the lock he just struggled with snapped into place on the gate of St. Roch Cemetery #2. "That's my boy. That's my buddy—St. Roch."

There are very few people in the world who could have possibly spent as much time in one cemetery as has Albert Hattier in St. Roch. At age sixty-seven, he can be found in the Campo Santo almost every day, living out a remarkable affinity for St. Roch the person, St. Roch the cemetery, and his own beloved family. This city of the dead is a place where he has found himself on practically each day of his life, starting way back.

When Albert was a small child, his family moved to St. Roch Avenue, right across from the cemetery. Because he loved the cemetery so much, Albert's grandfather, George Perrot, a fireman, began to cross the street to help the cemetery sexton, Louis Haley. "He didn't go on the payroll or anything. He came over here just to be here," explains his grandson, Albert. He loved and emulated his grandfather so much that young Albert

would literally follow him in his footsteps through the cemetery, cleaning up and maintaining tombs just for the love of it, like his grandfather did. After Louis Haley passed away, Grandpa Perrot retired from the New Orleans Fire Department and became the sexton of St. Roch Cemetery, living out everybody's ideal of a job: getting paid for something you would do with your free time. Albert cannot determine what attracted his grandfather more—the cemetery or its devoted visitors, but he can emphatically conclude that his grandfather loved them both enough to make the cemetery, after his family, the central part of his life. (In a sense the cemetery and his family are one and the same, as St. Roch is the site of the family tomb.) "And the people loved him too, because he was so nice to everybody. They always hollered to him, 'How you doin' Mr. George?' His good spirits made this cemetery a nice place to visit. And his spirit is still here," explains "Mr. Albert."

Walking through St. Roch today brings back memories of his childhood, such as playing base-

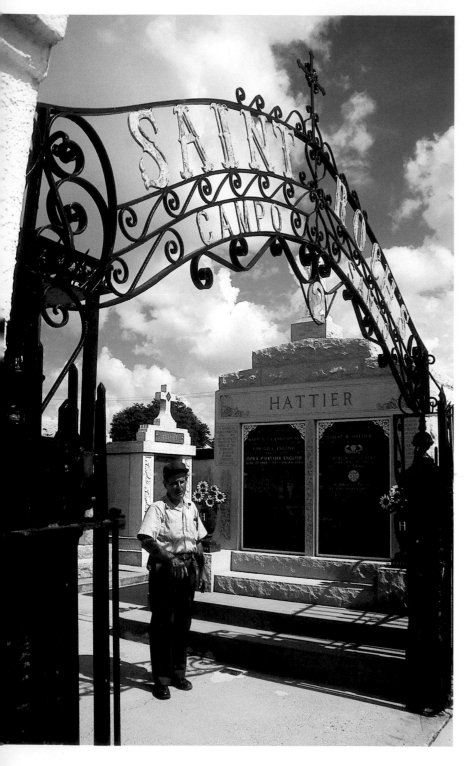

Under the name of "Hattier," Mr. Albert stands beside his family tomb, final resting place of his beloved grandfather, and ultimately himself.

ball and football in square 1 when square 2 still tapered into a cypress swamp. He recalls what he believed to be "hoodoo" practice, for after thoroughly cleaning up the cemetery in the afternoon, they would find strange objects and rotten food the next day. "Either they were jumping over the gate at night or throwing things over the wall," Mr. Albert remembers. "It was no big deal. I never found any sacrificed animals or anything. The biggest problem it ever caused me was almost slipping on a banana peel once." He also recollects the many ghost stories, particularly the one during the 1930s when nightly crowds would wait to catch a glimpse. Sexton Louis Haley substantiated claims of the apparition, which the *New Orleans Tribune* ultimately discredited. Looking back, Albert is not surprised. "You want to talk about a storyteller! That Louie Haley, man! . . ." he comments, then laughs.

But what Albert remembers most is the lifetime labor of love executed by his grandfather, a man he looked up to so much that he followed his exact course through life. Albert himself would join the New Orleans Fire Department, a dangerous calling which he believes his prayers to St. Roch pulled him through. As if it were predetermined, after Mr. Albert retired from the New Orleans Fire Department he too became the full-time sexton of St. Roch Cemetery, because, like his grandfather before him, he too already knew the job inside and out. "What's more," Albert explains, "he loved this cemetery, and I love it like he loved it." The large granite Hattier family tomb bears witness to their records of service. Inscribed to either side of the vaults are the words:

IN MEMORY OF GEORGE H. PERROT, SR.
1886–1953
FOR HIS DEVOTED SERVICE TO THE COMMUNITY
AS SEXTON OF ST. ROCH CEMETERIES
1941–1953

ALBERT W. HATTIER, JR.
GRANDSON OF GEORGE H. PERROT, SR.
A MAN WHO CARRIED OUT THE LEGACY OF HIS
GRANDFATHER
AS SEXTON OF ST. ROCH CEMETERIES
1955—1987

As if there were any question as to where Mr. Albert himself will be interred, the tomb's tablet already bears the inscription:

IN MEMORY OF ALBERT W. HATTIER
MARCH 13, 1929—

When asked if much change has occurred, one difference Hattier notes is that the cemetery used to be segregated, and he points out where the "black section" used to be in the back corner. When asked if racial demographics have changed the neighborhood that he has watched throughout his entire life, he says no. "I don't think the neighborhood has changed that much. It's changed some, but this was always a mixed place, so it's really nothing new for people if you think about it. We don't have much trouble. Whites and blacks get along fine." But he comes back to the cemetery, stressing, "It's really the feeling of the cemetery that hasn't changed. We always had good

white and black people. We never had too many bad black or white people. People all come here for the same thing, and that's to be nice, not to make trouble. I mean, we get a little vandalism, but we always did have that. Once in a while you got to run the kids out at night, but they're just being kids. That's always been the case. We don't have no real smart alecks. We're doin' pretty good, thank God."

If anybody ever wondered why St. Roch is so spotless, they need look no farther than Mr. Albert. He's constantly maintaining, as the metallic sound of his trowel scraping margins of pavement perpetually punctuates conversation with him. "You can't let it get ahead of you," he insists. As he finishes a final sweep of the cemetery to seek out stragglers while the staff prepares to lock the gate, cemetery workers—already overtime—are unable to locate him in the maze of aboveground tombs. They call out, "Mr. Albert!" Albert quietly says, "They're lookin' to go home," and he laughingly hollers, "All right, I'm comin'!" He then mentions, "Me, I could stay here all night."

As Mr. Albert locks the front gate to call it a day, a recently clear blue sky unleashes a torrential downpour in typical New Orleans fashion. "Good thing it didn't rain on us, or any of that work we just did," Mr. Albert muses, "Y'see, St. Roch took care."

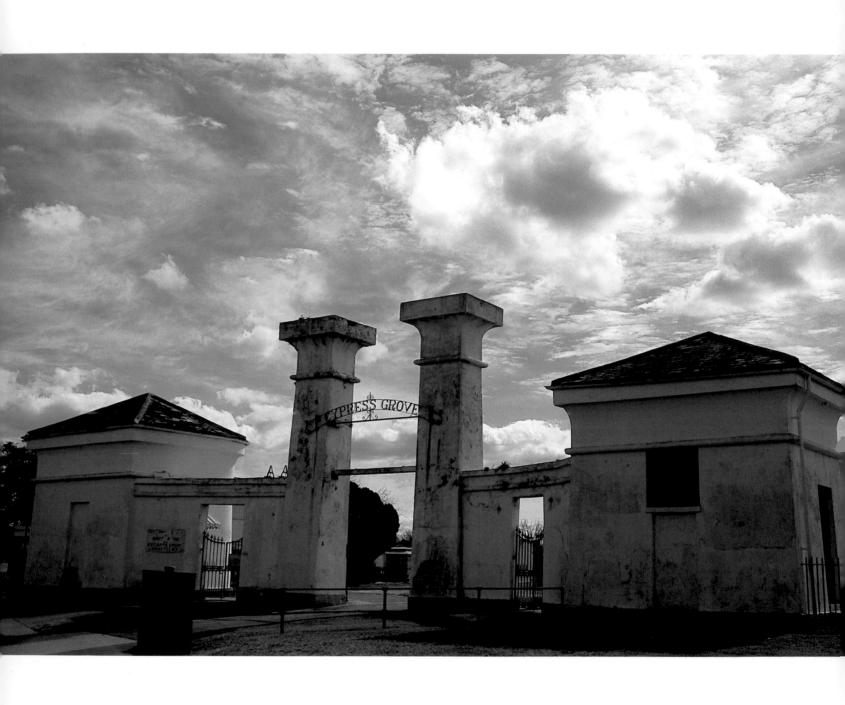

14

Cypress Grove Cemetery

ESTABLISHED: 1840
OWNER: FIREMAN'S CHARITABLE AND
BENEVOLENT ASSOCIATION

\mathcal{T}he word "grove" connotes a cluster of trees, implying an abundance of closely knit arboreal life that creates an environment of lush refuge. This verdant intermingling of foliage provides the life-sustaining supply of oxygen, the titillating call-and-response communication of birdsong, and the restorative power of shade. Cypress Grove Cemetery offers such an environment. The surprising lack of Louisiana's state tree, the cemetery's namesake bald cypress, is compensated for by scores of magnificent live oaks, magnolias, pecan trees, and cedars, creating a canopy far from funereal. This multilayer of emerging leaves spreads toward an infinite sky, leaving moribund thoughts of mortality far behind.

Fire, one of the most swiftly and suddenly striking forms of death, gave birth to this serene city of the dead. Founded in 1840 by the Fireman's Charitable and Benevolent Association, Cypress Grove has entombed and commemorated life-risking firefighters since its inception. This benevolent association grew out of New Orleans's first fire company, the Volunteer Company No. 1 (1829). An organized, functional fire company had been sorely needed in a city more than once profoundly decimated and redefined by the ravages of flame. The present appearance of the French Quarter was profoundly influenced by two fires (1788 and 1794), which virtually destroyed the entire original mostly wooden French colonial settlement during the Spanish period. The Spanish administration then drew up building codes that forbade building with burnable material. As a result, inhabitants of this stoneless Delta region would reside in dwellings of brick covered with plaster, an architectural signature of classic, old New Orleans.

Fires have therefore acted as milestones in New Orleans history, and New Orleans would not be able to grow and thrive until fire could be controlled. Shortly after the Louisiana Purchase, in 1807 a bucket ordinance was passed, requiring every resident to have at least two fire buckets in his home. At the same time, the city required the arrangement of a somewhat structured fire com-

pany. Then in 1829, on the brink of New Orleans's antebellum building boom, Volunteer Company No. 1 was organized, and in 1834 six volunteer fire companies formed the Fireman's Charitable and Benevolent Association.

This benevolent association not only devised a means of providing relief for the families of deceased members but it acted as a crucial watchdog over a city highly vulnerable to conflagration. For its first thirty-seven years, this fraternal organization independently administered the New Orleans fire department while perpetuating its own charitable activities. As the FCBA came to control fire, New Orleans grew in a way few American cities ever had. In 1838, well-to-do New Orleanian Stephen Henderson's will left the benevolent association property which they sold for cash, enabling them to buy the cemetery site at the far end of Canal Street on the former Bayou Metairie's banks. The city of the dead known as Cypress Grove was established in 1840 and now stands as a monument to those who have protected the city of New Orleans by combating fire.

Cypress Grove begins with a bang. Its imposing entrance pylons and lodges of Egyptian design frame the gate, an overall structure whose patina of age gives it an ancient feel. The title Cypress Grove is emblazoned across the top of the entrance, still partially spelled out in neon which no longer illuminates. Past the gate lies an array of extraordinary monuments. Beyond the gate to the right sits the **Irad Ferry** monument, the tomb of a Mississippi Fire Company No. 2 volunteer fire fighter who died in a blaze on Camp Street, New Year's Day, 1837. Ferry had an epic funeral and was interred in the now defunct Girod Street Cemetery but was moved to Cypress Grove after its 1840 opening. His tomb, featuring a broken column, was designed by the celebrated cemetery architect J.N.B. de Pouilly, who modeled it

after a tomb in the Parisian Père Lachaise Cemetery.

The year after Cypress Grove opened, the remains of fire fighters entombed elsewhere were moved to this Fireman's Charitable and Benevolent Association cemetery. Here they built many multi-vault society tombs for volunteer fire companies. The most stunning, Perseverance Fire Company No. 13, sits just past the cemetery gates. This monument is surmounted by a dome suspended by eight circularly arranged columns. There are also the Philadelphia Fire Engine Company No. 14's twin tombs, and the tomb of the Eagle Fire Company No. 7, which has interred the remains of **Reverend Theodore Clapp**. After the 1841 exodus of entombed firemen from other New Orleans burial grounds to Cypress Grove, Reverend Clapp delivered this cemetery's first eulogium.

The words of Theodore Clapp, a man who spent thirty-five years ministering to the dying and sick of New Orleans, are highly resonant. The prolific writings of this reverend who buried legions of infected dead during New Orleans's most devastating and nightmarish epidemics are some of the most vivid accounts of the diseases' horrors. They reveal much about the grim realities of nineteenth-century burial in the cities of the dead, and render Clapp a human link between epidemic and cemetery.

In *Autobiographical Sketches and Reflections During a Thirty-five Year Residence in New Orleans,* Clapp wrote of the Asiatic cholera epidemics in fall 1832 and summer 1833:

> On the evening of the 27th of October, it had made its way through every part of the city. During the ten succeeding days, reckoning from October 27 to the 6th of November, all the physicians judged that, at the lowest computation, there were five thousand deaths—an

J.N.B. de Pouilly designed the Irad Ferry monument, behind which can be seen the domed cupola of the Perseverance Fire Company No. 13 tomb.

average of five hundred every day. Many of whom died no account was rendered. A great number of bodies, with bricks and stones tied to their feet, were thrown into the river. Many were privately interred in gardens and enclosures, on the grounds where they expired, whose names were not recorded in the bills of mortality. Often I was kept in the burying ground for hours in succession, by the incessant, unintermitting arrival of corpses, over whom I was requested to perform a short service. One day I did not leave the cemetery till nine o'clock at night; the last interments were made by candlelight. . . .

. . . The morning after the death scene which I have just described, at six o'clock, I stepped into a carriage to accompany a funeral procession to a cemetery. On my arrival, I found at the graveyard a large pile of corpses without coffins, in horizontal layers, one above the other, like corded wood. I was told that there were more than one hundred bodies deposited there. (They had been brought by unknown persons, at different hours since nine o'clock the evening previous). . . Large trenches were dug, into which these uncoffined corpses were thrown indiscriminately.

(Clapp does not specify which burial ground this scene describes.)

Of the momentous 1853 yellow fever epidemic, the most devastating in New Orleans history, during which more than 10 percent of the city died within two months, Clapp recorded haunting impressions: "The horrors and desolations of this epidemic cannot be painted; neither can they be realized, except by those who have lived in New Orleans, and have witnessed and participated in similar scenes. Words can convey no adequate idea of them . . ." Having said that, his

words actually do a pretty good job. The reverend writes:

The physiognomy of the yellow fever corpse is usually sad, sullen, and perturbed; the countenance dark, mottled, livid, swollen, and stained with blood and black vomit; the veins of the face and the whole body become distended, and look as if they were going to burst; and though the heart has ceased to beat, the circulation of the blood sometimes continues for hours, quite as active as in life. Think, reader, what it must be to have one's mind wholly occupied with such sights and scenes for weeks together; nay, more—for months, for years, for a whole lifetime even. Scarcely a night passes now, in which my dreams are not haunted more

Detail of grotesques on the cast-iron Leeds tomb

or less by the distorted faces, the shrieks, the convulsions, the groans, the struggles, and the horrors which I witnessed thirty-five years ago. They come up before my mind's eye like positive, absolute realities. I awake, rejoicing indeed to find that it is a dream; but there is no more sleep for me that night…

These scenes were common to most New Orleans burial grounds, and the reverend's graphic language adds a chilling dimension to the old cities of the dead. It is somehow ironic that the recorder of all this horror now lies peacefully in one of New Orleans's most beautiful natural settings, a setting suited by its stunning burial facilities.

Just beyond Cypress Grove's signature Perseverance Fire Company No. 13 tomb sits the grave of former New Orleans mayor **Charles L. Leeds**, a structure that Mary Louise Christovich described as "unusual for its classic simplicity and perfection of workmanship." All elements and enclosures on the Leeds tomb are of cast iron, including the marvelous downspout grotesques. This should not be surprising because Leeds owned one of the region's largest iron foundries. Another curious grave sits to the right beyond the Leeds tomb, the **Soon On Tong Association** monument, a society tomb established in 1904 for Chinese New Orleanians. Emblazoned above its entry is Chinese and English lettering bearing the

Soon On Tong Association tomb, constructed at the turn of the twentieth century. As Leonard Huber writes, "Local Chinese buried their dead here with ceremonies that included burning prayers (on paper) in a small fireplace at the rear of the corridor and bringing food and drink to the burial rite. The remains were eventually removed and sent to China, a custom that no longer prevails."

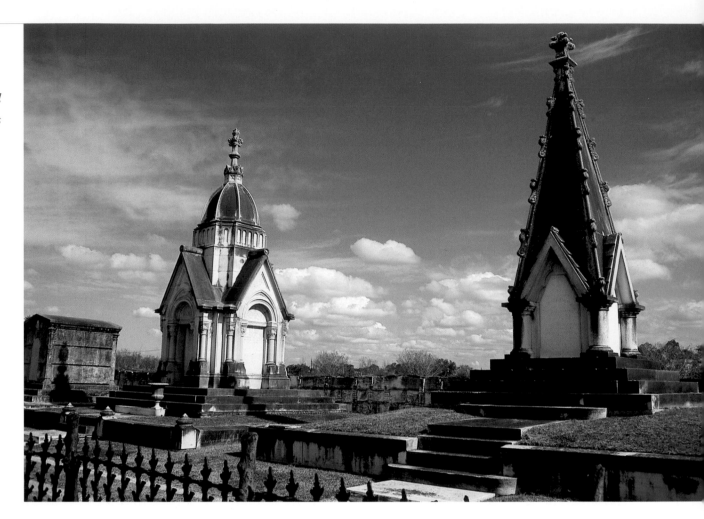

The Slark and Letchford tombs

association's name, and within the gate can be seen a little fireplace at the corridor's far end. Here mourners would burn prayers on paper and leave food and drink offerings during the burial service. After a year and a day had terminated, the remains could be removed and sent to China.

Two of the most arresting tombs in the city are situated side by side, the **Robert Slark** and **W. H. Letchford** monuments. These memorials more closely resemble small churches than graves. Speaking of churches, not only is the morbidly eloquent Reverend Theodore Clapp entombed in the Perseverance Fire Company No. 13 Tomb but another leading Presbyterian minister is as well, **Reverend Sylvester Larned**. Like one of Cypress Grove's earliest inhabitants, Irad Ferry, Reverend

Larned was moved from the Protestant Girod Street Cemetery to this final resting place of firemen. Two strong bearers of aesthetic pursuit coupled with capitalistic achievement are also herein entombed: **Maunsel White**, a Battle of New Orleans veteran who created the delectable Maunsel White Peppersauce, becoming an early mover in one of Louisiana's most well-known industries. Lafcadio Hearn described White as "immortalized among epicures." He now rests in a well-composed marble J.N.B. de Pouilly tomb. And then there is British-born **James Caldwell** (1793–1863), the New Orleans Gas Light Company's founder and the First American Theater Company's builder. Caldwell constructed the first English-speaking theater in New Orleans,

The St. Charles, which was then the finest theatrical facility in America with its five tiers, 4,100 seats, and a bejeweled two-ton chandelier. Never accused of lacking self-confidence, Caldwell would produce, direct, write, and star in his theater's productions.

From theatrical impresario, James Caldwell would become one of the most consequential entrepreneurs of an era in which New Orleans developed at a staggering pace. His energies went into organizing the St. Charles Hotel, the New Basin Canal, and the New Orleans Water Works. He created his own railroad line, the New Orleans and Nashville Railroad Company, founded his own bank, and established the first steamship service from New Orleans to Liverpool. Caldwell

served as city council member, mayor, and state legislator. Some of his seemingly boundless energy went into his three leading lady wives (his second wife was twenty-three years younger than he, and he was ten years older than his third wife's mother). He died in 1863, stranded by the Civil War in New York City, but was returned to New Orleans for a Cypress Grove burial.

Cypress Grove's lush serenity and transcendent otherworldliness make this city of the dead feel more like a place for picnics than for mourning. Although walled in, it does not feel confined and claustrophobic, like other nineteenth-century New Orleans cemeteries. Its tombs are woven through a rambling grove of healthy majestic trees, creating an atmosphere of limitless repose.

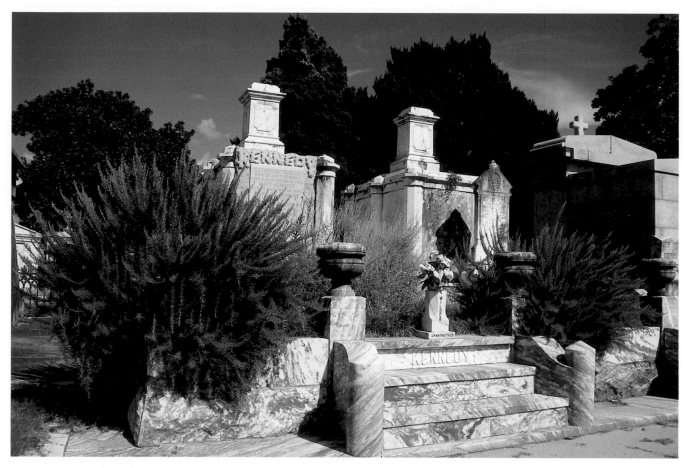

In a city renowned for culinary delight, this city of the dead hosts a coping framed by two strong stands of the Mediterranean herb rosemary.

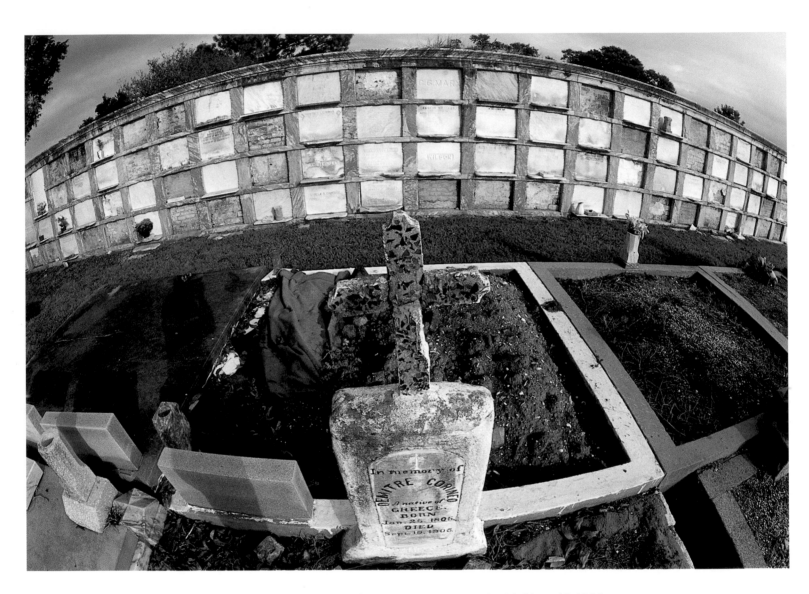

In memory of Demitre Corineo. A native of Greece, Born Jan. 25, 1805, Died Sept. 19, 1905.

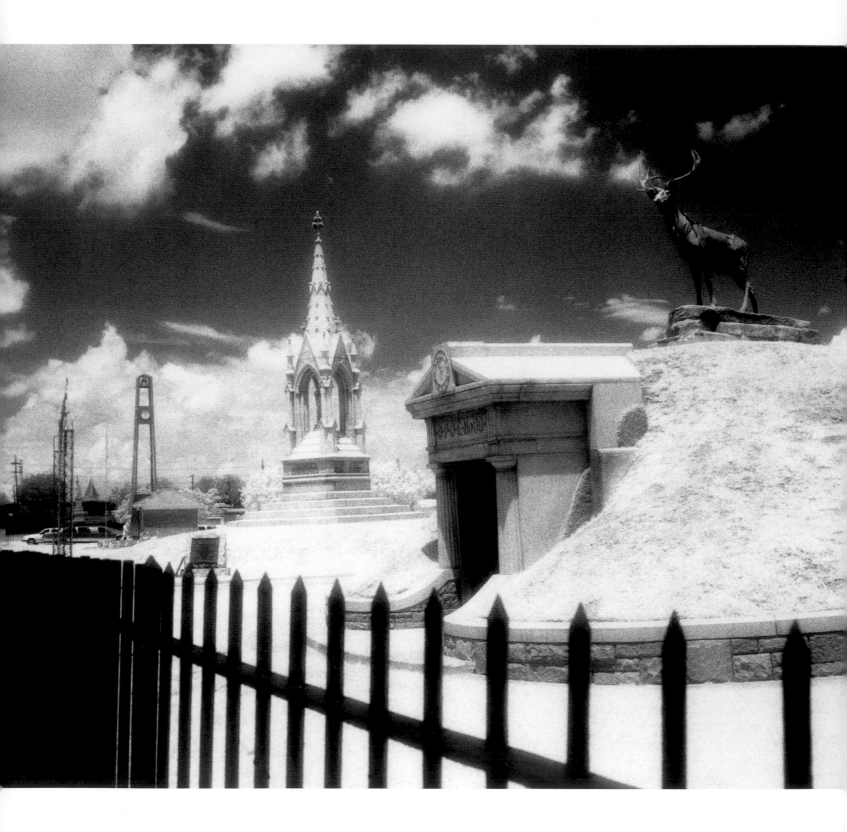

15

❧❧

Greenwood Cemetery

ESTABLISHED: 1852
OWNER: FIREMAN'S CHARITABLE AND
BENEVOLENT ASSOCIATION

*G*reenwood Cemetery is massive and sprawling. Established in 1852 by the Fireman's Charitable and Benevolent Association, it is in a sense an extension of Cypress Grove, whose yellow fever–induced crowding caused this benevolent association to expand its burial environs across the street. Greenwood, however, is in many ways a break from Cypress Grove and all prior New Orleans cemeteries because it was the first aboveground cemetery not to be walled in. It is consequently not visibly concealed from outside the graveyard. Long before entering it, this burial ground makes a statement to the keen peruser as well as to thousands of casual passersby each day.

Greenwood Cemetery is situated at the end of Canal Street. The destination markers on the New Orleans Regional Transit Authority's buses label this area "Cemeteries." Here is where Metairie, Cypress Grove, Charity Hospital, St. Patrick #3, Chevra Thilim, Gates of Prayer #1, St. John/Hope Mausoleum, Dispersed of Judah, St. Patrick #2, Chevra Thilim Memorial Park, Masonic, Holt, St.

Patrick #1, and Greenwood lay side by side. This is the destination which Blanche DuBois refers to at the beginning of Tennessee Williams's *A Streetcar Named Desire* when exclaiming, "They told me to take a street-car named Desire, and then transfer to one called Cemeteries . . ." Streetcar service to this stop is soon to resume.

Under a bank of traffic lights at the nexus of Canal Street and City Park Avenue, Greenwood faces one of the metropolitan area's most heavily traveled arteries. Here countless incidental rush hour and workaday drivers ceaselessly stream by this conspicuously visible city of the dead. Poised literally above and beyond these municipal streets is the Pontchartrain Expressway, the main byway which brings traffic into New Orleans from I–10 East and West, funneling hundreds of cars a minute in and out of the Crescent City. The one hundred fifty-acre Greenwood Cemetery demands attention from the passengers of these passing vehicles. Although what many consider to be the most dazzling burial ground in the United

States—Metairie Cemetery—is situated directly across the expressway, this glamorous neighbor of Greenwood is shrouded by trees. Since Metairie's vastness and staggering monuments are largely concealed from Pontchartrain Expressway passengers, Greenwood Cemetery's endless sprawl is more visually arresting to the passing driver.

Without enclosed wall vaults, the facade of Greenwood makes a statement with a row of notably imposing and finely constructed monuments. Appropriately, the center piece of this Fireman's Charitable and Benevolent Association cemetery's front row is the Fireman's

The Fireman's Charitable Association tomb

Monument. Honoring the fiftieth anniversary of the benevolent association, this forty-six-foot tall granite structure was designed by Charles Orleans, who probably modeled it after the Sir Walter Scott memorial in Edinburgh, Scotland. Under a crowning steeple and clustered Gothic arches stands a fire fighter of piercingly alert posture, bearing his hose with a far-off gaze, scanning the horizon of an historically fire-ravaged city. This lifelike statue was executed by New York sculptor Alexander Doyle and carved by Nicoli. The monument honors volunteer firemen who perished in the line of duty, its base bearing the names of twenty-three volunteer fire companies. On March 4, Volunteer Fireman's Day is commemorated annually by members of the Fireman's Charitable and Benevolent Society who lay a wreath at the monument. Prior to the organization of a professional New Orleans fire department in 1891, March 4 was a civic holiday during which the volunteer firemen paraded through the city streets, another in a long list of historical reasons to parade in New Orleans.

Adjacent to the Fireman's monument is an equally striking structure, the tomb of the Benevolent Protective Order of Elks Lodge #30. The Elks were founded in 1868 by professional theater people. Atop the grassy mounded tumulus stands a stunning bronze statue of an elk, symbolic of the order's fraternity. Under the elk, inside the mound, there lies a marble chamber containing eighteen burial vaults. Its Doric style entrance to the burial chamber is sealed with bronze doors, and the entablature is supported by two fluted columns. Symbolic of the Elks customary 11:00 Toast, a clock set at that hour is affixed to the pediment. In *Clasped Hands: Symbolism in New Orleans Cemeteries,* Leonard Huber explains: "Members of this organization originally met at night and when the business of the meeting was

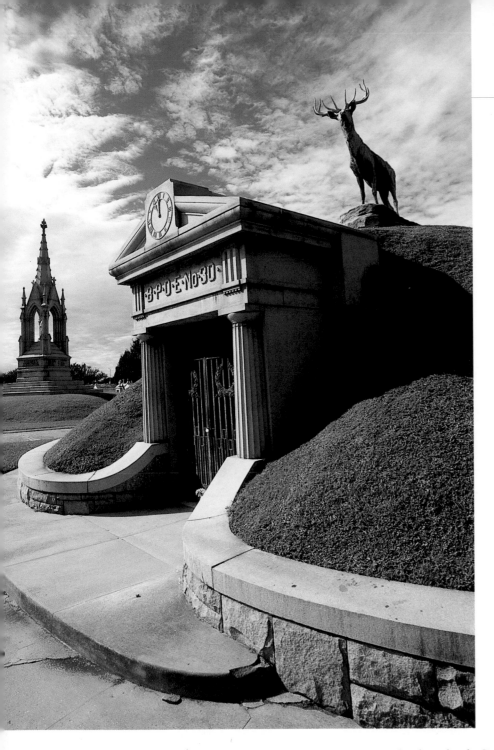

The Benevolent Protective Order of Elks society tomb atop a tumulus. This fraternal organization, founded by members of the theatrical profession in 1868, is symbolized by the figure of an elk and a clock with its hands at the eleventh hour. As Leonard Huber explains, "Members of this organization met at night and when the business of the meeting was over, it became a custom to pause for a moment and recite the Eleven O'Clock Toast 'To our absent brother.' The toast is now part of the ritual of the organization."

over, it became a custom to pause for a moment and recite the Eleven O'Clock Toast 'To our absent brother.' The toast is now part of the ritual of the organization." Built upon unstable ground and a mislaid foundation, this lofty monument is slightly tilted.

Flanking this front row of memorials, toward the Interstate side, is the first Civil War memorial erected in New Orleans. The Confederate monument's low mound serves as a mass grave for six hundred Confederate soldiers. Atop the marble statue's pedestal an anonymous infantryman leans on his rifle, while below him sit carved busts of Confederate generals Robert E. Lee, Stonewall Jackson, Albert Sidney Johnson, and Leonidas Polk. Adjoining the Elks monument are two tombs of past Fireman's Charitable and Benevolent Association president's tombs—**Michael J. McKay** and former New Orleans mayor **John Fitzpatrick**. Off the far end of the front

First Civil War memorial in New Orleans, the Confederate monument designed by Achille Perelli. Atop busts of the four generals, Stonewall Jackson, Robert E. Lee, Leonidas Polk, and Albert Sidney Johnson, an anonymous infantry soldier leans against his rifle.

toward City Park also facing Canal Street sits the white marble Police Mutual Benevolent Association tomb, and the pediment bears an inscribed policeman's cap and badge.

Greenwood entombs the remains of two New Orleans mayors who presided over trying and contentious times. Mayor John Fitzpatrick served during an era when the social unrest of Reconstruction had dissipated and Jim Crow laws became codified. Close by, an urn sits atop a fluted column surmounting the Jacques de Pouilly–designed grave of Mayor **Abial Daily Crossman**, who served from 1846 to 1854, and presided over the city's most devastating and harrowing yellow fever epidemics.

Other notable graves in Greenwood include the

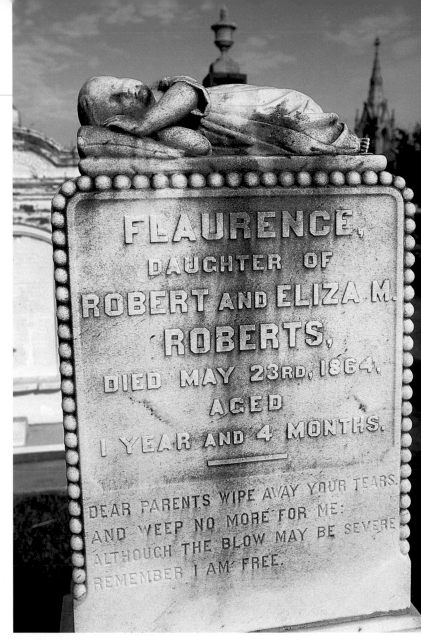

FLAURENCE, DAUGHTER OF ROBERT AND ELIZA M. ROBERTS, DIED MAY 23RD, 1864. AGED I YEAR AND 4 MONTHS.

DEAR PARENTS WIPE AWAY YOUR TEARS AND WEEP NO MORE FOR ME: ALTHOUGH THE BLOW MAY BE SEVERE REMEMBER I AM FREE.

Family tomb swallowed up by blooming vine

Swiss Society Tomb and the New Orleans Typographical Union, which in 1855 was the first labor union established in the New Orleans region. Interred here is educator **Warren Easton**, for whom the New Orleans high school on Canal Street is named. There are a few magnificent cast-iron tombs, such as that of the **Isaac Newton Marks** family, enclosed within a Gothic-style fence. Fascinating Gothic design is found in the double tomb of **A. T.** and **W. O. Thompson**, which suffered severe hurricane damage and was subsequently rebuilt. But perhaps the most curious grave in terms of structure is the **Mahon** family memorial with the various iron crosses, poised like antennae picking up frequencies from some other galaxy.

Today Greenwood stands out because it is so sprawling with its more than twenty thousand lots and because it stays so busy. This city of the dead experiences an average one thousand burials per year, which ensures consistent visitation and diligent maintenance.

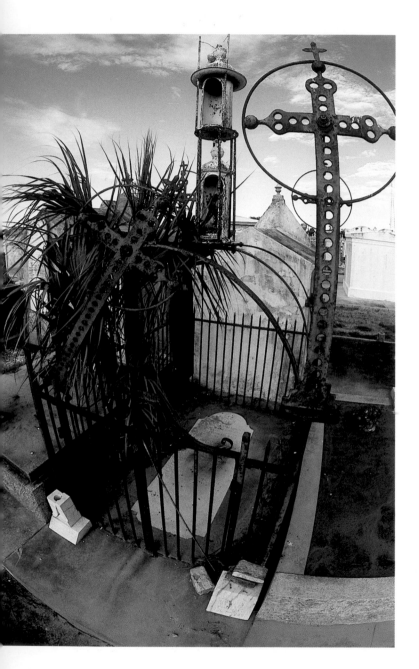

Mahon family memorial

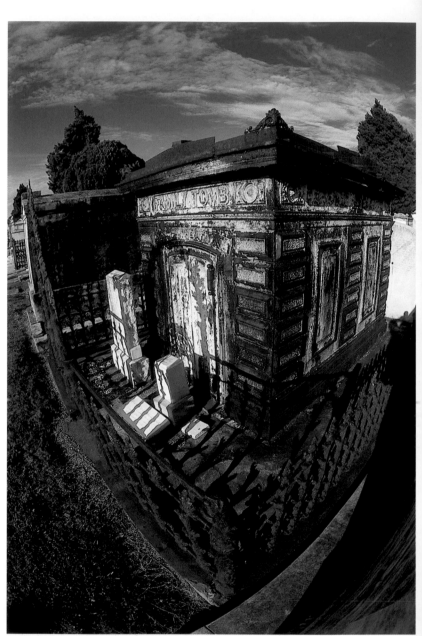

Cast-iron tomb

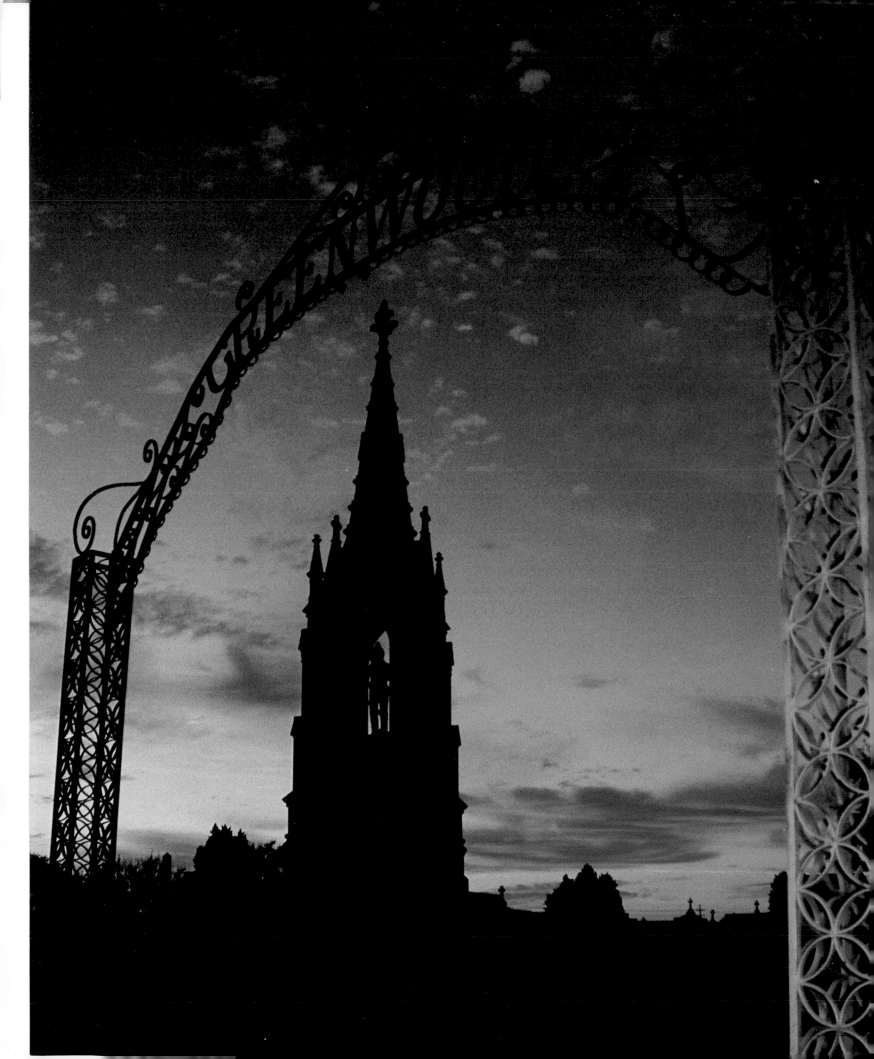

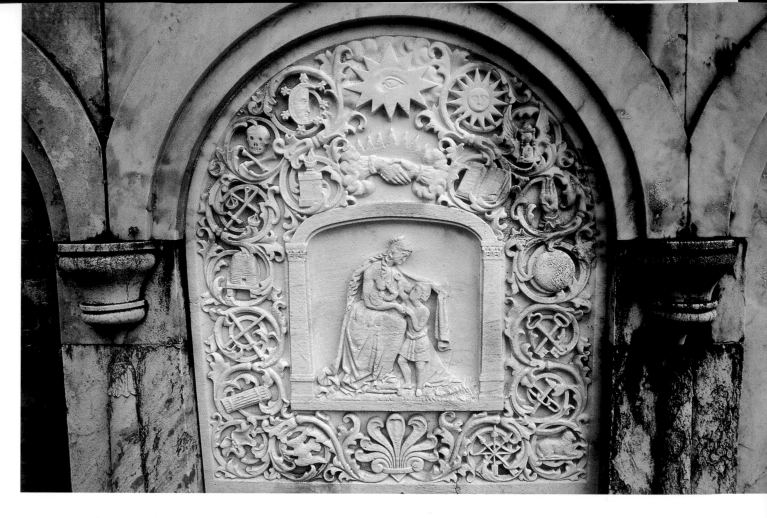

Center panel carving on Southwestern Lodge No. 40 society tomb. Many I.O.O.F. symbols are pictured here. The German words Freundschaft und Warheit (Friendship and Truth) indicate that this was originally the Teutonia Lodge No. 10 society tomb.

fitted up in a very appropriate manner, covered with emblems of mourning.

Introducing the circus into the realm of the funeral and cemetery is about as "New Orleans" as it gets. Drawn by six fine horses, this funereal vehicle carried Odd Fellows Rest's first interments, the cremated remains of sixteen I.O.O.F. members collected from other cities of the dead.

This petit cemetery forms a triangle, which causes a geometrical phenomenon similar to an occurrence throughout many of the irregularly laid New Orleans streets thrown askew by the enveloping Mississippi River: the cemetery paths cut burial plots of land that are not square or rectangular but more triangular, if not trapezoidal or some other strange shape. This triangular ceme-

tery is walled on two sides, with high wall vaults framing two magnificent iron gates. This tall, seemingly insurmountable boundary, shrouded by oaks that cloak the burial ground in an air of mystery, creates a curious sense of vertical depth to the enclosed cemetery. The side gate, although vandalized, teems with beguiling detail: the Odd Fellows signature symbols, the "all-seeing eye of Deity," five-pointed stars, the Bible, the widow and her children, the beehive, the world, the cornucopia, and the initials I.O. of O. F., are minutely cast in iron as is the order's trademark symbol, three interlocking rings engraved into the marble above.

Perhaps the most curious factor upon approaching Odd Fellows Rest is a health food store, which sits on the same lot. Pure and Simple Foods abuts this historic burial ground and even

shares a driveway. Many find this curious or ironic. But Margaret, the owner, has no problem with running a health food store by (if not in) a cemetery. "It's actually good advertising," she claims as she prepares a customer's vegetarian lunch. "If someone looks at a cemetery while they're food shopping, they often realize that they should work on improving their diets." Sandwiched between St. Patrick Cemetery and Odd Fellows Rest, this store is actually amid a sea of cemeteries. When conducting programs about New Orleans cemeteries, Ranger Roger Green of Jean Lafitte National Park describes this location by saying, "Cemetery, cemetery, cemetery, … health food store, … cemetery, cemetery, cemetery …" in his inimitable deliv-

ery of wry deadpan humor. This always gets a laugh.

An odd transition is made from the health food store to the burial ground: inside the graveyard grow a healthy orange, grapefruit, and peach tree, which do bear fruit. Margaret, the planter of the fruit trees, has been asked whether her organic fruit stand is supplied by these trees seemingly fertilized by some very familiar bone meal. She replies, "No. There's not much that will make things grow well out there. I doubt the human bones make any difference. That's virgin soil. Why, during the first four years after I planted those trees, they bore no fruit at all. The only fertilizer we had any luck at all with was manure from my friend's race horse, Risen Star, the famous thor-

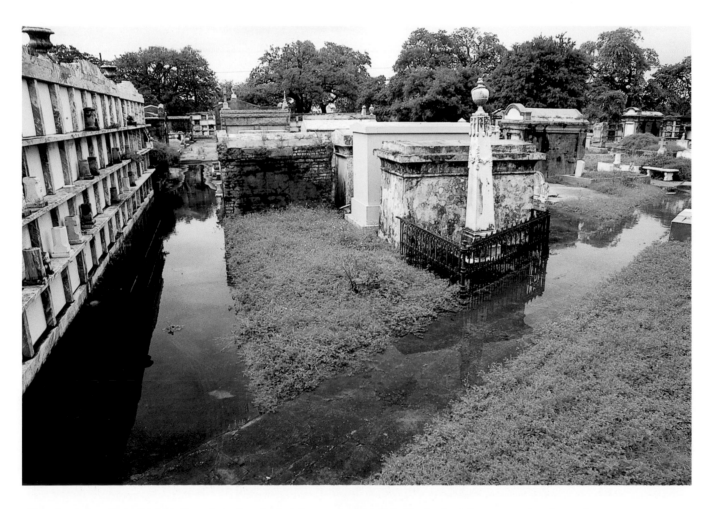

The triangular-shaped Odd Fellows Rest drenched with water on May 9, 1995, the day after a storm that dropped eighteen inches of rain in six hours.

Detail, gryphon on Fairchild tomb

Bas-relief of John Howard, founder of the Howard Society, which provided aid to indigent yellow fever victims

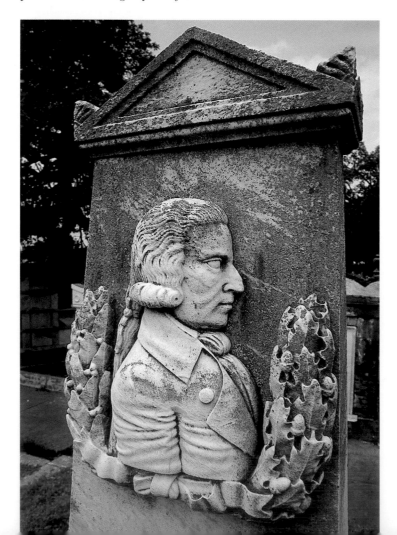

oughbred. But the horse died and it seems that Risen Star's mess has worn out under those cemetery fruit trees." Margaret also complains that she rarely gets to eat the fruit because some idiots always pick it before it ripens.

Some of Odd Fellows Rest's most interesting monuments include the large centrally located **Southwestern Lodge No. 40** society tomb. Probably built initially as the Teutonia Lodge No. 10, about 1851, this grave bears a dazzling marble plaque on its side inscribed with a montage of some of the Odd Fellows signature images, featuring the words "Freundschaft, Liebe und Warheit," German for Friendship, Love and Truth. Not far from this is the **Howard Association Memorial**, a group that provided assistance to indigent yellow fever epidemic victims. This group was extremely active during the 1853 epidemic. The grave's facade is graced by a bas-relief sculpted of the organization's founder, British social reformer and philanthropist **John Howard** (1726–1790). The bas-relief is an art form not commonly seen in New Orleans cemeteries. The Howard Association disbanded when the battle against yellow fever ended in the early twentieth century. There are two fabulous cast-iron tombs, one of the **Fairchild** family. But how ever much precious detail still clings to the ancient-looking structures, it is apparent that doors and other irreplaceable features have been pillaged.

What may be most impressive, and hence immortal, about this cemetery is neither the tombs nor their occupants but some of the inscriptions on wall vault enclosure tablets. Although it is obvious that only a fraction of the original plaques remain or are even legible, Odd Fellows Rest is unquestionably the most verbally expressive city of the dead. Emblazoned across tablets of marble and granite are poetic inscriptions, inspiring as they are heartbreaking:

Weep not for me, I am not dead
I am only sleeping here.

Remember friends, as you pass by
As you are now so once was I
As I am now so you must be,
Prepare for death and follow me.

I leave the world without a tear,
Save for the friends I hold so dear
To heal their sorrows, Lord, descend
And to the friendless prove a friend.

In the midst of life we are in death.

Beyond this vale of tears
There is world of bliss.

Grieve not for me oh parents dear,
I am not dead but sleeping here
I was not yours but Christ's alone
He loved me best and took me home.

Sleep mother sleep, thy rest is sweet
For in heaven we shall meet.

Farewell husband, my life is past
My love was yours while life did last
Now after me no sorrow take
But love my children for my sake.

A loving husband's heart and hopes
Be buried in this dark, cold tomb

Ere sin could blight or sorrow fade
Death came with friendly care
The opening bud to heaven conveyed
And bade it blossom there.

He came to us in Beauty bright
His lovely eyes now veiled in night
Whence beamed the rays of hope and joy,
Are dimmed and gone. Death claimed our boy.

We deeply mourn the loss dear son
Thou we know thou art blest
As an angel pure and undefiled
In Heaven now art thou at rest
Dear father and mother mourn not for me
for I am now in the land of the blest
My spirit is yet ever present with thee
Though my form is now laid in the
Odd Fellows Rest.

In 1963 Odd Fellows Rest was almost demolished. By the early 1960s, the population of the greater New Orleans area was beginning to seriously expand toward the Lakefront and west into Jefferson Parish, and commuters began to choke the intersection of Canal Street and City Park Avenue leading to Canal Boulevard. The City Planning Commission determined that they could eliminate this traffic snarl by eliminating Odd Fellows Rest Cemetery and New Orleans made the Odd Fellows a financial offer to "move" their cemetery. The Grand Lodge and civic authorities could not reach an agreement and today the cemetery stands where it has since 1849. Odd Fellows Rest Cemetery has since secured national historic status.

Although Odd Fellows Rest managed to stave off that past crisis, this city of the dead presently seems vulnerable. There is still some burial taking place here, but with no Odd Fellows lodge currently in New Orleans, this cemetery appears neglected and the ravages of recent vandalism are evident. Most old New Orleans cemeteries are captivating in their own specific ways and all of them have been victimized by vandals to some degree. But the rate at which the inherent beauty and wonder of Odd Fellows Rest diminishes is alarming. Hopefully, this city of the dead will revive; it is by no means out of the question.

Oranges ripen above a tomb in Odd Fellows Rest

Encircled by a wreath, a crucifix is suspended between clasped hands upon an onyx inscription slab on the Odd Fellows Rest wall vault.

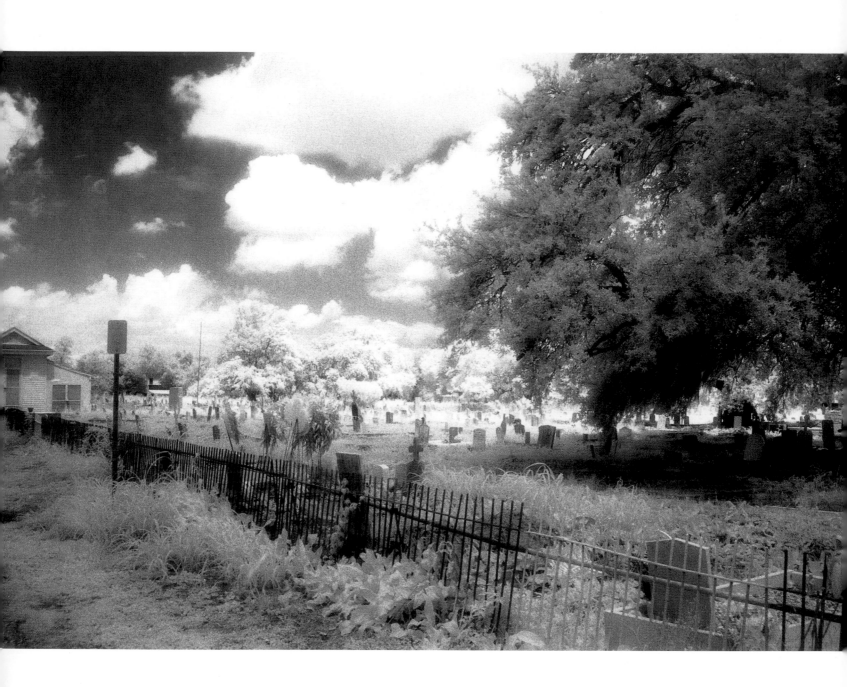

17

Holt Cemetery

ESTABLISHED: 1879
OWNER: THE CITY OF NEW ORLEANS

Most New Orleans cemeteries make a strong visual statement from the outside. They display imaginative ornate iron gates framed by nine-foot wall vaults covered with whitewash peeling over plaster chipping away above brick, over which are glimpsed the tops of staggeringly dramatic society tombs and their surreal yet lifelike statuary. One of New Orleans's most curious and enticing cities of the dead, Holt Cemetery makes no such statement from afar. Hidden away beyond Delgado Community College's crowded parking lot and a police training academy, its entrance obscured behind a chain-link fence, this cemetery rather demurely keeps to itself. Upon first entering "the Holt," a visitor making a casual survey may not detect much of interest. There are no rows of monuments that jump out, because Holt interment is in-ground and most of its memorials are homemade and humble. But upon closer inspection, basking under the sway of hypnotic Spanish moss dangling from ancient live oaks, a wondrous world of enthralling and playful labors of love clearly reveals itself.

Holt Cemetery grew out of the now defunct Locust Grove cemeteries No. 1 and No. 2, established by the city in 1859 and 1876 respectively on Freret Street between Sixth and Seventh streets for burial of indigent dead. In 1879 a municipal body with the exhausting name of the "Committee of the Council of the Locust Grove Cemetery" closed the graveyard. Its land was ultimately used for a playground and the Thomy Lafon School. The committee acquired land for a new cemetery at the southeast corner of City Park Avenue. At that time this area was remote and sat on the naturally occurring high ground of Metairie Ridge. This region was also desirable in an age of rampant infectious disease, when people still believed that yellow fever and malaria were spread by transporting caskets containing infected corpses through populated areas. Leonard Huber explains in *New Orleans Architecture: The Cemeteries* that the Holt Cemetery location was then considered "superior to the old cemeteries in that the bodies of the indigent dead were not brought through the heart of the city but could be carried through the extreme

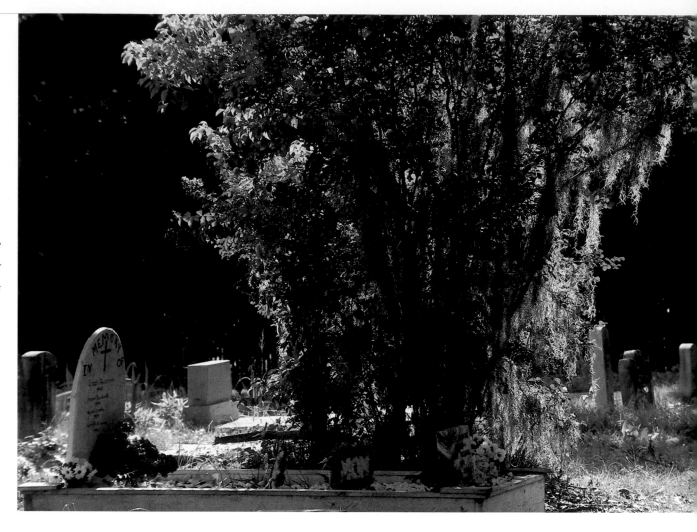

The rising sun illuminates crepe myrtle blossoms dancing with Spanish moss

upper and lower portions of the city by means of the shell roads." This cemetery, established in its location due to a public health concern, was named for a New Orleans board of health member, Dr. Joseph Holt.

Unlike many New Orleans cemeteries, none of the Holt's allure is found in expensive memorials but rather in the improvised and highly personal quality of the gravesites. What is so appealing is the very impermanence and consequent kaleidoscopic quality of ever-changing artwork in this extremely busy burial ground. Engendered here is a peaceful curiosity, a feeling of transcendence. Like its counterparts throughout the city, Holt Cemetery is also a place where one can truly leave the world behind for awhile.

A most expressive, eloquent characterization of Holt Cemetery appeared as a "Letter to the Editor" in *The Times Picayune*. Richard A. Caire wrote in response to another well-meaning missive that seemed to miss the point. The first letter to the editor regarding Holt complained that the cemetery was "deplorable, unkept (and), sickening" and asked whether the city had "obligations to its citizens to restore the serenity and beautification of these historical burial grounds . . ." Mr. Caire's response appeared in the paper shortly thereafter. It reads:

> I would like to add my comments to those already made in favor of maintaining the grace, peace, and beauty that is

Holt Cemetery exactly as it is.

Until one has walked this ground for more than a quick once through, it is difficult to appreciate the qualities of Holt Cemetery which are found at no other cemetery in this city. Grave sites at Holt are delineated with either headstones or markers made with varying degrees of individual craftsmanship, but each is created with great care and respect for the memory of the deceased.

There is no style sheet to be followed. This is a place which was once considered a "pauper's cemetery," and it is obvious that material riches are still not in abundant supply. But these are not reasons to "fix" it. Rather, they attest to the need to maintain and preserve its unique qualities.

Holt Cemetery is not a resting place for the rich and famous. It is not a paean to wealth and power. Its register is not dynastic. Holt has no imposing central edifice that takes the breath away.

What it has instead is simplicity, a sense of connectedness to a life beyond this life, a simple acceptance that death is only final when the deceased are lost to memory. At Holt very few remain unremembered.

This simple yet inescapable fact is most easily observed in the continually changing decorations at the grave sites. The mementos are changed at regular intervals to be appropriate for the age the deceased would have been in the present.

While there may be those who disagree with the use of the term "beauty" for a

Plots belonging to Arthur Raymond Smith. What may appear to be random mess is in reality a painstakingly arranged aesthetic and spiritually oriented design.

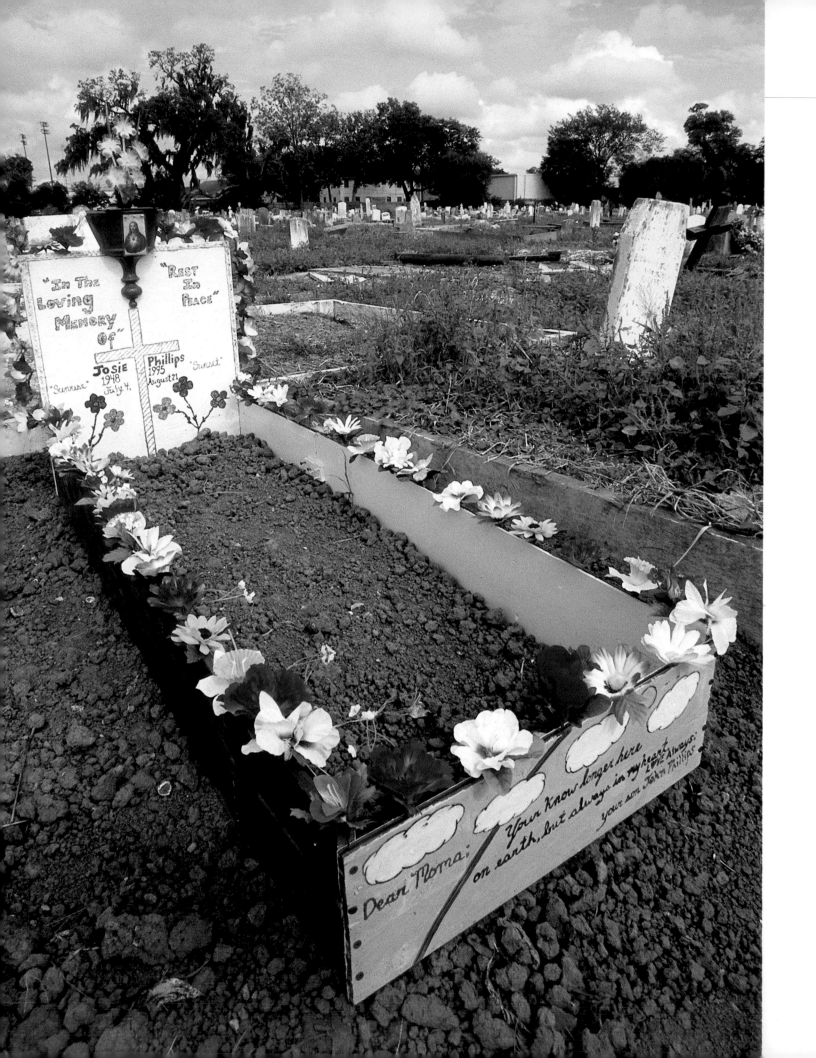

Easter Sunday, Holt Cemetery

Blessed Mother amidst a meadow

place as visually busy as Holt, those who disagree will never see it no matter what evidence is presented to the contrary. They will neither understand nor appreciate the ancient bearded oaks overlooking the goings-on with the patience born of age, the careful arranging of memorabilia, the annual visit to a particular grave by an unknown buddy remembering his friend by leaving a fresh beer at the headstone, the painting of the copings and markers in styles both simple and complex—the number of separate items is too long to list here.

It is for these reasons that I maintain that Holt Cemetery is possessed of a

sense of dignity that is added to, not subtracted from, by those who live on and remember.

Although Mr. Caire accurately states that "Holt Cemetery is not a resting place for the rich and famous," there is one person entombed here who died far from rich but who posthumously would achieve immeasurable fame: turn-of-the-century coronet player **Buddy Bolden**, whose ever-increasing influence continues to make itself known, moving and shaking people throughout the world. Although Bolden was never recorded, he is referred to by generations of New Orleans musi-

◄ *Grave of Josie Philips—the impermanent brilliance of Holt Cemetery*

cians as the man who "invented" jazz. In his book *In Search of Buddy Bolden, First Man of Jazz,* jazz historian Don Marquis writes:

Bolden's body lay in state at the Geddes-Moss Funeral Home for only a day, and according to the witnesses, there were very few at the wake … Few, if any, musicians came by; it is doubtful that many were aware of Buddy's death. There was no brass band to say farewell, nor even a former sideman to act as pall-bearer or to "walk the final mile" with the "king." The job had to be done by Geddes-Moss employees.

The pine-box coffin was taken to Holt Cemetery, a city-owned cemetery behind Delgado Trade School, where many of the city's indigents were laid to rest. Bob Griffin, the caretaker and handyman, had dug out the customary six feet of hard, clayish earth and the remains of Buddy Bolden were lowered into plot C-623 …

(Bolden's sister) Cora was unable to keep paying the upkeep on her brother's grave and in accordance with Holt policy, after two years his remains were dug up, reburied deeper, and another burial made on top. The plot number C-623 was changed, with no record being kept of the original burial. Records were not accurately kept until the 1940's and there have probably been at least eight or nine burials since Bolden's in that spot. Holt Cemetery today is overgrown with weeds. Even if one knew exactly where to look it would be difficult to locate Bolden's grave. It is possible to find Section C— about the size of a quarter of a city block and guarded by a wide-spreading majestic oak tree—and to know only that Bolden's grave lies somewhere in that space.

Although many jazz aficionados have for years fruitlessly searched for Mr. Bolden's burial site (including a recent MTV seance), a Buddy Bolden jazz funeral was finally held and a memorial marker unveiled on September 6, 1996, what would have been Bolden's 119th birthday. The Olympia Brass Band led the funeral procession to the event, which included speeches by Mayor Marc

The hypnotic sway of Spanish moss

Epitaph being swallowed by vegetation

Morial and Don Marquis. The family was represented by Bolden's granddaughter Gertrude Bolden Tucker of Chicago. The epitaph on the cenotaph, donated by Stewart Enterprises, quotes a famous Jelly Roll Morton assessment of Bolden: "The blowingest man since Gabriel." An effort will be made to have the street running from City Park Avenue to Holt Cemetery named Buddy Bolden Boulevard.

The ethereal ambience of Holt Cemetery imbues the place with a feel of the supernatural, which is certainly the reason why this city of the dead has been a hot bed for peoples' attempts at occult activity. Superintendent of City Cemeteries Ms. Clementine Bean claims that out of the seven city-owned cemeteries she oversees, Holt is by far the site of the most "unusual" activity, particularly at night. "Call it what you want—witchcraft, satanic

159

worship, voodoo—there's a lot of strange things happening at Holt Cemetery." This seems to have been the case for many years. In *Gumbo Ya-Ya,* published in 1945, the Holt sexton is quoted as saying: "Sometimes when we dig open a grave we find all kinds of things. I've seen potatoes scooped out and filled with salt, and the top placed back on, and I've seen the people take some of the dirt from the grave home to sprinkle around their house. That's all voodoo stuff, you know. Some of 'em throw packages of needles or papers or pins on top of the grave."

Holt Cemetery may soon be dealing with a different sort of curse. Mayor Marc Morial recently announced that the City of New Orleans wants to privatize five of their cemeteries and to close Holt to future burial. The day on which burial is forbidden in Holt Cemetery, there will be outspoken opposition which will illuminate a burial dilemma unique to New Orleans, one of the few U.S. cities that still runs cemetery systems.

For more than two centuries New Orleans has been a city accustomed to the reuse of tombs, but multiple burial has traditionally occurred in aboveground tombs. Holt Cemetery is comprised mostly of copings in which human remains do not decompose as quickly as in aboveground wall vaults, family tombs, or society tombs. The problem is that many of Holt's copings are more than full. People expect to reuse these Holt burial plots, whose fees are inexpensive. New Orleans is not only one of the few cities in the country that manages cemeteries, it is the only American city that

guarantees inexpensive burial. Comparatively, burial fees in the City of New Orleans cemeteries are remarkably reasonable—$150 for interment in a plot that is already paid for.

Although the reuse of a Holt Cemetery coping does save money, the conflict here is as much emotional as economic. People in New Orleans value burying current deceased in the same grave as their forebears. Many New Orleans families who own Holt plots expect to keep their relations together at the gravesite, because the comingling of family remains is an age-old New Orleans tradition. The controversy that the city could generate by forbidding burial in Holt is a predicament possible only in New Orleans.

If Holt is indeed "memorialized" any time soon, one of its last most notable burials will have belonged to the legendary rhythm and blues singer Jesse Hill. For Hill's Holt Cemetery burial, Ernie K-Doe, Dr. John, and Milton Battiste were honorary pallbearers. Of the many illustrious tributes to the "Ooh Poo Pah Do" man that occurred during the weekend of his funeral (September 28, 1996), one of the most momentous involved K-Doe, Hill's old friend and music associate. K-Doe not only spoke and sang at Hill's dismissal service but he and his wife, Antoinette, wore outfits identically matching Hill's burial clothes. At the request of Hill's wife, Doris, Antoinette K-Doe made the black pants and jackets trimmed with gold at the shoulder and lapel. Doris Hill commented that it was clothing suitable for a "jazz emperor."

formed into the site of an army training camp. (In a sense the Civil War brought an end to the racetrack and led to the cemetery's establishment; therefore it is fitting that this city of the dead contain so many Civil War veterans.) After the war, part of a dissenting faction from the Metairie Jockey Club then split off to form the Louisiana Jockey Club, which ultimately established the Fair Grounds Racetrack. This is when and where Charles Howard came into the picture. Howard was actually introduced to try to revive the troubled Metairie Jockey Club. Any social animosity toward him seems to have been more rooted in his ties to the Republican party. The Metairie Jockey Club did not survive, but in its place the cemetery was born in 1872, under the auspices of the Metairie Cemetery Association.

New Orleans then was in definite need of a new cemetery. Up until this time, the cities of the dead were mostly small in size and enclosed within wall vaults. The Metairie Cemetery developers did not think such grounds were appropriate for the grandiose tombs that had grown popular in nineteenth-century New Orleans. They conceptualized a more spacious setting reminiscent of an urban park. By this time, New Orleans was becoming more American, and there was an urge to model this new graveyard after the commodious

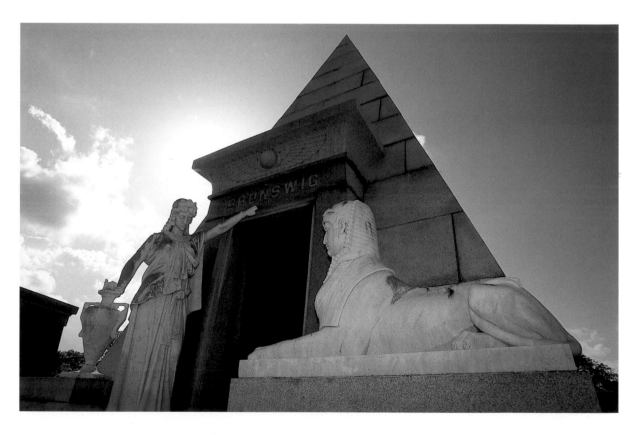

The Brunswig mausoleum is modeled after a tomb in the Cemetario Monumentale in Milano, Italy. Henri A. Gandolfo explains, "It is a true pyramid, the entrance portal to which is a grilled bronze gate, flanked on one side by a marble sphinx and on the other by a female figure with a libation urn at her side. In metaphysics, pyramids are reputed to give out a mystic aura. It may be this that attracted a bolt of lightning which moved some of the upper stones apart without disturbing the large apex stone. They were restored to their proper place by the operation of a turnbuckle and the damage was completely repaired. There has been no reoccurrence of the phenomenon."

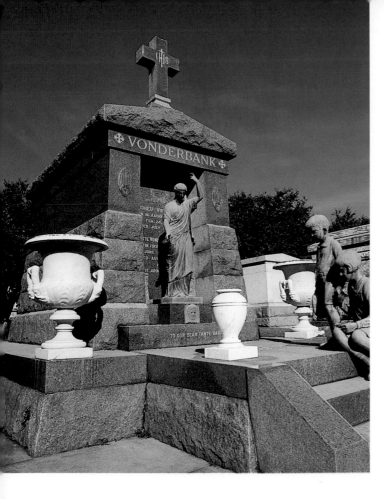

Vonderbank family tomb of red Missouri granite. Below the bronze statue of Memory is a portrait plaque of Mrs. Babette Vonderbank Ahrens; statuary of "Dear Tante Babette's" niece and nephew look on.

Rogers-Palfrey-Brewster Celtic cross carved from an eighteen-foot, fifteen-ton block of Indiana limestone. As Henri Gandolfo writes, "A material selected because it would weather and acquire a patina of antiquity in a relatively short time. There is no socket stone, the shaft is set into a reinforced foundation, entirely hidden from view, so that it seems to rise directly from the earth." The design was based upon the ancient crosses guarding the graves of kings off the Scottish coast, among which are the burial sites of Macbeth and Duncan, immortalized by William Shakespeare.

East Coast rural cemeteries that featured meticulous landscaping and wide-open spaces. Unlike previous New Orleans cemeteries, Metairie did have a master plan and did not just take shape piece by piece. But what Metairie Cemetery lacks in spontaneity it makes up for with stunning fanciful grandeur. The plan's most peculiar distinction lay in designer Colonel Benjamin Morgan Henry's decision not to scrap but to work with the racetrack layout, consequently destining eighty acres worth of tombs to be situated within the concentric ovals patterned from the horse track.

If, as Mark Twain said, the finest New Orleans architecture exists in the cities of the dead, then the finest New Orleans cemetery architecture is unquestionably in Metairie. This distinction transcends the very obvious sheer amount of money expended on these memorials. An awesome standard of engineering, craftsmanship, and artistry has been set which seems to have fed upon itself, as if a person who decides to build an imposing Metairie tomb could not just build any old monu-

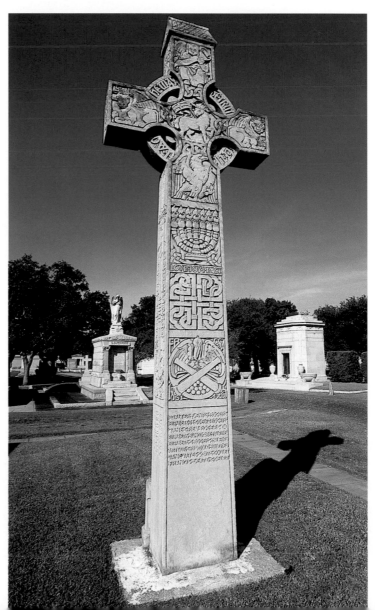

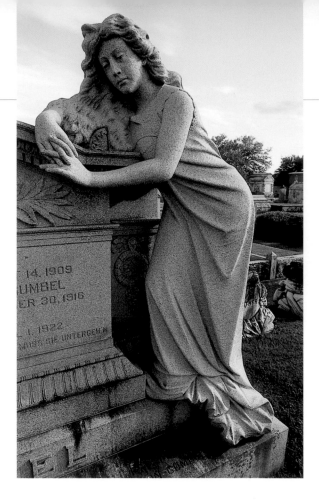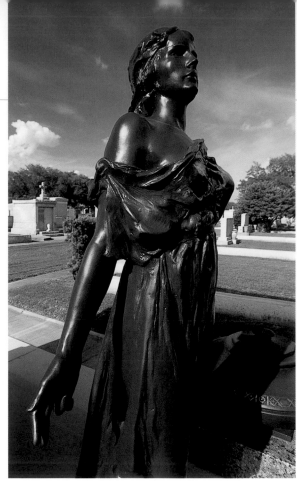

The sensual statuary of the Gumbel and Seidel monuments

ment. And like the old-moneyed New Orleans neighborhoods of the living, Metairie Cemetery is not simply made up of wealthy people building grand edifices. These are structures designed and executed with tremendous flourishes of fantastic imagination, perfect in proportion, but weird and otherworldly in overall effect.

Celebrated Occupants

The exactingly arranged rows of Metairie Cemetery are aisles of power and influence, as political leaders and influential families abound. There are nine governors entombed here, starting chronologically with **William Charles Cole Claiborne,** the first American governor of Louisiana following the Louisiana Purchase. He was initially buried in St. Louis #1 and moved to Metairie in 1880. Considering that Claiborne was assigned to govern a territory where a language barrier rendered him incommunicado and illiter-

ate; where he was confronted with ingrained social customs that were distractingly unfamiliar to him; where rampant piracy was the modus operandi; and where he was responsible for separating church and state in a community where the Archdiocese acted as government, this native Virginian, arriving in Louisiana at age twenty-seven, skillfully oversaw a rocky and challenging transition. He is certainly one of the most under-rated statesmen in United States history.

In a state characterized by remarkable politics, perhaps the most exceptional political story memorialized in Metairie is that of **Pelius Benton Stewart Pinchback**, Louisiana's only black governor. Born in 1837 to a white Mississippi planter and a mixed race mother, Pinchback's father died in 1848 and the family fled when the father's white heirs tried to enslave the widow and her offspring. Pinchback became a Mississippi River boat cabin boy and wound up in Civil War–occupied New

166

Orleans after avoiding the blockade as a Union soldier. During Reconstruction, an era when blacks had voting rights, he was suspiciously elected to the State Senate and in 1871 appointed lieutenant governor by Governor Henry Clay Warmoth.

Soon Warmoth's own political career was in jeopardy and Pinchback publicly endorsed his impeachment, claiming that Warmoth offered him a $50,000 bribe for his support. The House impeached Warmoth and Pinchback became governor. Pinchback spent much of his thirty-five-month term trying to quell questions surrounding his governorship, but was voted out of office in the next election. One of the more controversial aspects of his term as governor was establishing Southern University in 1880 under the condition of separate educational facilities for the two races. It is somehow fitting that this controversial and talented African-American leader who did not have great popularity among blacks was buried in a cemetery which was then *the* bastion of fallen Confederate heroes. Although Pinchback himself

was buried in a private family tomb, he was a strong proponent of the benevolent associations that establish communal society tombs.

Some more celebrated governors who are also buried here are **Michael Hahn, Henry Clay Warmoth, John McEnery, Samuel Douglas McEnery, William Wright Heard, John M. Parker,** and **Richard Webster Leche.** Entombed here are New Orleans mayors from seventy out of the ninety years between 1880 to 1970. In Metairie, aside from **Joseph Shakespeare, Walter C. Flower, Andrew McShane, T. Semmes Walmsley, Robert Maestri, deLesseps S. Morrison,** and **Victor Hugo Schiro**, one of the most popular and effective in the city's history was **Martin "Papa" Behrman.**

The New York–born Behrman, orphaned at age twelve, rose to become a quintessential machine-type politician. It is interesting that he is buried in the same cemetery as famed Storyville madame Josie Arlington and bar owner/pimp/State Senator **Tom Anderson** (aka the Mayor of Storyville because he held public office throughout much of the red light district's

It would seem that Metairie Cemetery is going to the dogs. The patriotically adorned weeping dog oversees the Masich family plot. The story goes that this loyal pet followed his owner's casket to this burial site. The dog had to be forced to leave and would return to this grave every chance he had. Two life-size bronze German shepherds guard the coping of Captain James Dinkins, C.S.A.

twenty-year history), since Anderson was a backer of both Mayor Behrman and Madame Arlington. Behrman traveled to Washington, D.C., to protest the U.S. Navy's 1917 command to close the district, since he realized that this legally legitimized zone of ill-repute helped control prostitution and crime. Ultimately complying with the federal order, Behrman pronounced Storyville's obituary with his legendary comment on prostitution, "You can make it *illegal*, but you can't make it *unpopular*." Behrman died while serving his fifth term, making him the longest serving mayor in New Orleans history. On the day of his funeral, twenty thousand people paid tribute to this mayor, one of the most popular leaders in New Orleans history.

Another machine-style mayor well known for a highly publicized quip lies here. Mayor **Robert Maestri**'s machine politics were a vestige of his close friendship with Senator/Governor Huey Long, and his immortal comment addressed to the President of the United States was pure *New Orleans*. While hosting a presidential visit with a dinner of Oysters Rockefeller at Antoine's Restaurant, Maestri leaned over and asked Franklin Delano Roosevelt, "How ya like dem erhsters?" Unseating Maestri in a surprise 1946 upset was a young reform candidate, decorated World War II Colonel **de Lesseps S. "Chep" Morrison**, now entombed in Metairie as well. This four-term mayor presided over an era of widespread civic rejuvenation. In 1961 President John F. Kennedy appointed him ambassador to the Organization of American States. Morrison died with his son in a 1964 Mexican plane crash and his memorial service was epic, featuring regards from Zsa Zsa Gabor and planes flying overhead in salute formation.

In Metairie Cemetery lies another historic New Orleans civic leader, police chief **David Hennessey**, around whom one of the most tumultuous public events in the city's history occurred. During the 1890s, an era characterized by rampant police corruption, this chief had a reputation for honesty. The late nineteenth century was a time of prodigious Italian immigration and the resulting job competition caused serious ethnic friction. Two factions of the Italian Mafia started a violent battle against each other and Chief Hennessey instigated a crackdown. He drew up lists of "undesirables" and put out orders to arrest any Italians fitting the profile. Shortly thereafter, Hennessey was assassinated in front of his home.

The police department brought charges of murder and conspiracy against nineteen Italian

Statuary in front of the Army of Tennessee monument. General Albert Sidney Johnson rides atop the tumulus in the background.

Egan family tomb, the Ruined Castle. Of Gothic design, it is modeled after the ruins of a chapel on family estates in Ireland, representing a vandalized and burned building. Henri Gandolfo comments, "The stones only appear damaged, however, because they are skillfully fashioned and purposely carved to represent cracked and broken marble—a perfect portrayal of destruction." In New Orleans a sense of controllable decay is a favored quality.

It is only fitting that this cemetery which came into existence due to the Civil War would inter scores of its veterans. The biographies of the notable and anonymous Civil War dead who lay here could fill volumes, but two of the Confederacy's most significant icons were laid to rest here. The first is **Jefferson Davis**, president of the Confederate States of America, who died in New Orleans. Upon his death many former Confederate states appealed to his widow to become Davis's final resting place, but it was a letter from Mayor Joseph Shakespeare to Mrs. Davis that kept Davis in New Orleans. It stated: "While the entire South claims him as her own, New Orleans asks that Jefferson Davis be laid to rest within the city where he fell asleep."

His epic memorial observances subsumed the city. His body lay in state for three days at City Hall as 140,000 people passed by his bier. All business and government shut down as his massive funeral cortege proceeded to Metairie Cemetery, and 10,000 people were already gathered there. He was entombed in the Army of Northern Virginia mausoleum and two years later moved to the Hollywood Cemetery in Richmond, Virginia.

The same year that Jefferson Davis was disinterred and moved, another of the Confederacy's most instrumental leaders, **General Pierre Gustave Toutant Beauregard**, was buried in Metairie. This Creole of French descent has been

suspects who were ultimately acquitted after the prosecutor did not use a confession from one of the accused. Much of New Orleans was outraged and a public gathering was held, at which civic leader W. S. Parkerson stirred up the crowd with these words: "When courts fail, people must act. What protection is there left us when the very head of our police department, our chief of police, is assassinated in our very midst and his assassins are turned loose on the community?" A lynch mob proceeded to the Parish Prison in Congo Square; "Who Killa Da Chief?!?" was their battle cry. They brutally executed eleven of the acquitted suspects to avenge Hennessey's death. Three of those killed were Italian citizens and the United States government ended up paying reparations demanded by Italy. This event received international attention and caused tension among Italian New Orleanians for years to come.

J. A. Morales tomb, former final resting place of Josie Arlington, infamous Storyville madam whose ghost would reportedly haunt this burial site.

credited with "starting" the Civil War by giving the orders to fire on Fort Sumter. Beauregard coming as Davis was leaving is uncanny timing, in that Davis and Beauregard had a longstanding rivalry instigated by Davis passing over Beauregard, a Louisianian, as commander of the Louisiana army. In fact, Beauregard, an aristocratic Creole with attitude to spare, considered Davis a "numbskull" and did not attend Davis's monumental funeral, explaining, "I didn't like him when he was alive. And my opinion has not changed in the last two days." Beauregard had an affection for the Metairie Cemetery location, as he had been a frequenter of the Metairie race club in its final days. The general was interred along the bend of the former track, in the Tumulus of the Louisiana Division, Army of Tennessee.

Not only does governing power lie in Metairie but so does influence in the form of society's scions. In his book *Metairie Cemetery: An Historical Memoir,* Henri A. Gandolfo writes:

"And this leads to the little known fact that there are more kings and queens buried in Metairie Cemetery than in Westminster Abbey.

Fifty-one Kings of Carnival rest 'far from the maddening crowd' in the peaceful purlieus of Metairie. Since the queens invariably get married, they are a little more difficult to identify, but no less than fifteen of the royal ladies are known to have chosen Metairie Cemetery as their final resting place."

If ever there was an epic tale around a New Orleans tomb, that of **Madame Josie Arlington** stands out. Mr. Gandolfo, who served as Metairie Cemetery's caretaker for more than half a century, states, "It is likely that the memorial arousing the greatest interest over the years is the tomb built for the primadonna of Storyville, Josie Arlington." Not lost upon people was the irony that one of this scandal-ridden city's most socially scandalous characters was entombed among the darlings of old-line aristocracy. Josie Arlington (1864–1914) was the most notorious and successful madam of the infamous red light district Storyville. This legendary hotbed of early jazz activity was bordered by the St. Louis #1 and #2 cemeteries. Josie Arlington was born Mary Anna Deubler in 1864. Orphaned at age four, this future madam was raised by the Sisters of Charity in St. Elizabeth's Home.

As a teenager, Josie made the acquaintance of widower Philip Lobrano and under his guidance turned to prostitution. The young whore named herself Josie Arlington and shortly thereafter opened her own house of ill repute in the Tenderloin that would soon become Storyville. The brothel also became home to Lobrano and Arlington's family, who Lobrano considered a "flock of vultures." Lobrano himself was evicted from the premises in 1890 when, after a domestic

dispute, he shot Josie's brother, Peter. Josie then decided to try to upgrade the establishment's rowdy reputation and to remake her own violent image. She herself earned quite a reputation after a notorious 1886 fight with one of her competitors, Beulah Ripley. Ripley pulled out most of Josie's hair, but Josie bit off part of Beulah's ears and lips.

Madam Arlington opened a "château" for non-brawling, refined gentlemen desiring "amiable, foreign girls." Although her château may not have achieved its intended and advertised heights of highbrow sophistication, Al Rose, author of *Storyville, New Orleans,* described the Arlington as "perhaps the grandest—certainly it was the gaudiest—bordello in the District." Her brothel was extremely lucrative, particularly after the 1897 legislation was passed creating Storyville.

Josie's business was very profitable, but a 1905 fire wreaking havoc on the Arlington was costly and moreover seemed to dampen her spirits. She became preoccupied with death and purchased a $2,000 burial plot in Metairie Cemetery and built an $8,000 tomb. It features a statue of a young woman bearing a wreath and touching the bronze door to a stately red granite tomb whose pilasters support two large flaming urns, which is engraved with a large crucifix on the back. The figure at this doorway would become a big source of New Orleans cemetery myth and mystique.

Some believe the statue symbolizes Josie being turned away by her parents, when in reality she was orphaned at age four. Some claimed it stood for Josie "trying like hell to get into heaven," or that the wreath the statue bore was an indication of Josie's predilection for being awoken each day with fresh flowers. Some say that the statue pictured a virgin being turned away, embodying Josie's claim that no girl ever lost her virginity at her brothel. The simple truth is that the monument was modeled after a picture of a tomb from

Islamic Revival–style tomb of Laure Beauregard Larendon, built for her by her father, General P.G.T. Beauregard

Marie Laveau is not the only New Orleans hairdresser/altruist with a celebrated tomb. Former Bourbon Street hairdresser Eugene Lacosst made a fortune in the stock market and along with willing much to Charity Hospital and the Delgado Museum (New Orleans Museum of Art), he was able to build this marble sarcophagus for his mother and himself. It was modeled after a monument to a cardinal in Santa Croce, Florence, Italy.

Munich, Germany, which Josie found appealing.

After she died, it seems Madam Arlington found no immediate peace. The funeral was sparsely attended and one week after her death, Arlington's significant other, Tom Brady, married her niece, Anna. Within a decade this couple had spent the fortune Josie acquired. After the sale of her Esplanade Avenue mansion, Arlington's grave was foreclosed in 1924 and her remains moved to a receiving vault. Strangely, her former tomb's next owner also had the initials "J.A." A peculiar happenstance had occurred shortly after her death which bred commotion around her already notorious gravesite, rendering Josie as controversial in death as she was alive.

Across from her gravesite was placed a streetlight and every evening a red luminescence would flash off the Arlington tomb, causing people to believe that Josie haunted the tomb. Reports abounded of fire blazing from the urns and her grave became known as "the Flaming Tomb." Many people reported seeing the statue walk and bang the bronze knockers on the tomb's door.

Nightly crowds would gather to witness the weird glow and keep watch for the allegedly mobile statue. Legend has it that the tombside vigils were such a distraction that the cemetery decided to move Arlington's remains elsewhere, whereas it was really Tom Brady and her niece Anna's profligate spending habits that caused Josie's postmortem upheaval. Once that streetlight was removed, the tomb fell dark. Josie Arlington's remains now lay in an anonymous location. The gatherings of people gawking for paranormal activity have long ceased, but the legend of this celebrated Storyville madam and her ghost live on.

The district's biggest wheel of all, **Tom Anderson**, the Mayor of Storyville (also consort and benefactor of Josie Anderson), lies to rest in Metairie. Born in 1858 to a poor Irish Channel family, Anderson began his career as a *Daily Picayune* newspaper hawker but through interaction with the police force began to moonlight as a combination stool pigeon and cocaine/opium runner. Despite little education, he found employment as a bookkeeper for the ill-fated, corrupt

Louisiana Lottery Company, and in 1892 opened a restaurant that became a hub of political and police patronage. He ensconced himself in the realm of vice by opening the Astoria Club on South Rampart Street in 1895, and forged a business connection with the young Madam Josie Arlington on the eve of Storyville's birth. Anderson, the most well known and powerful pimp in the district, was elected to the state legislature and served for sixteen years, heading important committees. He subsequently became an oil tycoon. Later in life the Mayor of Storyville found religion, turning away from vice and toward the church. Upon his death New Orleans did not condemn his racy past but rather let him go to his Metairie grave peacefully.

Not far from the tombs of these Storyville veterans lies another figure from the scandalous and fast New Orleans nightlife of decades past. Although not as celebrated a denizen of the night as was Arlington or Anderson but nonetheless as notable, the gambler **Joseph "Never Smile" Harrington** is entombed in Metairie. Barely moving his stoic face, "Never Smile" could read his hand without appearing to glance at it. He made a fortune in the turn-of-the-century gambling dens on the one hundred block of Royal Street. In July 1924, after a particularly successful night's work, he was shot while driving home and found dead in his car wrapped around a utility pole. His wife, Bertha, chose an expensive tomb, but the succession judge did not approve, claiming that it exceeded the estate's assets. However, the widow Harrington was aware of capital that the judge was unaware of, and she paid for the tomb in cash with bills in denominations of twenties to hundreds.

Another instance of a Metairie tomb owner's succession wrangling in the courts is memorialized by the **Angele Marie Langles** cenotaph. In June 1898, Angele Langles and her mother,

Tomb of legendary gambler "Never-Smile" Harrington

Pauline Costa Langles, wrote their wills and the next month they both perished on La Bourgoyne, a steamship that sunk en route to France. The successions went to court because their wills named different heirs and the question of who died first would effect the inheritances. All other five hundred passengers met a watery grave, and with no witnesses the jury could not determine the order in which the Langles died. The judge decided that Angele, being younger and able to swim, survived

173

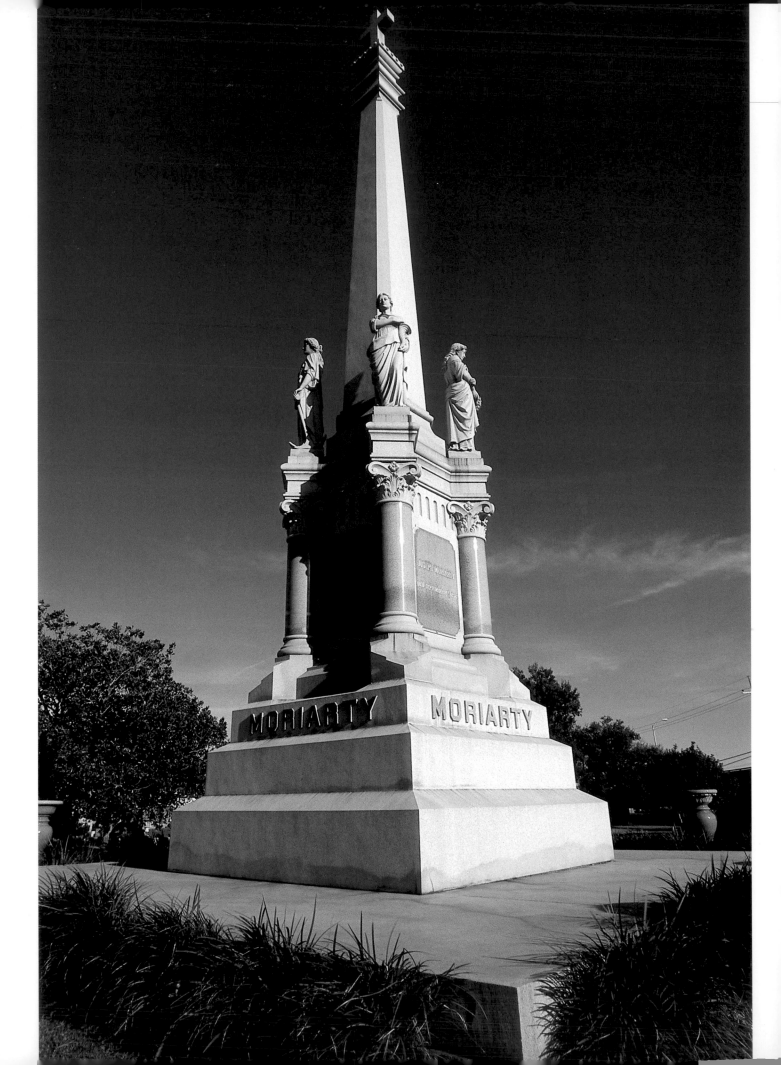

the mother. This decision allowed for the $3,000 Angele had specified in her will to go toward the construction of a memorial. Her heirs claimed that since no body remained, there was no need for a tomb. They may have had other ideas for spending that three thousand dollars.

The heirs challenged the decision, but the judge ruled that a tomb was not merely intended to shelter a corpse but to serve as "a monument in memory of the dead." Under Angele's name on the cenotaph is the inscription "105 LA. 39," legal reference to her case. Three other New Orleans ladies who also perished on La Bourgoyne, **Mrs. Jules Aldige**, her daughter, and granddaughter, are commemorated a few tombs down from Angele Langles. Their successions were based on the precedent set in the Langles case. Their tomb features two angels struggling to rise from a sinking ship.

It is highly appropriate for Metairie to harbor a nationally significant musical figure since New

◄ Popularly referred to as "the tallest privately owned monument in the United States," this sixty-foot granite memorial that Daniel Moriarty built for his wife has aroused much curiosity. As Henri Gandolfo explains, "The pedestal is ornamented with a small column at each corner, above which stand four granite statues representing the three virtues—Faith, Hope, and Charity. Who then is the fourth figure? The story is told that the famous humorist, Irving H. Cobb, in the 1920s visited the cemetery and inquired about the identity of the four females on the monument. 'Faith, Hope, and Charity,' answered the cabby. 'Well, who is the fourth one?' to which the cabby answered in his rich Irish brogue, 'And who but Mrs. Moriarty?' Actually, the figure represents Memory, carrying a symbolic wreath of immortelles."

Orleans is the most musical city in the United States. Initially buried in Greenwood Cemetery and then moved to Metairie, entombed here is the legendary singer and composer **Louis Prima**. This larger-than-life bandleader also had a thriving career on the silver screen. Although often discredited by jazz purists, Prima played a prominent role when jazz *was* popular music. Benny Goodman commented: "Gene [Krupa] wasn't the first guy to mix fine musical ability with showmanship...Louis was," and after Prima's death a music writer noted that "rock 'n roll history has neglected to mention that Louis was one of the founding fathers." Perhaps his highest musical achievement was composing the big band standard *Sing, Sing, Sing*, but he is remembered more for his penning and singing of the classic popular song *Just a Gigilo*. One could well imagine that after singing the lyrics of that song so often, Mr. Prima had decided upon his epitaph long before he died. His Metairie grave now bears the inscription:

> *When the end comes they'll know*
> *I was just a gigilo*
> *Life goes on without me*

Regarding music, Metairie, and cemeteries, no book about New Orleans cemeteries would be complete without the bizarre tale of the burial of Gram Parsons. His interment did not actually take place in Metairie Cemetery, but it was in the city of Metairie, Louisiana, at the Garden of Memories Cemetery. Harvard dropout Parsons had a brief and shining career in the late 1960s and early 1970s fusing country music and rock 'n' roll as a solo artist and songwriter and with such bands as the Byrds and the Flying Burrito Brothers. He hailed from a wealthy family, his grandfather having been a successful Florida citrus grower. Gram's strange and circuitous connection to New Orleans came via his stepfather Bob Parsons, who had

adopted Gram and had moved to New Orleans briefly after Gram's mother died. In 1971 Gram was married in Bob Parson's Audubon Place home.

In 1973 Gram Parsons died of a probable drug overdose. Just prior to his death, Parsons told friend Phil Kaufman that he did not want a conventional funeral but would rather be cremated in the desert around the Joshua Tree National Monument, a place he dearly loved (and in fact, where he actually did die). "We made a deal that if one of us should die, the other would take the body out to Joshua Tree, have a couple hundred beers and burn it and let the ashes go where they may," says Kaufman, who borrowed a hearse and at the Los Angeles airport purloined Parsons's dead body. He drove the musician's corpse to Joshua Tree, soaked the

coffin in gasoline, and set it ablaze. Yet this cremation attempt was not a complete success, and the remains undevoured by flame were sent to Louisiana and interred at Garden of Memories. Stepfather Bob Parsons had legally arranged for the corpse to be sent to New Orleans, thinking that if he had established a Louisiana address for Gram, that under the Napoleonic Code he would be the only heir as the musician's nearest male relative.

Today, Joshua Tree National Monument and Garden of Memories Cemetery are shrines for Gram Parsons fans. Phil Kaufman recently commented: "They [Parson's family] wouldn't tell me where he was. Now that I know, maybe I'll go out there and dig him up again and take him back to the desert."

Lion, Clapp family sarcophagus

*Angel with
bird and book,
Marks-Wise
family tomb*

*The alpha and the
omega of the Carbajal
family cross*

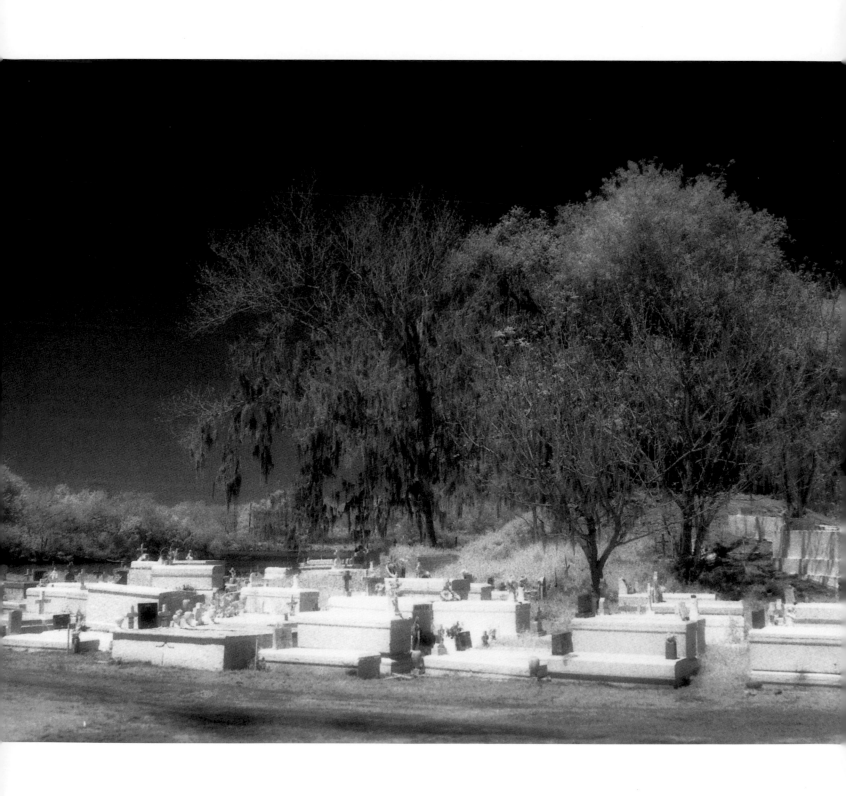

19

Fleming (Berthoud) Cemetery

FOUNDED: NINETEENTH CENTURY
OWNER: THE FLEMING FAMILY

*T*he New Orleans region is one of the most artificially manipulated and industry-laden natural settings in the world. Although many people associate New Orleans with swampland, one would never know the natural tendencies of its innate land forms while strolling down Canal Street. To see South Louisiana in a more pristine form, one must leave the greater New Orleans area. Some of America's most vibrant wetlands lie just southwest of the city in an area known as Barataria.

This region is delineated by Lake Salvador and Bayous Barataria, Rigolettes, Perot, and Villars. Although subject to some of the flood control engineering familiar to the more densely populated areas, and somewhat desecrated by the ravages of the timber and petrochemical industries, Barataria is still a refreshing step back in time, a place where the natural order of things confronts civilization in a deliciously immediate way. Here is where terra firma tapers into the sea, a place where some towns refer to themselves as "the end of the world," for there the road simply ends. A vast complex of bayous, streams, canals, coulees, lakes, ponds, and inlets weave around "land" varying in altitude and firmness, an area where, with a slight turn of the head, one can view hardwood forest on natural levees grading into cypress swamp, giving way to tidal marsh with varying intermediary transitional zones in between. Geology young and mutable, its constant shifting, settling, changing, and shaping of itself is so rapid that transformation almost seems perceptible at a brief and casual glance. A realm teeming with life-forms of all description, numerous genus and species of reptile, fish, mammal, plant, bird, crustacean, and insect comingle in a frenzied symphony of fecund natural activity—a zone where the bald cypress and the snowy egret reign supreme.

Long inhabited by Native Americans, Barataria was almost certainly investigated by the French shortly after they arrived, for it featured the only regional inlet deep enough to harbor their ocean-going ships. Barataria also served as an entryway to the city for traders, hunters, trappers, and fisher-

men because from its bay many bayous converge upon a location by the Mississippi River across from New Orleans. (Long after the invention of the railroad and automobile, people throughout South Louisiana were navigating bayous as their main means of transport.) But most heavily associated with maneuvering this serpentine labyrinth of ever-shifting waterways are the pirates and smugglers, particularly those under the leadership of Jean Lafitte.

Although there were many "privateer" operators, Lafitte was probably the biggest, most organized and successful, making him today Louisiana's largest historic legend alongside Marie Laveau the Voodoo Queen. (Louisiana is the only state in the country whose only national park, Jean Lafitte National Park and Preserve, is named for a notorious organized criminal.) He is believed to have had command of one hundred ships and one thousand men, a group known as the Baratarians due to their mastery of the Barataria region. It is popularly believed that the region was named after its association with pirates, in that the French word *barraterie* literally means "deception." As Betsy Swanson explains in *Historic Jefferson Parish: From Shore to Shore,* "the Provençal equiva-lent *barataria* means any type of fraudulence, ille-gality, or dishonesty at sea."

Factual information about Lafitte's life is murky, but rumors, gossip, and speculation seem to feed upon themselves. People are still looking for his buried treasure, which is as elusive as it is purport-edly widespread, and Lafitte's supposed burial locations are as difficult to pinpoint as undiscov-ered chests of Spanish doubloons. With Lafitte allegedly buried in Illinois, Charleston, Tampa, Paris, two places in the Yucatán Peninsula, and six in New Orleans, his burial locations are something akin to Elvis Presley sightings. But his most note-worthy final resting place is in a Barataria region town, his namesake Lafitte, wherein he is report-edly buried alongside Napoleon Bonaparte and John Paul Jones.

Legend has it that Lafitte was supposed to deliver Napoleon from exile on St. Helena and replace him with a lookalike, yet as this pirate kingpin transported the former French king to New Orleans, Bonaparte would die and be buried along the banks of Bayou Barataria. John Paul Jones gets in on this postmortem act when, accord-ing to popular belief, he died while pirating and was buried in a grave neighboring Napoleon's.

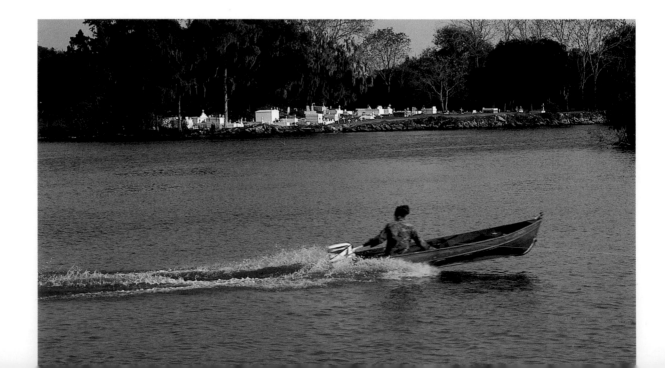

When Lafitte himself died, his men buried him in between these two formidable historic figures. The South Louisiana myth-making machinery is unimpeded by the fact that John Paul Jones died in 1792, a year when Jean Lafitte was approximately twelve years old.

In *Historic Jefferson Parish,* Betsy Swanson attributes the location of this legendary trio of final resting places to the Lafitte Cemetery, also referred to as Perrin Cemetery, once owned by descendants of a Manuel Perrin, an alleged relative of Jean Lafitte. But the writers of *Gumbo Ya-Ya* attribute this location, which they refer to as "the source of the most fantastic legend in the entire State"—a whopping distinction indeed—to Fleming Cemetery, where from time to time the three historical celebrity ghosts make appearances. *Gumbo Ya-Ya,* however, may have the two cemeteries confused or melded into one, for this book sites the owner of Berthoud Cemetery as Madame Toinette Perrin, who, in defending the validity of the legend claims:

> I tell you like my mamma and my *gran'mère* tell me. Lafitte is buried dere. Other mans? Napoleon? *Mais, oui!* Zat is his name. Me, I'm old, and don't remember like I used to, but I know dis: every year some woman comes to zat grave on All Saints' Day, and light candle and pray. She say she come from far away and he is her kin. And she give me plenty money to keep his grave nice. Where she live? I don't remember, me. But she come from far off place every year, on All Saints' Day. Zat is all I know, me.

Both the Lafitte (Perrin) Cemetery and Fleming (Berthoud) are examples of a noteworthy bayou country phenomenon: graveyards located atop a Native-American shell mound. Prehistoric Indians constructed earthen burial mounds, elevated temple mounds for spiritual purposes, and

The road to Fleming Cemetery. An iron sign that once temporarily named the burial ground La Croix Casse for a film scene now lies in the weeds, having been accidentally knocked off its supports by a truck.

A crawfish hole supported by a grave

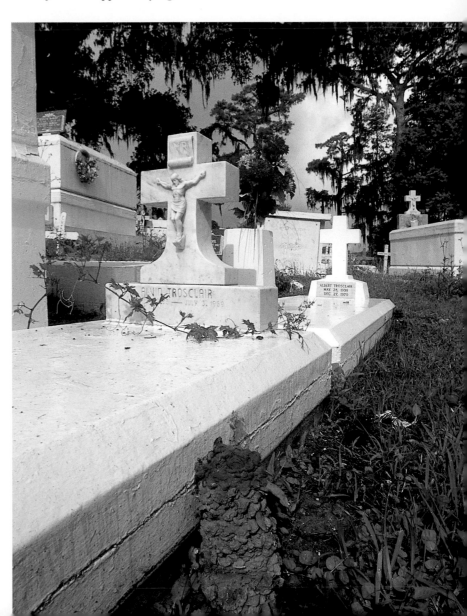

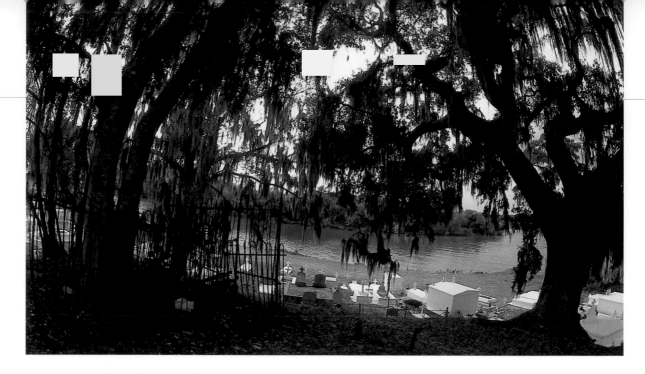

Bayou Barataria seen from atop the Indian mound. The iron fence encloses the graves of brothers William and James Berthoud.

"midden" mounds of discarded rangia clamshells. Many of these mounds rich in archeological information and natural history were tragically plundered to temper mortar in colonial masonry buildings and to build roads. Some of the most intact remaining mounds now lie under presently used cemeteries.

If low altitude posed a problem for cemetery workers in early New Orleans, a relatively high place at the time, they had it easy compared to the first settlers in the swamps of Barataria. To get a leg up on Mother Nature during annual floods, bayou country burial employed the elevated mounds left behind by Native Americans to assist in their attempts at burial in a region in close contact with sea level. Of Fleming Cemetery, Betsy Swanson writes: "Perhaps the most valuable landmark of its kind in Louisiana is the Berthoud, or Fleming, Cemetery located on a large Indian mound on the bank of Bayou Barataria, in the community of Barataria."

The cemetery was probably an early graveyard for the Mavis Grove Plantation of which its land was part. The Brothers Berthoud owned the plantation, hence the cemetery's name. These brothers were the children of Eliza Bakewell, sister of Lucy Bakewell Audubon (whose husband was the naturalist, John James Audubon). After the Berthouds died and were buried on top of the mound, their graves were enclosed within an iron fence and the Barataria community eventually began to use the mound as a burial ground.

The Fleming family acquired the property in 1913. Until recently, floating funeral processions approached the cemetery by boat on Bayou Barataria. The coffin would be accompanied by the priest, pallbearers, and family in the front boat followed by vessels transporting friends and relatives. Although floating funeral processions are no longer seen, some of Lafitte's present-day observers of All Saints' Day still arrive with their flowers and candles to the shores of Fleming Cemetery by boat.

While there are no big celebrities buried here (except perhaps for Jean Lafitte, Napoleon Bonaparte, and John Paul Jones), and the tombs are not staggering architectural monuments, this burial ground has a wonderful homespun quality that blends nicely with the natural setting. Someone recently propped up palmetto leaves as headstones for two tombs on the mound's slope.

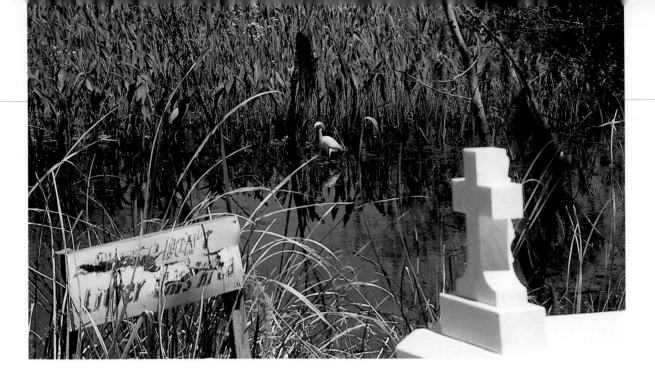

An egret hunts

While there are some prefabricated grave markers and marble crucifixes, many memorials are hewn from wood and discarded iron and bear hand-painted inscriptions. There are occasional glass-paneled boxes that house crucifixes, artificial flower bouquets, saints' statues and pictures, and memorabilia of the dead. In the past, these commemorative containers sheltered figurines, toys, pottery, mason jars, bottles of medicine, and plates of food. Currently, one of these memorial boxes contains a heartfelt lamentation—another disappearing tradition—which reads:

> For Traciee…
> I think there will never be a sister quite like thee. Your heart as big as me, your smile so bright it gives delight. Your laughter cheers even the saddest of men, only to hide your pain from them.
> I see God's hand reaching out to thee, to take you to his side. God said you need the rest; I know we have to abide. Your family keeps holding you here, because we love you so. To keep you here in such pain is selfish, I know.
> It's just so hard to let go of an angel such as thee. Always my sister, always my friend, always with love when my thoughts are with thee. May God bless you, hold you, and comfort you until we all meet again.
> To my most beautiful and loving sister… Traciee.
> With Love,
> Your Family

The most fantastic expression of remembrance on the bayou is the Fleming Cemetery observance of All Saints' Day. In a region known for enthralling November first commemorations, this cemetery presently earns the distinction of having the most spectacular All Saints' celebration. In October's final days, as in the rest of the region, families weed, paint, embellish, place flowers on, and whitewash their graves. On the day of the first, a priest attends to each burial ground and blesses the graves. Then comes the riveting, age-old practice of holding a candlelight vigil after nightfall, on this eve of All Souls' Day. (The candlelight vigil used to be commonplace in New Orleans, but no longer occurs in the city. However, it is still a thriving practice in the town of Lacombe north of Lake Pontchartrain.)

As the sun sets, families arrive and bedeck the

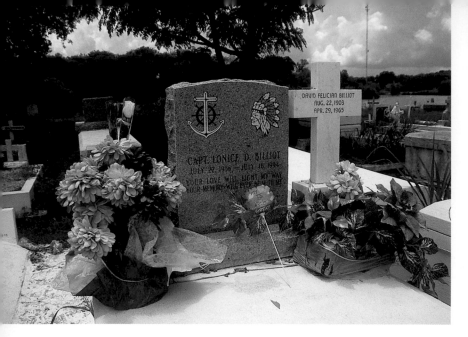

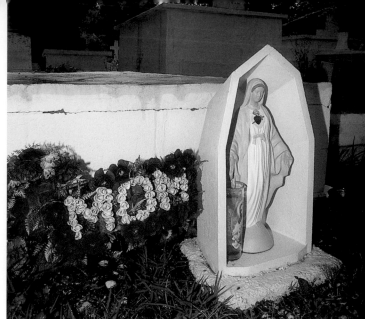

My Dad Is Great!

Mom

white tombs with candles artfully arranged in geometric patterns designed to honor the deceased. These candle arrangements do call attention to individual tombs but also fit into a larger luminescent scheme of the unbroken chain of glowing graves. In between prayer and paying homage to the departed, Barataria residents visit with members of their closely knit community, partaking in an experience that their ancestors shared together on this same spot ages ago. They then continue to "make the rounds" to further illuminate other candle-lit Baratarian cemeteries. It is a hypnotically beautiful, almost surreal sight to behold. Betsy Swanson describes the image: "As darkness falls it becomes a mound of flickering lights dimly illuminating multicolored flower arrangements and swaying streamers of Spanish moss."

However, as enchanting as this artificially enhanced environment is, the workings of Nature herself steal the show in Fleming Cemetery. This bristling universe of myriad life-forms can carry the human visitor worlds away from trouble and worry. As centerpiece, a monstrous live oak festooned with Spanish moss protrudes skyward from the mound's slope, while around the mound's perimeter grow sublimely restful bald cypresses. Silently glistening from tree branches

are barely perceptible networks of spider webs, upon which hover large, very perceptible goldensilk spiders with their brilliant black, yellow, and orange color schemes. Burial plots are strewn with gleaming white rangia clamshells. A symphony of cicadas sets a soundtrack to the sight of the lubber grasshopper's red-striped design darting from tomb to tomb beneath a psychedelic squadron of dragonflies as a red-eared slider turtle slowly saunters in search of shelter in and around the tombs of human beings. In front of a brilliantly blooming blue field of Louisiana irises, the neighboring inlet harbors a snowy egret hunting with surgical powers of concentration, thrusting its beak at lightning speed into the mud to snare crawfish. Occasionally there is the camouflaged yet conspicuous sight of a juvenile alligator poised sunning itself on the cemetery's margins, and other reptiles which conjure up a very real notion of death: the lethal cottonmouth, copperhead, or canebrake rattler. All the while lapping at its banks is the rhythmic pulse of Bayou Barataria, from which an occasional mullet jumps and with a splash breaks the seeming stillness.

Here the deceased are truly returned to the natural order and the creative forces of Nature.

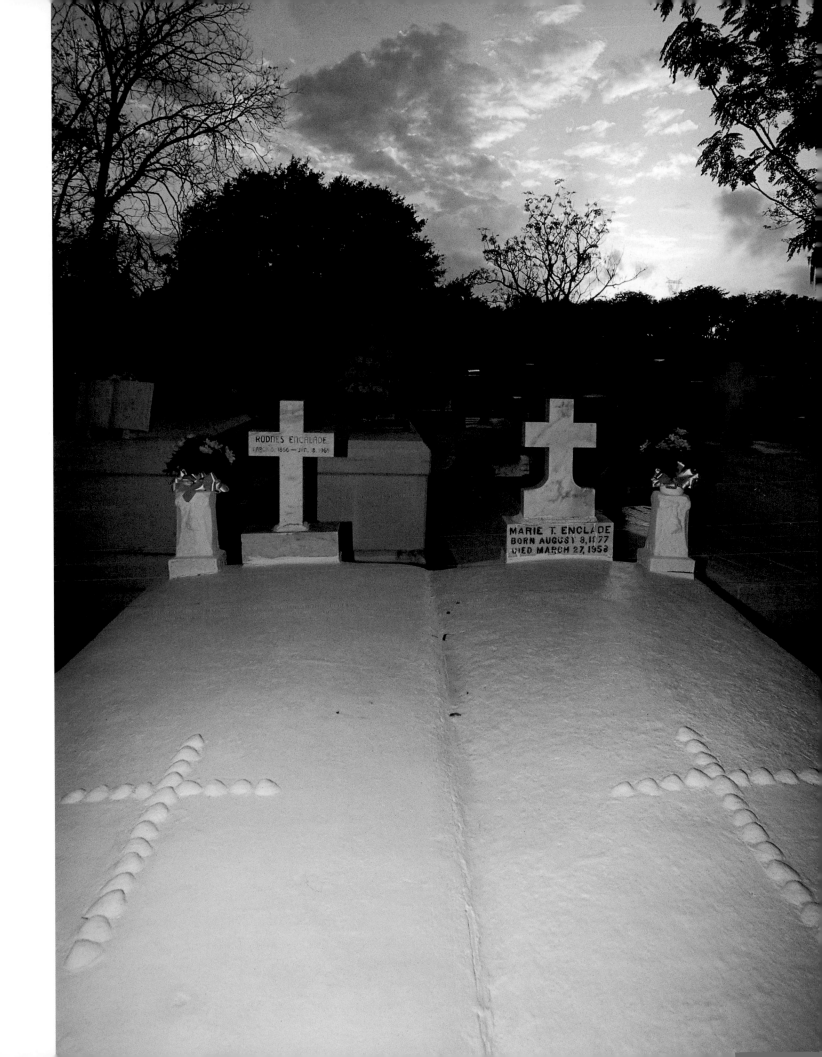

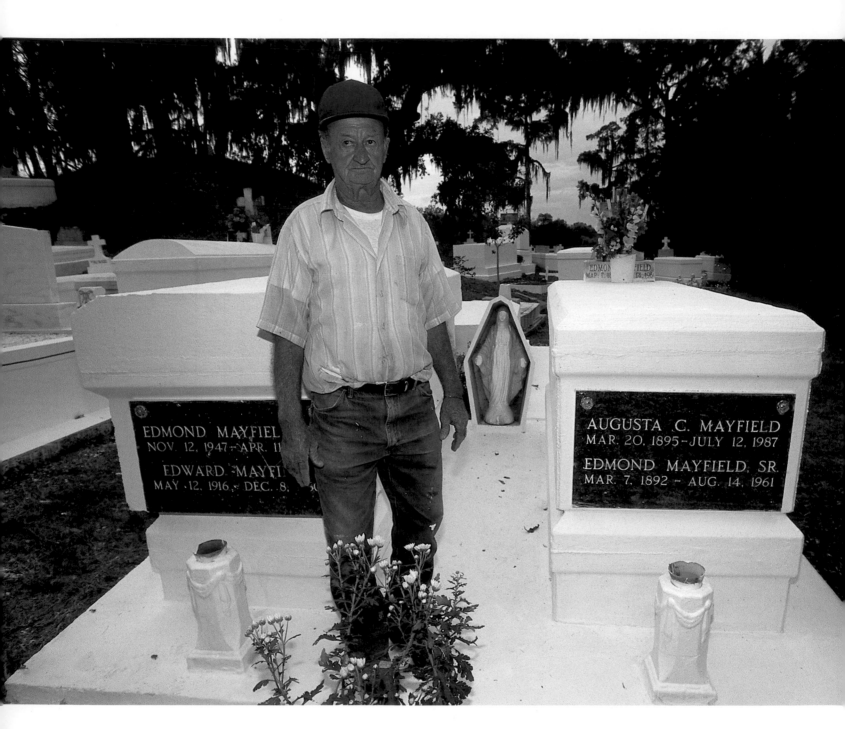

Edmond Mayfield stands among his family, in between Edmond Mayfield, Sr., and Edmond Mayfield III

20

Edmond Mayfield

ENDURING CEMETERY VIGILANCE FROM A CAJUN COWBOY

Fleming Cemetery abounds with many vibrant forces of life. Set to a rattling chorus of cicadas, the plant life irrepressibly reaches from between tombs to the light of the sky, which is often flocked with migratory water fowl. If this cemetery were left to its own devices, the memorials would certainly be throttled, overtaken, and torn asunder by the timeless biological whims of bayou, swamp, and marsh. In the city of New Orleans, there are cemeteries whose ground has been entirely paved over with cement but which are still besieged with unruly weeds and many other visible forms of organic and human-induced decay. Yet amid the junglelike wilds of Barataria, Fleming remains well kept, constantly maintaining a cared-for appearance. Although Fleming Cemetery often provides a chance for the visitor to be alone, the presence of an attending hand is more than suggested, the hand of someone who knows this land like the back of his own hand: Edmond Mayfield.

Born in Lockport, Louisiana, Mr. Mayfield moved to Lafitte in 1933 at age eleven. Being Cajun, he was raised by a family who spoke only French. Although he now converses *en anglais,* Mr. Mayfield speaks with one of the thickest Cajun accents this side of Lafayette. "A few people in the area are speaking it today. Not too many young ones, but they got a few old ones still talking French," he comments in a tone that is pure Acadian. At age fifteen, he began working for the Fleming family who owned much of the land in and around Lafitte, including the cemetery. For the past forty years, Mr. Mayfield has been living directly across the road from Fleming Cemetery in a raised house surrounded by a kitchen garden, farm equipment, and roaming livestock and beasts of burden. His life of hard work has been part of a bucolic scene rapidly disappearing from an area where the real estate market is booming and seems to be giving way to a spasm of suburban-style home construction.

Edmond Mayfield became a caretaker of the wide-ranging Fleming family properties, main-

taining structures, land, livestock, and crops. Although the expression "Cajun Cowboy" is a notion normally associated with the prairies of southwest Louisiana, Mr. Mayfield is living proof of their existence in Jefferson Parish. "They used to raise a bunch of cattle, along with sheep and goats, back here," he says. "This was their pasture, all the way from the cemetery here to the bridge. I used to keep everything grazed down, round em up, feed em, everything. Used to make a lot of hay." Mr. Mayfield explains that prior to the arrival of the Fleming family, most of the traffic in the area was by boat, and that the Flemings were the first to build decent horse trails. "When these people came, it was just enough for one horse to come down. When people get past the bridge off 45, they call it the old road. They made that road by hand, and they picked up the high spots. That's why it has all those curves." His lifetime of service with the Fleming family bonded him very closely with this cemetery.

Although Mr. Mayfield saw the advent of automobiles as a child—recalling that "there were maybe two or three in the whole area. It was all shell roads, not the best for them big old cars"—he has vivid memories of a bygone bayou country. "We did everything by boat: all business, we went to church by boat, and we brought people to the graveyard by boat." That era, in which the nearby Bayou LaFourche was affectionately know as "the longest main street in the U.S.A.," is a time Mr. Mayfield misses. He would like to see all that small boat traffic return.

However, Edmond Mayfield is not nostalgic about everything from the past; he has some pretty grisly memories about the cemetery. "They fix the tombs better today. Before, they used to put people in the ground and we used to see them get pushed back up by the water. Now they put them in cement tombs." Another less than desirable fact he recalls

from the past has something in common with the neighboring Jean Lafitte National Park. Mayfield reports: "There were times when nobody took care of the cemetery. It was a trash dump sometimes." Prior to the park's establishment in 1978, the high ground of this region was used as an automobile graveyard. Similar to how two decades of federal staffing and hundreds of community volunteers restored the "Barataria Unit" to a pristine state, Mr. Mayfield has been significantly responsible for the revival of this picturesque cemetery.

Although Edmond Mayfield always professionally tended to Fleming family property, he is now retired and maintains the cemetery simply because he wants to. His motivation behind the landscaping and tomb-mending visits—visits that may occur up to three times a day—is the same inspiration that pulls most people into cemeteries: family. "A good way to visit the family" is how Mr. Mayfield describes his dutiful daily toil. "I got a bunch of em in there: my mamma, my daddy, my wife, I got a boy in there, I got a brother, three uncles, grandma, grandpa…" reciting a long litany of lost loved ones.

He also feels that his duty is not only to his relatives but to the whole cemetery. Mr. Mayfield religiously cuts the grass and literally keeps the gate, personally deciding when to open and close the cemetery entrance, a gate he himself helped build about ten years ago. "I don't close it every day. If I lock it, it would be at night. Any time they got a big deal going on, like a holiday. You know, they get all tanked up and then come finish in the graveyard. So the next day I gotta clean up all kinds of cans and bottles and whatever else. The biggest mess is on Mardi Gras and New Year's, naturally," he explains in a tone more amused than annoyed.

Although Mr. Mayfield has lived through decades in which the world has changed drasti-

cally, what strikes him about the Lafitte area is how much it has actually stayed the same. He says that "it's just built up a little bit more. A few more houses, more cars and less boats, that's all." Although he still does a little handy work for the Flemings, Edmond Mayfield steadfastly passes his personal time commemorating his family. From his house he continues to make lamentation boxes, wherein he can place a saint's picture and protect a candle from the wind and rain, and in this cemetery populated by many more birds, reptiles, and insects than humans, this man, with much of his family deceased, never feels alone.

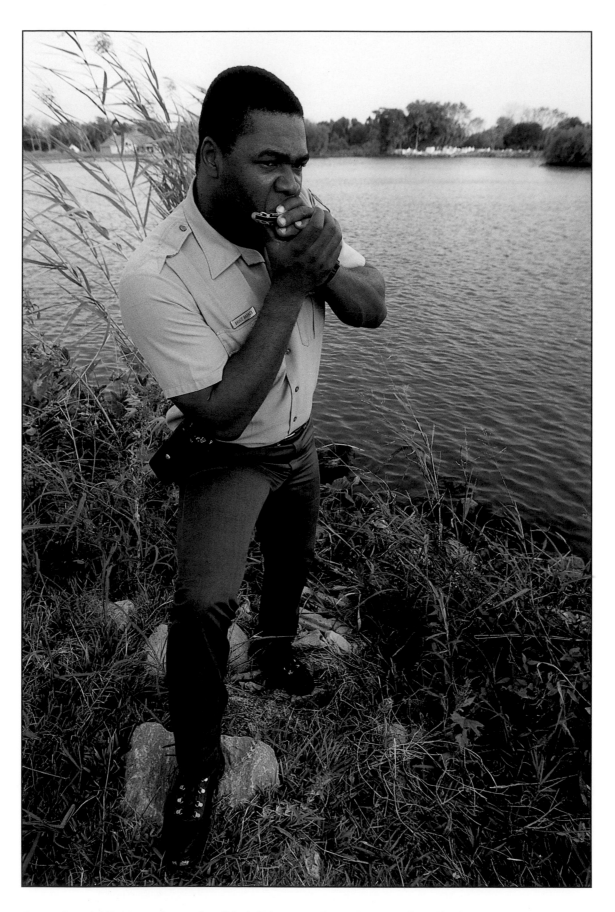

Bruce "Sunpie" Barnes makes music at John's Point across Bayou Barataria from Fleming Cemetery

21

Bruce "Sunpie" Barnes

CEMETERY MUSIC

*T*he legendary New Orleans jazzman Danny Barker once said that there was something "musical" about the cemeteries of New Orleans. This significance has not been lost on one of New Orleans's most dynamic musicians, Bruce "Sunpie" Barnes.

This harmonica and accordion player is described as a Zydeco/Blues artist, in that his performances and recordings combine both. He lives in a musical world that incorporates blues extending from the Delta to Chicago and Zydeco as defined by Clifton Chenier and Boozoo Chavis, with a New Orleans sound never too far away. Sunpie moved to New Orleans in 1987 from his Arkansas hometown of Benton, where he grew up steeped in the rural blues of the Mississippi Delta. He never had to learn it from listening to records, having a childhood whose activities included playing the harmonica and farming the land out of which the blues literally grew. The music was handed down to Bruce from his father, the son of a slave who himself had been a sharecropper for four decades. Sunpie's daddy was a piano and har-

monica player who worked the WPA levee camps along the Mississippi River. Bruce learned not only instrumentation but also the camp work songs directly from his father.

Moving to Louisiana, Bruce Barnes was instantly drawn to Zydeco and its Creole version of the blues. He taught himself the accordion and learned French from his wife, Maria, a native of Le Mans, France. His voracious cultural appetite would as well gain him Cajun and Creole French language skills, making him one of the most fluent French language vocalists in the state. Despite the fact he is from out of the state and does not reside in southwest Louisiana, he is doing as much as any Zydeco player of his generation born in the Lafayette area to keep the French language alive in Louisiana music.

What astounds most people about Bruce Barnes is not only his unique musical range but also the many different lives he has led and continues to live. He was a college football All-American who went on to play for the Kansas City

Chiefs and has also appeared as an actor in major motion pictures. But beyond music, the calling closest to his heart that fatefully led him to Louisiana is that of natural scientist. With his degree in biology and specialty in ichthyology (the study of fish), this former high school biology teacher moved to New Orleans to work as a ranger at the Jean Lafitte National Park. This job changed his life personally, for here he would meet his future wife. And it would have immeasurable musical impact. Just as he learned the blues first-hand directly from the Delta land which gave rise to it, Sunpie injested the feeling of Zydeco from his hundreds of hours of wetlands fieldwork—whether by canoe on the bayou or in hip waders slogging through the marsh, muck, and flooded forests that are the breeding grounds of Zydeco and Cajun music.

As Mr. Barnes explored twenty thousand watery acres of the Barataria preserve, one of the first things that caught his attention was a mysterious cemetery of simple aboveground tombs. From John's Point, where he would play his harmonica after work, across the bayou he noticed Fleming Cemetery; under the Spanish moss-draped cypresses the stark white tombs shimmered like a vision. "It was very attractive and alluring. It made me want to come across the bayou. And then seeing it on the other side of the bayou was a totally different perspective," he explains.

Sunpie was intrigued by the cemetery. Investigating its history, he became fascinated by its past as a former Indian burial mound that eventually serviced Africans and Europeans, not too mention all those tales about Jean Lafitte. As he got to know people in the community of Lafitte, he learned more about the cemetery on a personal level. Bruce is particularly fond of one story: "A friend of mine, who's dead now, Gilbert Kreppel, the pirogue builder, was telling me all kinds of stuff about the cemetery, about the floods and how the graves would float away. He told me about this big flood that happened right after his Uncle Joe had just died and his grave floated out. The casket floated right up in his backyard. Gilbert looked out there and said, "Oh. Uncle Joe came to see me ..."

It was not until several months after he arrived that he formed a strong connection to this cemetery. One evening Bruce was playing music at John's Point and as he gazed out across the bayou he noticed children playing in the cemetery, something he himself did on a regular basis as a child. The image brought back powerful memories. As a young boy he would frequently stay with his grandmother in Arkansas, who happened to live right in front of a cemetery. He and his friends spent hours at a time playing games such as kickball in this country graveyard. His grandmother would watch them play and watch out for things they were not necessarily paying attention to, as she was considered clairvoyant. This was a woman who had predicted the eruption of Mount Saint Helens and the shooting of Pope John Paul II, and who would talk with her deceased brother visible only to her, conversations that always brought her to tears.

The sanctity of the cemetery was important to Bruce's grandmother, and she would make certain that the boys' playing did not accidentally desecrate the final resting places. If she saw a kid bump into a headstone or step on a grave, she would advise them to cross their fingers, stomp their toes, and bite their tongue simultaneously to ward off bad luck. One of the most profound and memorable moments in Sunpie's life involves his grandmother and her neighboring cemetery.

"I remember one day particularly," he recalls. "We were in there playing, and this is no joke, there was a white wolf in that cemetery. This is extremely unusual. I'd never seen anything like this before. The first way we noticed it was that a dog took off runnin'. This dog ran right past us and we all looked

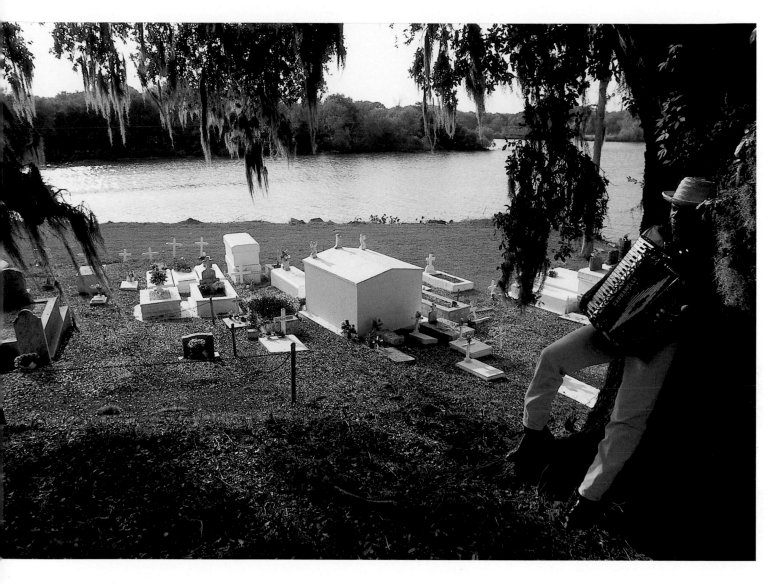

Sunpie atop the Indian mound

around and saw this big white wolf. It was not like a German shepherd or any type of dog. I remember it as a wolf. Everybody ran, and I ran. I was the youngest at the time, about 4 years old, and I ran right toward the edge of the cemetery. There was a string of barbed wire down low which I had forgot about and I tripped on it. As a matter of fact, I still have a little scar from that. I turned around and this big wolf or white dog or whatever it was, was bounding straight toward me. Right then my grandmother, who was watching, threw the rim of a bicycle tire and hit that thing right in the head and it turned and ran and jumped the fence and

went the other way. It was something! I'll never forget it."

Sunpie has an infant son of his own now. Maybe he too will end up playing music, and perhaps first play in cemeteries. Bruce still draws inspiration from the sight of this burial site across the Bayou Barataria, improvising riffs and composing songs as the sun sets behind him to the west. (As a matter of fact, he wrote the song "Eh Tout Quelqu'un" from this very spot.) But more than drawing musical inspiration from the spot and image, Sunpie says he gets something here equally as valued—a deep sense of peace and tranquillity.

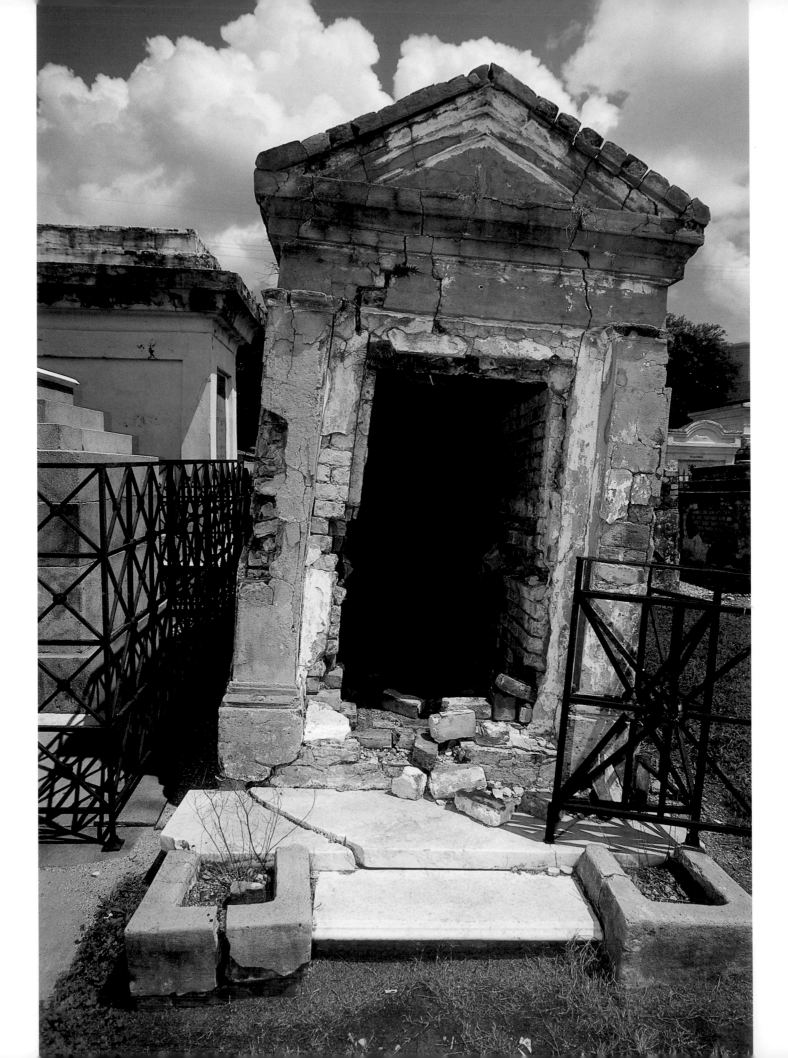

Afterword

As much mystique and significance as there is surrounding the cemeteries of New Orleans, there is as much controversy and debate over whether they will withstand the ravages of time, weather, vandalism, and neglect. Of course, there are varying degrees of decay throughout all the cities of the dead: some are immaculate, some are moribund, some are somewhere in between. But taken as a whole, there is a general feeling in New Orleans, as with any beloved natural or man-made irreplaceable phenomenon, that the cemeteries are in jeopardy, as if they are an endangered species. Both professional and personal preservation battles are waged by groups and individuals, and a general community vigilance has arisen in this town which places a large value upon what has come before—a city that makes a conscious effort to nurture the past in the present.

People voice negative criticism over the state and fate of the cemeteries, but there have been some very positive developments in the recent past involving the major players. To begin with, in 1966 the Catholic Church established the New Orleans Archdiocesan Cemeteries, a centralized administrative body to operate their twelve cemeteries of immeasurable historic significance. Prior

to their existence, the twenty-two thousand some-odd graves in Catholic cemeteries were not centrally monitored, but since the Archdiocesan Cemeteries' founding, tremendous amounts of research, field work, and money have gone into maintaining their cemeteries. Then there was the founding of Save Our Cemeteries in 1974. If New Orleans cemeteries ever had an angel, it is in the form of S.O.C. This group has gathered preservation techniques from authorities around the world and executed field work ranging from complex restoration to crucial cleanups throughout New Orleans. Save Our Cemeteries recently qualified Lafayette Cemetery #1 to receive a substantial grant from the World Monuments Fund. This will not only perpetuate preservation but will place a New Orleans cemetery in the august company of monuments ranging from the Taj Mahal to the Temple of Hercules.

Then there is the recent sustained prosperity of Stewart Enterprises, proprietor of Metairie, Louisa Street, and Mt. Olivet cemeteries. This corporation has grown to become the third largest cemetery and funeral provider in the United States. In June 1996, a year when the price of their stock almost doubled, as they were buying five

more funeral homes in Auckland, New Zealand, Stewart Enterprises declared their second three-for-two stock split since going public in 1991. *Times-Picayune* financial editor Charley Blaine wrote that this move reflected "the company's ability to deliver on an aggressive expansion strategy." Such corporate prosperity bodes well for the care of their three historic New Orleans cemeteries, the cities of the dead from which their cemetery dynasty was born.

Then there is the healthy presence of two fraternal orders, the Fireman's Charitable and Benevolent Association and the Masons. One need only glance at Greenwood or Masonic Cemetery to see that these organizations are preserving cemetery heritage through their strict maintenance. The same can be said for every Jewish cemetery in New Orleans. And the enduring presence of the Huber family in the cemetery business is very reassuring. Mr. Lloyd W. Huber, grandson of tomb builder and Hope Mausoleum founder Victor Huber and son of historian/preservationist Leonard V. Huber, continues to operate the immaculate St. John Cemetery.

There is also the tourist industry, New Orleans's bread and butter. New Orleans has been a favored destination of world travelers since the nineteenth century, and the cities of the dead have always been one of the most popular features. Today the tourism industry continues to call attention to the uniqueness and importance of these unparalleled graveyards, and the presence of tourism there definitely discourages vandalism. But perhaps the key to ensuring the endurance of New Orleans cemeteries lies in the community itself, in the reverent connection that this town of jazz funerals and All Saints' Day observances has with the occupants of the cities of the dead.

People who love the cemeteries the most seem to bemoan the perceived demise most loudly, and these expressed sentiments of vigilance are indeed healthy. But at the same time we should recognize the good news—the visible and tangible improvements that give reason to cheer. A parallel can be found in a recent *New Orleans Magazine* commentary written about the French Quarter:

> To those who care about New Orleans institutions, the Vieux Carre may seem like Mardi Gras: We like it, but it's not as good as it used to be. That perception may be clouded by the fact that both the Quarter and Carnival are so rich in color and vibrancy that while our memories record the extraordinary, the present reminds us of troubles.
>
> There are many problems in the French Quarter. It is true that the neighborhood is not what it used to be. To that we add, however, that the Quarter has never been what it used to be...The romanticized memories have always been a few notches above the everyday reality.

The word "cemeteries" can be substituted for "Vieux Carre" and "French Quarter" in this passage. The commentary then notes that progress has been made in the recent past, one being "improved properties." The point is made that "many of the places that today have been renovated and are well-cared for were run-down, slum-level housing as recently as the 1960's. Courtyards were neglected, some were used for parking and, in at least one case, as a working area for a mechanic. The houses were feeling their age and looking even older." A similar critique could be made of the cities of the dead.

Examples of similarly recent cemetery recovery abound. Peruse the pages of *New Orleans Architecture: The Cemeteries* and compare the 1972 images of St. Louis Cemetery #1 with its present condition (specifically the Orleans Battalion of

Artillery Monument, the Claiborne-Lewis Family tomb, and the Italian Mutual Benevolent Society tomb, to name a few); vast improvement is evident. Or note the photo of St. Roch Cemetery's Mausoleum of Michael the Archangel in the 1945 *Gumbo Ya-Ya* and read its description:

> The mausoleum looks like something left over from an air raid. The Gothic building is flanked by medieval towers, one containing the former belfry.

Beneath and in all the walls are crypts which were formerly occupied by deceased priests and nuns, but are now empty with a sole exception, this one bearing a comparatively new marble slab and a name. Old and rain-beaten notices on all sides of the ruins warn that all remains must be removed by November 1, 1931, and apparently this order was thoroughly obeyed. Ferns, goldenrod and Virginia creeper grow abundantly on the roof and wave from the yawning crypts.

Mausoleum of Michael the Archangel, St. Roch Cemetery #2, 1996

All the once-handsome stained-glass windows are smashed and most of the murals, executed by Carmelite monks—formerly at Carmel, Louisiana—are defaced, though a few are in remarkably good condition. Once statues of saints occupied pilasters on all sides of the exterior of the structure, but all are now gone except one which has no head. There has been much discussion regarding whether the mausoleum should be demolished or restored…

It is good that they did not decide to demolish this monument. Today it gleams formidably amid a cemetery that itself is in stellar condition.

Eminent historian Jerah Johnson notes a physical improvement in the condition of St. Louis #1 since his arrival to New Orleans in 1959, and he is someone who pays attention to such matters. Dr. Johnson's 1995 tomb purchase was the first transfer of St. Louis Cemetery #1 private property in more than forty years. (His acquisition seems to have triggered a gentrification of sorts, as the general condition of St. Louis Cemetery #1 surrounding his tomb appears spruced up, and there have been a number of recent nearby tomb restorations.) Although Dr. Johnson characterizes the St. Louis Cemetery #1 that he first encountered in 1959 as having possessed "wonderful decay" and in "a romantic sense of decline," he believes that it is better to lean toward the direction of slick-appearing repair than to let the damage of decline become irreversible, noting that Mother Nature will inevitably reintroduce the charming patina of age.

Jerah Johnson was not the first chronicler of Louisiana cultural history to scrutinize the condition of this oldest of the cities of the dead and to take preservative action. In the 1920s author Grace King (now entombed in Metairie Cemetery) railed at the neglected state of the St. Louis #1

Protestant section and formed "The Society to Preserve Ancient Graves." She commenced a 1930 *Times-Picayune* article with the sentence: "Is there a more forlorn, desolate, neglected-looking spot in New Orleans than this old relic of history—the Protestant corner of the old St. Louis cemetery?" Today this Protestant section is in fine condition.

This list of vigilant luminaries goes on, but the point is that all is not worse off in the New Orleans cemeteries of today; there is actually much improvement. Well-meaning people will always complain that the cemetery owners or private historic preservation groups or government agencies "don't do enough," but the question is, enough of *what?* It seems that people do not have any idea of the capital needed to restore cemeteries. Consider the following figures. In 1983 preservationists figured it would cost $975,000 to save only the decrepit wall vaults of St. Louis Cemetery #2. In 1984 the Archdiocese spent $50,000 simply to restore the St. Louis #1 Italian Mutual Benevolent Society tomb; $35,000 alone went into fixing its ornamental iron. And raising cemetery restoration money is not easy, even for the most worthwhile of causes. Ask anybody who has ever tried, starting with Save Our Cemeteries.

If people in New Orleans critical of the conditions of cemeteries are really concerned, here is a piece of advice: use them. Visit your family tomb. Weed, whitewash, maintain, and not only on All Saints' Day. (And there's always the option of buying a perpetual care policy. Fortunately, perpetual is no longer an option in Archdiocesan cemeteries, but it is mandatory for new tomb construction. This is a wise requirement that all New Orleans cemeteries could benefit from.) And most important, if you have a family tomb, make sure to make arrangements for any impending burials to occur there. (Many people are starting to realize that it is very economical to use a tomb that their great-

What will save the cemeteries? Tomb construction and restoration. St. Louis Cemetery #3

great-grandfather fully paid for. New Orleans defies many national trends, including the fact that its cemeteries pull people who moved to the suburbs back to the city after death.) As they say, use it or lose it.

New Orleans is actually quite fortunate to have this option of reusing tombs, an opportunity that contributes to cemetery survival. Much Louisiana law is different from that in the rest of the United States, including Statute #308, Title 8, under "Cemeteries." It states that after twenty-five years of nonuse, a grave can be legally reclaimed by the cemetery owner (be it church, temple, municipality, fraternal order, or private company) and be lawfully resold. And individual tomb owners themselves often resell tombs. In New Orleans it is common to see "For Sale" signs on graves and classified ads announcing the resale of tombs.

In other states the reselling of gravesites is a felony. A highly publicized infraction of such laws occurred in Los Angeles in September 1995. Two class action suits were filed against Lincoln Memorial Park and Paradise Memorial Park cemeteries because bodies were removed from graves shortly after burial and the gravesites were then resold. What these cemeteries did clearly seems wrong, unethical, and illegal, and the tomb owners are rightfully infuriated (and rightfully filing suit). But the saga of these unfortunate incidents in Los Angeles highlights a major way in which South Louisiana burial differs from its American counterparts.

In the New Orleans region, one never hears of cemetery owners creating more room by illegally and scandalously clearing out graves. After a "year and a day" the remains of millions of New

Orleanians have been removed without protest from living relatives, and according to Statute #308, Title 8, people can wait for twenty-five years to legally reclaim an apparently abandoned tomb, without controversy.

But more than in state laws and regional burial procedures, a distinction can be found in the reactions and attitudes of the tomb owners and community members themselves. Regarding the Lincoln and Paradise Memorial Park cemetery scandals, the Los Angeles Department of Consumer Affairs deputy director stated: "I've never seen anything as disgusting as this, disturbing the dead," and a justifiably upset family member of one of the disturbed deceased expressed these sentiments, "What happened to 'rest in peace'? They were supposed to be resting in peace. We found them, but we don't know if they're in there."

In New Orleans, however, people have matter-of-factly witnessed the removal of remains for more than two hundred years; here, when done legally, it is not considered disturbance of the dead. The reshuffling of remains in New Orleans is just an accepted part of the process. Fran Grazzo, operator of the world-renowned Hartsdale Canine Cemetery in Hartsdale, New York, commented on this relatively laissez-faire attitude toward post-mortem traffic in New Orleans with the statement: "The way people handle death in New Orleans is so advanced compared to the rest of the country."

Multiple burial is indeed legal and accepted in New Orleans, which may be why the recycling of burial space will consistently render burial a viable business in New Orleans as opposed to elsewhere. Referring to burial in the state of California, it was once written that "there will always be more dead people, but there will not

. . . the affliction of decay

always be more land to put them in. Which makes owning a cemetery, industry analysts say, a limited-term investment, much like brokering a tract of homes; it is the business of selling real estate a swatch at a time until the land is gone, owned finally by the families of the dead." This complaint is never voiced in New Orleans, where burial is hardly a "limited-term investment." Not only does multiple burial allow tomb owners to save money by sharing burial space with family members but it also allows the cemetery to make more money over the long haul by being able to charge repeated burial fees.

More significantly, this same simultaneous legality and acceptability of New Orleans multiple burial allows age-old history to lie juxtaposed with the morning paper's headlines. Most historic American cemeteries that buried residents of the original thirteen colonies either have not seen a funeral in generations or have fallen prey to development (except for national military cemeteries). Yet in New Orleans, Dutch Morial reposes right next to Marie Laveau.

Preservationists should find comfort in the assumption that this reusability will someday *have* to revive most if not all old neglected New Orleans burial grounds. There is one simple reason for the predictability of this forecast's outcome: We will have no other choice but to use them. Consider the finite nature of land as a resource, and couple that fact with the rate at which the human population is exploding, and it is obvious that, unless people stop using burial grounds altogether, we will have to revive and reuse already established cemeteries.

This anticipated trend will undoubtedly lead to much preservation and restoration, whose potential brings to mind the old proverb: "Be careful of what you wish for, because you just might get it." As with development of the city of the living, we do not want to get carried away. One must ask, is

Planet Hollywood or the Fashion Cafe really an improvement upon French Quarter deterioration? (In 1992 a visitor to the newly restored Ellis Island historical site loudly voiced related sentiments amid a crowded room of onlookers. While observing photographs that portray the dingy, decrepit conditions of turn-of-the-century Ellis Island facilities, she noted the immaculate, spotless state of the renovated site and exclaimed, "They really screwed this place up!")

Preservationists grapple with these same concerns all around the world. A fascinating example of this debate is being played out at the ancient Cambodian city of Angkor Wat, one of the seven wonders of the world. As the Southeast Asian tourist industry booms, preservationists agonize over how to reclaim Angkor Wat from the surrounding jungle's vegetation, which has done much damage but has simultaneously created stunning displays of tree root systems engulfing the mysterious man-made structures. The initial impulse of many admirers is to just leave it alone. The Archeological Survey of India, who is responsible for Angkor Wat's conservation, subscribes to the views of Sir John Marshall, the father of modern archeology and former A.S.I. director. Marshall stated that "although there are many ancient buildings whose state of disrepair suggests at first site a renewal, it should never be forgotten that their historical value is gone when their authenticity is destroyed, and that our first duty is not to renew them but to preserve them."

As with Angkor Wat, some of the most remarkable features found in the cities of the dead involve former grandeur fused with serendipitous plant life sprouting from crumbled mortar between the bricks of a tomb tapering into the sublime decay, decay that is so quintessentially New Orleans.

NOTES

Chapter 2 New Orleans Cemeteries

Page

10 "The horrid image of this place…" *The Courier*, June 11, 1833, quoted from *Gumbo Ya-Ya* (New York: Bonanza Books, 1945), 337-338.

11 "Girod Cemetery reflects…" Lyle Saxon, Edward Dreyer, and Robert Tallant, *Gumbo Ya-Ya*, 337.

12 "And by the light of flaring torches,…" Ibid, 339.

12 "The great Bayou cemetery…" Bennet Dowler, *Researches upon the Necropolis of New Orleans* (New Orleans: Bills and Clark, 1850), 7.

12 "at high tide…" *A History of Regional Growth*, quoted from *The Beautiful Crescent: A History of Regional Growth* (New Orleans, 1984), 33.

13 "There was still no wish…" Jacquetta Hawkes, *The Atlas of Early Man* (New York: St. Martin's Press, 1976), 21-22.

13 "learning in time…" W.H.F. Basevi, *The Burial of the Dead* (New York: E. P. Dutton, 1920), 35.

13 "Graves developed from shelters…" Ibid.

13 "the oldest towns…" Hawkes, 40.

13 "preferred to bury…" Ibid.

13 "while the bones…" Ibid, 42.

14 "Their great tombs…" David Cuthbert, "Mummy Mania," *The Times-Picayune*, June 22, 1996.

14 "The pyramid is…" Talbot Hamlin, *Architecture Through the Ages* (New York: G. P. Putnam's Sons, 1940), 39.

14 "by digging into…" Basevi, 79.

14 "Louisiana's 'Meso-Indians,'…" Terri Brewig, *Louisiana Life*, November/December, 1990.

15 "were often interred together…" Fred B. Kniffen, Hiram F. Gregory, and George A. Stokes, *The Historic Indian Tribes of Louisiana* (Baton Rouge, LA: Louisiana State University Press, 1987), 33.

15 "Perhaps the strangest experience…" Bob Krieger, "When God Walks in Heavy Boots," *Gambit*, September 6, 1994.

18 "Mild winters and soft springs…" Randolph Delehanty, *New Orleans: Elegance and Decadence* (San Francisco: Chronicle Books, 1993), 6.

18 "New Orleans is a cosmopolitan city…" Tennessee Williams, *A Streetcar Named Desire* (New York: Signet, 1947), Act I, Scene 1.

20 "New Orleans isn't like…" Ibid.

20 "Then I hear about New Orleans…" Robert Olen Butler, *A Good Scent From A Strange Mountain* (New York: Henry Holt, 1992), 47.

Chapter 3 Burial Types and Techniques

23 "There is no architecture in New Orleans…" Mark Twain, *Life on the Mississippi* (New York: Bantam Books, 1990), 199.

23 I say thou hast belied… William Shakespeare, *Much Ado About Nothing* (New York: Harcourt, Brace & World, 1968), Act V, Scene 1.

23 Now, when the bridegroom… William Shakespeare, *Romeo and Juliet* (New York: Harcourt, Brace & World, 1968), Act IV, Scene 1.

23 "Nicodemus, the man who had come…" Holy Bible (New York: Collins' Clear-Type Press, 1946), Book of John, 19:39–42.

25 1833 burial ordinance information: Leonard V. Huber, *New Orleans Architecture: The Cemeteries* (Gretna: Pelican Publishing Company, 1989), 14.

28 "in a way so that…" Ibid., 43.

Chapter 4 All Saints' Day

31 "They practice the sabbath…" quoted from *Daily Life in Louisiana; 1815–1830* (Baton Rouge: Louisiana State University Press, 1981), 71.

31 "Every provision is usually made…" Lyle Saxon, Edward Dreyer, and Robert Tallant, *Gumbo Ya-Ya* (New York: Bonanza Books, 1945), 357.

31 "The earliest [such] celebrations…" Ralph Linton and Adelin Linton, *Halloween Through Twenty Centuries* (New York, 1950), 4.

32 "The Pantheon was a Roman temple…" Father Donald Duffy, quoted from "Cleaning graves raises families' spirits, *The Times-Picayune*, October 27, 1994.

32 "by the end of the thirteenth century…" Linton, 79.

32 "the parochial skulls, neatly placed…" C. E. Vulliamy, *Immortal Man* (London: Methuen & Co. Ltd., 1926), 19.

32 "mournful complaints…" Ibid., 20.

32 "In Mexico the first and second…" Chloë Sayer, *Mexico: Day of the Dead* (Boston, MA: Redstone Press, 1990), 8.

32 "The first All Saints' Day…" Joan B. Garvey and Mary Lou Widmer, *Beautiful Crescent* (New Orleans: Garmer Press, Inc., 1982), 122.

32 Joe Never Smile information: Danny Barker, *A Life in Jazz* (New York: Oxford University Press, 1986), 52.

33 "Louisianians are as a whole..." Saxon, 357.

33 "We kids used to clean the graves . . ." Louis Armstrong, quoted from the museum exhibit *Louis Armstrong: A Cultural Legacy*.

33 This flower town . . . Lafcadio Hearn, quoted from *New Orleans Transit Reader's Digest*, November 2, 1970.

36 "It's hard *not* to garden" Randolph Delehanty, *New Orleans, Elegance and Decadence* (San Francisco: Chronicle Books, 1993), 6.

36 "farewell to the last days..." Joanne Wogan Arquedas, *All Saints' Day* (unpublished WPA manuscript, Louisiana State Museum Library).

36 "All Saints' is the city's great..." *The Daily Picayune*, November 2, 1903.

36 "for a long time, this flower..." Arquedas.

36 "squeezed together tightly..." Ibid.

36 All Saints' Day food information Ibid.

39 "sing a peculiar chant..." Vulliamy, 54.

39 This holiday comes on the first . . . Anita Brenner, "Skeleton Priests, Presidents, and Poets," quoted from *Mexico: Day of the Dead*, 32–33.

39 "balloons, toy birds..." Saxon, 362.

39 A young woman with dark hair... Ibid, 358.

42 It is the day in New Orleans . . . Anne Rice, *Interview With A Vampire* (New York: Ballantine Books, 1976), 108.

46 "There is much that is great..." Lolis Elie, "Indians Sing of Freedom," *The Times-Picayune*, March 29, 1996.

47 "Aren't there more ways . . ." Harnett Kane, *Queen New Orleans* (New York: Bonanza Books, 1949), 296.

Chapter 5 St. Louis Cemetery #1

51 1788 fire information: Leonard Huber, *New Orleans: A Pictorial History* (Gretna: Pelican Publishing Company, 1991), 4.

51 Everywhere white funeral notices . . . Rudolph Matas, quoted from "Mosquitoes not just a bother in 1800's, they were killers," *The Times-Picayune*, July 6, 1993.

52 "fortify themselves with liquor" Ibid.

53 "the placing on view (laying out)..." Our Lady of Guadalupe Church (New Orleans), 3.

53 "Catholic funerals had to be..." Ibid.

53 "The morning train of funerals . . ." William L. Robinson, "Diary of a Samaritan," quoted from *New Orleans: A Pictorial History*, 262.

55 At the gates, the winds . . . *New Orleans Daily Crescent*, August 11, 1853.

55 1904 railroad excavation information: *New Orleans Transit Readers Digest*, February 12, 1968.

Chapter 6 St. Louis Cemetery #2

61 Funeral processions crowded every street. James Parton, *General Butler in New Orleans*, quoted from *Gumbo Ya-Ya*, 340–341.

62 "exhalations from the dead . . ." Our Lady of Guadalupe Church, 3.

62 "poisonous effluvia from the swamps..." Ibid.

64 Service for Napoleon Bonaparte *Louisiana Gazette*, December 20, 1821.

68 "by the 1820's church authorities . . ." Raphael Cassimere, Jr., Danny Barker, Florence Borders, D. Clive Hardy, Joseph Logsdon, and Charles Rousseve, *New Orleans Black History Tour of St. Louis Two Cemetery, Square Three*.

69 "there are secrets that . . ." Pelius Pinchback, quoted from *Great Characters of New Orleans* (San Francisco: Lexicos, 1984), 45.

71 "Preservationists, mounting an intense . . ." Coleman Warner, "Thomas wants to save facades," *The Times-Picayune*, May 14, 1996.

Chapter 7 Lafayette Cemetery #1

79 The Americans have found a way... P. Forest, quoted from a Louisiana State Museum exhibit entitled "Disease, Death, and Mourning."

80 "a land boom of staggering proportions . . ." S. Frederick Starr, *Southern Comfort* (Cambridge, MA: The M.I.T. Press), 21.

80 "By taking over her plantation..." Ibid., 22.

81 "I shall live, by God . . ." Samuel Peters, quoted from *Southern Comfort*, 22.

81 Henry Watkins Allen epitaph quoted from *Gumbo Ya-Ya*, 344.

83 "the deteriorating Garden District graveyard . . ." Katherine Ramsland, *Prism of the Night* (New York: Plume, 1992), 325.

83 "bury the past." Joy Dickinson, *Haunted City* (New York: Citadel Press, 1995), 136.

Chapter 8 Masonic Cemetery

89 "Sedella was a Freemason..." "Precis Historique de la Franc Maçonnerie à la Louisiane," *Le Franc-Maçon*, January 1846.

91 "a dead museum." William S. Burroughs, quoted from the film *Naked Lunch*.

91 "The land in Masonic . . ." Leonard V. Huber, *New Orleans Architecture: The Cemeteries* (Gretna: Pelican Publishing Company, 1974), 49.

Chapter 9 Hebrew Rest

93 "was said to have been . . ." Henri A. Gandolfo, Metairie Cemetery: An Historical Memoir (New Orleans: Stewart Enterprises, 1981), 80.

93 "We enjoin the Directors General . . ." the Code Noir, Article 1, quoted from *The Early Jews of New Orleans* (Waltham, MA: American Jewish Historical Society, 1969), 4.

94 "would be politically unreliable . . ." Company of the Indies bureau document, quoted from *The Early Jews of New Orleans,* 5.

94 "a missionary concern . . ." Bertram Korn, *The Early Jews of New Orleans,* 4.

94 "If Jewish landowners . . ." Ibid.

94 "in a state of confusion . . ." Edwin A. Davis, quoted from *The Early Jews of New Orleans,* 3.

95 "According to Jewish belief . . ." quoted from Louisiana State Museum exhibit entitled "Disease, Death, and Mourning."

Chapter 10 St. Louis Cemetery #3

100 "Leper's Land," Lyle Saxon, Edward Dreyer, and Robert Tallant, *Gumbo Ya-Ya* (New York: Bonanza Books, 1945), 329.

100 "There's even an example . . ." John Pope, "Progress mislaid many meant to rest in peace," *The Times-Picayune,* August 18, 1985.

101 "a rather uncrowded appearance . . ." Samuel Wilson and Leonard V. Huber, *The St. Louis Cemeteries of New Orleans* (New Orleans: St. Louis Cathedral, 1963), 37.

102 "he who is like the Choctaw" Mel Leavitt, *Great Characters of New Orleans* (San Francisco: Lexicos, 1984), 4.

102 "formed two rows alongside . . ." Ibid., 5.

Chapter 12 St. Roch Cemetery / Campo Santo

115 "healing many with . . ." Roger Baudier, *St. Roch and the Campo Santo of New Orleans* (New Orleans).

117 "the visitor sees one of . . ." Ibid.

117 "testify to the cures . . ." Ibid.

117 "the suffered affliction or disease . . ."

119 "Why shouldn't they pray . . ." Reverend Peter Leonard Thevis, quoted from *Queen New Orleans* (New York: Bonanza Books, 1949), 307.

119 "gravel or beans in their shoes . . ." Baudier.

119 "that the ghost-woman was . . ." Lyle Saxon, Edward Dreyer, and Robert Tallant, *Gumbo Ya-Ya* (New York: Bonanza Books, 1945), 335.

Chapter 14 Cypress Grove Cemetery

128 On the evening of the 27th . . . Reverend Theodore Clapp, *Autobiographical Sketches and Recollections During a Thirty-Five Year Residence in New Orleans* (Hallandale, FL: New World Book Manufacturing Company, 1972), 120.

130 The morning after the death scene . . . Ibid., 124-125.

130 The horrors and desolations . . . Ibid., 210.

130 The physiognomy of . . . Ibid., 189.

131 "unusual for its classic simplicity . . ." Mary Louise Christovich, *New Orleans Architecture: The Cemeteries* (Gretna: Pelican Publishing Company, 1989), 178.

132 "immortalized among epicures." Lafcadio Hearn, quoted from *New Orleans Architecture: The Cemeteries,* 31.

Chapter 15 Greenwood Cemetery

138 "Members of this organization . . ." Leonard V. Huber, *Clasped Hands* (Lafayette, LA: Center for Louisiana Studies, 1982), 125.

Chapter 16 Odd Fellows Rest

145 "that common laboring men . . ." Don R. Smith and Wayne Roberts, *The Three Link Fraternity—Odd Fellowship in California, An Introduction to the Independent Order of Odd Fellows and Rebekahs,* from the Internet.

145 "various or odd trades." Ibid.

145 A grand procession was led . . . Leonard V. Huber, *New Orleans Architecture: The Cemeteries* (Gretna: Pelican Publishing Company, 1989), 35.

Chapter 17 Holt Cemetery

153 "superior to the old cemeteries . . ." Leonard V. Huber, *New Orleans Architecture: The Cemeteries* (Gretna: Pelican Publishing Company, 1989), 60.

154 "deplorable, unkept (and) sickening" Judy Lieberman, "Cemetery needs fixing up," *The Times-Picayune,* December 14, 1995.

154 "obligations to its citizens . . ." Ibid.

154 "I would like to add my comments . . ." Richard Caire, "Unique qualities of a cemetery," *The Times-Picayune,* January 13, 1996.

158 Bolden's body lay in state . . . Donald M. Marquis, *In Search of Buddy Bolden* (Baton Rouge: Louisiana State University Press, 1978), 132−133.

159 "Call it what you want . . ." Author's interview with Clementine Bean, March 1996.

160 "Sometimes when we dig . . ." Former Holt Cemetery sexton, quoted from *Gumbo Ya-Ya* (New York: Bonanza Books, 1945), 349.

160 'jazz emperor.' Doris Hill, quoted from "A Farewell to Jesse Hill," *Gambit*, October 8, 1996.

Chapter 18 Metairie Cemetery

168 "You can make it *illegal* . . ." Martin Behrman, quoted from *Metairie Cemetery* (New Orleans: Stewart Enterprises, 1981), 65.

168 "How ya like dem erhsters?" Robert Maestri, quoted from *The Beautiful Crescent* (New Orleans: Garmer Press, Inc., 1984), 183.

169 "When courts fail, people must act . . ." W. S. Parkerson, quoted from *Metairie Cemetery*, 74.

169 "While the entire South . . ." Joseph Shakespeare, quoted from *Haunted City* (New York: Citadel Press, 1995), 148.

170 "numbskull" P.G.T. Beauregard, quoted from *Great Characters of New Orleans* (San Francisco: Lexicos, 1984), 42.

170 "I didn't like him . . ." Ibid., 43.

170 And this leads to . . . Henri A. Gandolfo, *Metairie Cemetery*, 105.

170 "It is likely that . . ." Ibid., 65.

171 "flock of vultures." Philip Lobrano, quoted from *Storyville, New Orleans* (Tuscaloosa, AL: University of Alabama Press, 1974), 48.

171 "amiable, foreign girls." Al Rose, *Storyville, New Orleans*, 48.

171 "perhaps the grandest" Ibid.

175 "a monument in memory . . ." Louisiana Supreme Court ruling, quoted from *Metairie Cemetery*, 69.

175 "Gene [Krupa] wasn't the first . . ." Benny Goodman, quoted from *Just a Gigilo: The Life and Times of Louis Prima* (Lafayette, LA: The Center for Louisiana Studies, 1989), 172.

175 "rock 'n roll history . . ." *Interview* magazine, quoted from *Just a Gigilo*, 172.

176 "We made a deal . . ." Phil Kaufman, quoted from "Ashes to Ashes," *People* magazine, June 17, 1996.

176 "They [Parson's family] . . ." Ibid.

Chapter 19 Fleming (Berthoud) Cemetery

180 "the Provençal equivalent . . ." Betsy Swanson, *Historic Jefferson Parish: From Shore to Shore* (Gretna: Pelican Publishing Company, 1975), 134.

181 Perrin Cemetery information Ibid., 140.

181 "the source of the most . . ." Lyle Saxon, Edward Dreyer, and Robert Tallant, *Gumbo Ya-Ya* (New York: Bonanza Books, 1945), 318.

181 I tell you like my mamma . . . Madame Toinette Perrin, quoted from *Gumbo Ya-Ya*, 318.

182 "Perhaps the most valuable . . ." Swanson, 140.

184 "As darkness falls . . ." Ibid., 142.

Afterword

196 "the company's ability to deliver . . ." Charley Blaine, "Stewart declares stock split," *The Times-Picayune*, June 11, 1996.

196 To those who care about . . . *New Orleans Magazine*, June 1996, "Quarter notes—some ways the Vieux Carre has improved."

196 "many of the places . . ." Ibid.

197 The mausoleum looks like . . . Lyle Saxon, Edward Dreyer, and Robert Tallant, *Gumbo Ya-Ya* (New York: Bonanza Books, 1945), 334.

198 "wonderful decay" Author's interview with Jerah Johnson, June 1996.

198 "Is there a more forlorn, . . ." Grace King, "Grace King appeals for historic tombs to have more care," *The Times-Picayune*, June 29, 1930.

200 "I've never seen anything . . ." Louis Bonsignore, quoted from "Dead aren't allowed to rest, lawsuit says," *The Times-Picayune*, August 20, 1995.

200 "What happened to 'rest in peace'?" DeLong Jackson, quoted from "Dead aren't allowed to rest, lawsuit says"

200 "The way people handle . . ." Author's interview with Fran Grazzo, May 1996.

200 "there will always be . . ." Eric Slater, "Grim evidence emerges from soldout cemeteries," *The Times-Picayune*, September 17, 1995.

201 "They really screwed . . ." Comment overheard by author on a visit to Ellis Island.

201 "although there are many . . ." Sir John Marshall, quoted from "Giving the World's Largest Monument a Facelift," *Angkor Magazine*, July-September 1996.

BIBLIOGRAPHY

Archdiocese of New Orleans: Our Lady of Guadalupe Chapel.

Archdiocesan plaques in the St. Louis Cemeteries.

Archeology News, Vol. 3, No. 1, "Uncovered French Quarter Burials Analyzed." State of Louisiana, Division of Archeology, April 1986.

Arquedas, Jeanne Wogan. *All Saints' Day.* Unpublished WPA manuscript, Louisiana State Museum Library.

Barker, Danny. *A Life in Jazz.* New York: Oxford University Press, 1986.

Basevi, W.H.F. *The Burial of the Dead.* New York: E. P. Dutton, 1920.

Baudier, Roger, K.S.G. *St. Roch Chapel and the Campo Santo of New Orleans.*

Boulard, Gary. *"Just a Gigilo": The Life and Times of Louis Prima.* Lafayette, LA: Center for Louisiana Studies, 1989.

Caffrey, Mary. "Visitors buried in their work to preserve N.O. cemeteries." *The Times-Picayune,* section B, page 1, June 3, 1987.

Carey, Joseph S. *St. Louis Cemetery Number One.* New Orleans, 1948.

———. *Your Cemetery Plot and Title.* New Orleans, LA: St. Louis Cathedral, 1948.

Cassimere, Raphael, Jr.; Danny Barker, Florence Borders; D. Clive Hardy; Joseph Logsdon; and Charles Rousseve. *New Orleans Black History Tour of St. Louis Two Cemetery, Square Three.* New Orleans N.A.A.C.P.: 1980.

Clapp, Theodore. *Autobiographical Sketches and Recollections during a Thirty-Five-Year Residence in New Orleans.* Hallandale, FL: New World Book Manufacturing Company, 1972.

Cypress Grove Cemetery/Greenwood Cemetery and Mausoleum. New Orleans: Fireman's Charitable and Benevolent Association.

The Daily Picayune, "Homes of the Dead," October 30, 1892.

Florence, Robert. *City of the Dead.* Lafayette, LA: Center for Louisiana Studies, 1996.

Gandolfo, Henri A. *Metairie Cemetery: An Historical Memoir.* New Orleans, LA: Stewart Enterprises, 1981.

Garvey, Joan B., and Mary Lou Widmer. *Beautiful Crescent: A History of New Orleans.* New Orleans, LA: Garmer Press, Inc., 1982.

Gehman, Mary. *The Free People of Color of New Orleans: An Introduction.* New Orleans, LA: Margaret Media, Inc., 1994.

Hall, Gwendolyn Midlo. *Africans in Colonial Louisiana.* Baton Rouge, LA: Louisiana State University Press, 1995.

Hamlin, Talbot. *Architecture Through the Ages.* New York: G. P. Putnam's Sons, 1940, 1953.

Hawkes, Jacquetta. *The Atlas of Early Man.* New York: St. Martin's Press, 1976.

Hirsch, Arnold R. and Joseph Logsdon, editors. *Creole New Orleans: Race and Americanization.* Baton Rouge, LA: Louisiana State University Press, 1992.

Huber, Leonard V. *Clasped Hands: Symbolism in New Orleans Cemeteries.* Lafayette, LA: The Center for Louisiana Studies, 1982.

Huber, Leonard V.; Peggy McDowell; and Mary Louise Christovich. *New Orleans Architecture: The Cemeteries.* Gretna, LA: Pelican Publishing Company, 1989.

———. *New Orleans: A Pictorial History.* Gretna: Pelican Publishing Company, 1991.

Hyman, Vicki. "Cleaning graves raises families' spirits." *The Times-Picayune,* October 27, 1994.

Jackson, Jack. "Tales from the crypt." *The Times-Picayune,* October 30, 1994.

Janssen, James S. *Building New Orleans: The Engineer's Role.* New Orleans, LA: Waldemar S. Nelson and Company, Inc., 1984.

Kane, Harnett T. *Queen New Orleans, City by the River.* New York: Bonanza Books, 1949.

Kent, Doris. "History of St. Louis Cemetery one of interest." *The Times-Picayune,* February 1, 1920.

King, Grace. "Grace King appeals for historic tombs to have more care." *The Times-Picayune,* June 29, 1930.

Korn, Bertram Wallace. *The Early Jews of New Orleans.* Waltham, Mass.: American Jewish Historical Society, 1969.

Laughlin, C. J. "Cemeteries of New Orleans." *Architectural Review,* vol. 103, #614, February 1948.

Leavitt, Mel. *Great Characters of New Orleans.* San Francisco: Lexicos, 1984.

Marquis, Donald M. *In Search of Buddy Bolden.* Baton Rouge, LA: Louisiana University Press, 1978.

Meyer, Richard E., editor. *Cemeteries and Gravemarkers: Voices of American Culture.* Ann Arbor, Michigan: U.M.I. Research Press, 1989.

New Orleans Magazine, "Julia Street" letter on Odd Fellows Rest Cemetery, May 1996.

New Orleans Transit Riders' Digest, November 2, 1970.

Norwich, Jihn Julius, ed. *Great Architecture of the World.* New York: Random House, in association with American Heritage Publishing, 1975.

Perkins, Spike. "Gram Parsons Lives in New Orleans." *Offbeat Magazine,* September 1994.

Pope, John. "Progress mislaid many meant to rest in peace." *The Times-Picayune,* August 18, 1985.

———. "Slave's skeletons from Quarter dig puzzles scientists." *The Times-Picayune,* April 17, 1986, p. A-27.

Ramsland, Katherine. *Prism of the Night.* New York: Plume, 1992.

Ronquillo, Leon. *Matters of Life and Death.* New Orleans: Louisiana State Museum, 1979.

Saxon, Lyle; Edward Dreyer; and Robert Tallant. *Gumbo Ya-Ya.* New York: Bonanza Books, 1945.

Sayer, Chloë, ed. *Mexico: Day of the Dead, An Anthology.* Boston: Shambhala Redstone Editions, 1993.

Smith, Don R. and Wayne Roberts. *The Three Link Fraternity—Odd Fellowship in California, An Introduction to the Independent Order of Odd Fellows and Rebekahs.* Linden Publications, 1993, from The Internet.

Starr, S. Frederick. *Southern Comfort: The Garden District of New Orleans, 1800–1900.* Cambridge, Massachusetts: 1989.

The States-Item, "Sixty enroll to save New Orleans historic tombs." July 7, 1923.

Swanson, Betsy. *Historic Jefferson Parish: From Shore to Shore.* Gretna: Pelican Publishing Company, 1975.

Veigle, Anne. "Bones will give clues to lifestyle in 19th century." *The Times-Picayune,* February 22, 1987.

Vulliamy, C.E. *Immortal Man.* London: Methuen, 1926.

Warner, Coleman. "City appeals for help managing cemeteries." *The Times-Picayune,* September 11, 1996.

Wilson, Samuel, Jr., and Leonard V. Huber. *The St. Louis Cemeteries of New Orleans.* New Orleans, LA: Laborde Printing Company, 1963.

Other Sources

Caryn Cossé Bell

Myrna Bergeron

Rabbi Murray Blackmun

Michael D. Boudreaux

Clayton Bourne

Elizabeth Calvitt

Kenny Hauck

Lloyd W. Huber

Jerah Johnson

Janice Lee

Joseph Logsdon

National Park Service tours

Save Our Cemeteries tours

SAVE OUR CEMETERIES

Restoration of the Homer Plessy tomb, April 1995, an effort to which Save Our Cemeteries significantly contributed.

Save Our Cemeteries, Inc. (SOC) was founded in 1974 in an effort to prevent the demolition of nine city blocks of wall vaults surrounding most of the three squares of St. Louis Cemetery No. 2. Since 1974, SOC has broadened its focus from only the historic cemeteries of New Orleans to include those of the state of Louisiana. SOC's three tenets are restoration, preservation, and education. Why save these cemeteries of the old city commons or of

other residential areas of New Orleans and Louisiana? Because they are, many times, the earliest remaining sculptural monuments of an area; because early nineteenth-century New Orleans, through aboveground burial, exerted strong efforts to participate in the international neoclassic movement in cemetery styles; because much of the tomb and vault architecture is rendered in a practical, vernacular style found only in New Orleans

and south Louisiana; and because New Orleans has thirty-one historic cemeteries, each differing from the other, either through the dictates of ethnic or religious preferences, and each lending expression to local customs of reuse and family continuity.

Since its founding, SOC has raised and spent millions of dollars in the city's historic cemeteries. SOC's work has been reported in the local, state, national, and foreign media. SOC also has been recognized as a source for accurate historical information, as well as a source of documentation. SOC is dedicated to the restoration and preservation of the city's historic cemeteries, but it is also focused on the education of both residents and visitors on the importance of preserving one part of New Orleans's cultural and architectural heritage—its cemeteries. SOC also serves as a resource for others, outside the New Orleans area, who are interested in preserving their local historic cemeteries.

Research material generated by SOC is housed either at the SOC office or the Historic New Orleans Collection (HNOC) in the French Quarter. Many projects have been initiated by SOC to record and document New Orleans's historic cemeteries. SOC has received support and financial assistance from among others, the Historic New Orleans Collection, the Louisiana State Historic Preservation Office, the National Trust for Historic Preservation, the World Monuments Fund, the federal government, private foundations, and commercial establishments. It also has many hours of volunteer support from SOC members, and students from Tulane University and Columbia University who have helped further the research needed to preserve New Orleans's unique heritage.

Through its membership, programs, newsletters, and annual fund-raising efforts, including the All Saints' soiree, grants, and special donations, SOC is an organization dedicated to the success and determined to act as a catalyst for cemetery preservation.

For more information, please contact the SOC office, telephone (504) 525-3377, fax (504) 525-6677 or call toll free (888) 721-7493. Contact SOC by writing to Save Our Cemeteries, Inc., P. O. Box 58105, New Orleans, LA 70158–8105.